Behind the Wall

Behind the Wall

LIFE, LOVE, AND STRUGGLE IN PALESTINE

Rich Wiles

Foreword by Ali Abunimah

POTOMAC BOOKS, INC.
WASHINGTON, D.C.

Library of Congress Cataloging-in-Publication Data
Wiles, Rich.
 Behind the wall : life, love, and struggle in Palestine / Rich Wiles ; foreword by Ali Abunimah. — 1st ed.
 p. cm.
 ISBN 978-1-59797-439-4 (hbk. : alk. paper)
 1. Refugees, Palestinian Arab. 2. Refugee camps—Gaza Strip. 3. Palestinian Arabs—Israel—History—20th century. 4. Arab-Israeli conflict. I. Title.
 HV640.5.P34W55 2010
 956.95'3044—dc22

 2009039256

Printed in the United States of America on acid-free paper that meets the American National Standards Institute Z39-48 Standard.

Potomac Books, Inc.
22841 Quicksilver Drive
Dulles, Virginia 20166

First Edition

10 9 8 7 6 5 4 3 2 1

[CONTENTS]

PURITY AND LOVE

LAND OF PALESTINE

STRENGTH AND SUMOUD

DREAMS OF RETURN

[FOREWORD]

by Ali Abunimah

One of the questions I get asked most frequently is, What is the one book I can read that will explain what is going on in Palestine? This question never fails to stump me. After all, there are dozens of books published on the topic every year. Moreover, the newspapers and television news programs always seem to be filled with reports about another act of violence or another round of meetings in a seemingly endless "peace process." What a paradox that despite the availability of so many sources of information, many people are still left wondering, What on Earth is going on, and why does it never end? Why can't Palestinians and Israelis just put their differences aside and live together?

The mainstream media has done more to misinform than to enlighten, and it almost never provides the context and background needed to really understand what is going on and what it would take to bring justice and peace to Palestine. I learned that context the way most Palestinians of my generation learned it— from the lived experience of our parents and grandparents, passed down to us in stories.

Naturally, my parents' experiences had a decisive impact on the course of my own life. In 1948 my mother was a young girl living with her family in a small village called Lifta, just west of Jerusalem. Early that year, Zionist militias—the precursors of the Israeli army—swept through the country. All the residents of the village were forced to flee, leaving behind their homes and virtually everything in them. My mother's family ended up as refugees in Jordan. Lifta is now within

the borders of the state of Israel. Many of the houses—including the one my grandfather built—still stand, but now they are occupied by Israeli families.

My father was born in a small village called Battir, near Bethlehem. Life there was much more rural with few of the modern conveniences my mother knew in Lifta; the people there lived much as they had for centuries. They had an intimate familiarity with each other and with the land that they cared for and that sustained them. Taking a trip to a neighboring village a few miles away was enough of an occasion that family and friends would come over to bid one farewell or welcome one home.

When Zionist militia attacks forced Battir's residents to flee their village, it seemed very much as though it were the end of the world to them. My father recalls living for months under trees with little protection from the elements and with very little food. Above all, there was the trauma that all refugees experience, combined with fear of what the future—as lived day by day—would bring.

Between 1947 and 1949, 750,000 out of a total Palestinian population of 1.2 million at that time had been forced from their homes (there were just fewer than 600,000 mostly recently arrived Jews in the country as well). More than 400 villages and towns and several major cities were depopulated or destroyed. In their place, the state of Israel was established on 78 percent of the territory of Historic Palestine. Although most of the Palestinians inside what became Israel were expelled or fled, some remained behind. Today they are Palestinian citizens of Israel, a 1.5 million-strong minority in a total population of 7 million, facing systematic discrimination within the "Jewish state." As a direct consequence of Israel's creation, a multireligious, cosmopolitan Palestinian society was left in ruins, and Palestinians began their long journey of dispossession, exile, and occupation—a journey that continues to this day.

My father's village was relatively lucky. When the armistice was signed in 1949, it was one of the very few whose residents were allowed to return home. It lay right on the line separating Israel from the area that came to be known as the West Bank. Along with a smaller piece of territory bordering Egypt—the Gaza Strip—the West Bank was the rump of Palestine that did not fall under Israeli control. The West Bank, ruled by Jordan, and the Gaza Strip, controlled by Egypt, became home not only to their original Palestinian inhabitants but also to hundreds of thousands of refugees from other parts of Palestine. Many other refugees went to Jordan, Syria, Lebanon, and Egypt.

Palestinian diasporic communities tracing their origins to 1948 can be found all over the world.

In June 1967 the Israeli army swept into the West Bank and Gaza Strip. Another wave of refugees—this time about 400,000—were forced into neighboring Jordan. Many were displaced for the second time a mere generation later. From 1967 until today, the West Bank, including East Jerusalem, and the Gaza Strip have been known as the "Occupied Territories." In defiance of international law, Israel rules these areas by military force, even though it technically has no sovereignty over these lands.

Two decades after the occupation, Palestinians in the West Bank and Gaza Strip rose up spontaneously in what came to be known as the First Intifada. There were thousands of demonstrations (peaceful with the exception of some at which Palestinian youths threw rocks at heavily armed Israeli soldiers) that Israel attempted to suppress with frequently lethal violence, including the deliberate breaking of children's bones. That intifada ended in 1993 with the signing of the Oslo Accords, which many Palestinians hoped would lead to an end to the occupation.

The international community supported a peace process that was supposed to end with the creation of a Palestinian state in the West Bank and Gaza Strip, with East Jerusalem as its capital. But instead of moving toward withdrawing from the Occupied Territories, Israel has been tightening its grip. Since 1967, Israel has built vast settlements throughout the West Bank that are now home to more than a half million of its own Jewish citizens. In addition to being illegal, these settlements have devastated Palestinian communities whose lands have been seized for the settlements and for the network of settler-only roads that link them.

In September 2000, after Ariel Sharon, an Israeli general who later became prime minister, staged a deliberately provocative visit to the Al-Aqsa Mosque in occupied East Jerusalem, Palestinian frustration with the absence of a real peace process and the continued theft of their land led to the Second Intifada. This time, Israel's violent reaction to Palestinian demonstrations was even more extreme, and unlike during the First Intifada, Palestinians fired back. In all, more than a thousand Israelis and five thousand Palestinians were killed in the Second Intifada, which peaked for more than three years.

Sensational violence is the part of the Palestinian story that the worldwide media has always focused on, and many people around the world now know the Arabic word "intifada" (uprising). But the word *sumoud* (steadfastness) more accurately describes

reality for most Palestinians, especially refugees waiting to return home. Sumoud is a form of resistance deeply woven into the fabric of daily life; it is an attitude expressed in action. During the First Intifada, when Israel shut down schools and universities for more than two years, Palestinians organized clandestine classrooms in their homes; that was sumoud. Today, when farmers who are cut off from their land by Israel's illegal Separation Wall in the West Bank continue to find ways to reach their fields and farm them, that too is sumoud. In Gaza, the determination to live and exist despite devastating Israeli military attacks and a suffocating blockade is also a story of incredible sumoud.

This determination to resist Israel's attempts to destroy any independent Palestinian existence is perhaps the part of the Palestinian story that is least well known. There are now excellent scholarly books from Israeli and independent sources that confirm that what happened in 1948 was ethnic cleansing and that Israel's West Bank settlements were deliberately designed to prevent the establishment of a Palestinian state.

Today the Palestinian population inside Israel and the Occupied Territories has recovered to more than 5 million, with millions more refugees in the diaspora. The number of Israeli Jews is just more than 5 million as well but is growing more slowly.

What I love about this book is that it brings to life the voices of ordinary Palestinians, young and old, as they tell their own stories. Rich Wiles is a keen observer whose own insights taught me new things about Palestine. The book that provides the whole story hasn't yet been written—no single story of Palestine and its people could ever be complete—but this book opens up a whole world of Palestinian experience that should help any reader get closer to understanding the what, the why, and the where through the eyes of Palestine's people. It is a poignant reminder that the history of Palestine is not just a litany of wars and peace plans; it is a country whose people are bursting with life, hope, laughter, and resistance even amid extraordinary suffering, loss, and ongoing oppression. Ultimately, it is the spirit that permeates the people you will meet through Rich Wiles's words and images that offers the best hope for the future of all the people who inhabit that land.

Ali Abunimah
September 2009

[ACKNOWLEDGMENTS]

If I attempted to list all the people who have helped, encouraged, and assisted me in Palestine and around the world in support of Palestine, whether on a professional or personal level, it would fill the space of several long books in itself. To all those not mentioned here, I would like to say that I have not forgotten any of you and am eternally grateful to you all. I will attempt to keep this list brief and direct it to those who have specifically supported me in the writing and publication of *Behind the Wall: Life, Love, and Struggle in Palestine.*

I must begin by offering my endless thanks and love to my parents, Sue and Ken, and to my brother, Andy. Life has been difficult for them, but they have never wavered in the support they have shown me. Likewise, I thank all "the lads" in Hull who have endured my confusions, frustrations, and rants but who have always provided encouragement and shared in laughter.

Sincere thanks must be given to Hilary Claggett at Potomac Books, Inc., who believed in this project from the outset when many others believed it to be either "too risky" or "not suitable" for their catalog, and to other staff at Potomac who have been involved in this work—Kathryn Owens, for her much-needed advice on structure and format, without which these texts could never have become a book, and Julie Kimmel. Not only for writing the foreword, but also for his earlier advice, assistance, and support of my work, I would like to thank Ali Abunimah, whose clarity and work I respect greatly.

Ramzy Baroud, Jonathan Cook, and many other writers and authors have taken time from busy workloads to offer encouragement and to answer e-mails

seeking advice. David and Sue Halpin and Chris Burns-Cox have been rocks of support on many levels.

Within Palestine itself there are simply too many people who have played a role in this book and given me their time and friendship. It is impossible to mention everybody, yet I have the utmost respect for you all. To those whose stories are included in this book, and to those who shared stories with me that could not be included in the final edit, I hope I have done justice to you all.

I could not write acknowledgments without mentioning in particular Salah Ajarma and family and Nidal and the Al Azzeh family, without whom this book could never have been created and who have taken me in as one of their own, as have Abu Rasmi and family. I hope and believe you all know that these feelings are reciprocated. To all at BADIL Resource Center, thank you for your assistance and the clarity of your vision.

Finally, I would like to say to all friends, volunteers, *shebab* (youth), and children at Lajee Center and in Aida Camp: we have shared so much together, and you have touched the depths of my soul. And to all the people of Palestine— your humanity, strength, and sumoud are both inspiring and humbling.

[INTRODUCTION]

It seems that most people around the world, if asked, have an opinion about the situation in the Middle East. The use of the words "Palestine" and "Palestinians" is often enough to stir up long, heated debates. Tens of thousands of newspaper articles and hours of television coverage have been dedicated to the subject, and it is from the mass media that most people have acquired their "knowledge" of the subject. If today's mass media was truly the open, honest, and democratic vehicle it purports to be, the global understanding of the subject may have worked toward creating an entirely different geopolitical situation to the position the world finds itself in today. However, only a tiny percentage of people have actually spent time in Palestine in an attempt to observe and understand, for themselves, the realities of daily life endured by the 5 million or so Palestinians who are still living within the borders of Historic Palestine—that is, the areas referred to today as the West Bank, the Gaza Strip, and Israel.

Behind the Wall: Life, Love, and Struggle in Palestine is not intended to be a scholarly or academic critique of Palestine or its people. Rather it is a vehicle through which Palestinians themselves tell their own stories. While many people have an opinion about the Middle East, very few have actually listened to the people who have themselves suffered and struggled for more than sixty years under Israel's unique model of colonization, military occupation, and apartheid. Throughout these years, Palestinians have struggled under such conditions with profound dignity and humanity while exhibiting inspirational sumoud.

This book is a collection of vignettes, narratives, and oral histories that portray the struggles of daily life in both a contemporary and historical context, beginning with the ethnic cleansing of Al Nakba (the Catastrophe) and running through to today's challenges, which highlight the notion of the "ongoing Nakba" forced upon the Palestinian people. These are texts of life and struggle, but as the title of the book also suggests, and despite the dark realities of many of the pieces included within these pages, they are also stories of love—love for a country, a land, a people, and the relationships and love of family.

I first visited Palestine as a photographic artist in 2003, and like most people, I believed I had at least a basic idea of what was happening in the area. What I found, witnessed, and learned in that brief trip showed me how misguided those beliefs were. Now, about six years later, I no longer have an apartment in the city of Hull in Yorkshire, England; instead, I live in a small apartment in Aida Refugee Camp, near Bethlehem, in the area of occupied Palestine now referred to as the West Bank.

My work in Aida Camp began in 2005, when, standing on a patch of green, open land amid olive trees and flowers, I met a group of volunteers who lived in Aida Camp and ran a creative cultural children's center called Lajee Center. While my own photographic work in Palestine had attempted to let the images, and the Palestinians portrayed in them, speak for themselves, I soon found myself back at Lajee Center, where I began to lead photography projects with children from the camp. I wanted to assist them in presenting their own stories to the outside world through art. Since this work began in Aida Camp, my time, when not spent in Palestine itself, has largely been spent touring with photography exhibitions from Palestine. These exhibitions include both my own personal projects and the collaborative youth projects produced with the new generations of Palestinian refugees at Lajee Center. To date, these various exhibitions have been shown in eight countries across four continents and have also been featured in international media around the world. A month or two after my first visit to Aida Camp, the patch of open land on which I had first met Lajee Center's volunteers, part of Bethlehem, was annexed by the occupation as the Apartheid Wall was built around the camp. That land became another statistic of colonization, as it disappeared behind the Wall.

The vignettes and oral histories put together to create this book were written from within Palestine itself between 2006 and 2007. The stories are mainly based in the West Bank area of Palestine and focus on life in the refugee camps but also included are pieces relating to Palestinians who live in this area and who are attempting to travel to Al Quds (East Jerusalem) and other areas within 1948 Palestine.

The texts have been divided into seven thematic sections, the first of which, "Memories of Exile," briefly sets the scene with oral histories from Al Nakba and also 1967, the year that marked the beginning of the Israeli occupation of the tiny remnants of Palestine that had not been colonized during the original Nakba years. It then continues with more contemporary stories about the continued struggle for, and belief in, the Right of Return for all Palestinian refugees. The second section brings the book up to date with pieces describing some of the many devastating effects of the world's most starkly visual symbol of modern-day colonization and apartheid—the Apartheid Wall. The following four sections are themed around the four colors of the Palestinian flag and the national associations with these colors. "The Spirit of Resistance" is born from the vivid red of the flag, "Purity and Love" relates to the pure white, "Land of Palestine" stems from the rich green, and the final color, a strong black, is represented in the book's penultimate section, "Strength and Sumoud." The last and shortest section in the book, "Dreams of Return," completes the journey with two pieces relating to the continuation and development of the struggle for national rights, at the heart of which is the Right of Return. It demonstrates that the will of the people has not diminished; that, even after sixty years, the belief in this inalienable right is as strong as ever; and that the struggle for national, human, and moral rights persists. Also included in this book is a small selection of accompanying photographs. In some but not all cases, these images relate directly to the texts contained within the section, but in every photograph there are thematic links to the subject matter of the particular section in which it is included.

Editing and selecting the texts and images to be included in this book were major undertakings, and many examples had to be left out owing to space restraints. As I continue to write and work on both personal and collaborative

arts and media projects in Palestine today, I meet more and more people and hear and see more and more stories that the world needs to listen to but that the mass media refuses to cover. In Palestine, after more than sixty years of ongoing Nakba, everybody has stories to tell.

MEMORIES OF EXILE

[A Piece of Paradise]

Looking into the eyes of Fatima Al Khawaja as she talks about her life in Ajur, the village she was forced to leave nearly sixty years ago, you can begin to understand what was stolen from her in 1948—the pivotal year of Al Nakba. There is a sparkle in her eyes as she remembers Ajur but also pain, a deep, throbbing pain that seems as vivid now as it no doubt was in the immediate aftermath of these pivotal events in Palestine's troubled history.

When she begins to talk about life as it was all those years ago in Ajur, Fatima's body language also speaks volumes. She looks up to the sky and sighs very deeply, as if preparing herself:

"If you are not in your land, you do not have the life like before. We had delicious food. Now we must wait for help from the UN [United Nations] to provide it."

Fatima's family lived in six houses in the village, which is located about twenty-five kilometers west of Bethlehem. The houses were built from traditional stone, and five or six people lived in each one. As with most rural Palestinian villages, life in Ajur was based on agriculture. People had land and utilized it to its fullest. The Al Khawajas kept animals such as sheep and cows, but they also grew vegetables and fruit. They were self-sufficient.

"We loved the life in the village. We grew all our own food. I used to love eating *sabar* (cactus fruit). We had to buy nothing. Now we must buy tomatoes wrapped in plastic from Israel."

But it's not just food and stone that Fatima remembers so fondly yet misses

so painfully. She goes on to talk about the color, space, and light that have also vanished from her life.

"We don't see the sunrise anymore. We have nowhere to sit; there are too many people. We used to have a lot of land. From the house we could see trees and sit to watch the sunrise. Now I am sick, I have bad legs, and I never see green anymore. . . . There is no grass, no land, nothing."

The glint in her eyes vanishes instantly when Fatima talks about how everything changed. She slaps her face and stares away into the distance. It is clearly still very difficult to look back to those days in 1948.

"The Zionist soldiers came into the village; they were on the roof of the mosque and on the minaret, shooting everywhere. We were very afraid. We waited until it went quiet for a while, then we went, we escaped. I wrapped two of my children in a headscarf and carried them over my shoulders. I had another child in each hand. We took nothing but our children. A few of the old people in the village stayed behind; they were too sick or old to run. They hoped it might finish quickly. A few weeks later, a few of the other old people tried to go back to Ajur, but the soldiers caught them and asked them, 'Where is everyone else? Where are the women and girls?' We were scared they would do bad things to the women and girls. In another village, they had taken away all the girls, and we heard that they had raped them. We knew the soldiers were coming and what they had already done. Zaccaria, Beit Jibreen, Beit Natif, and Ajur were four of the last villages. We'd heard the stories from other villages, and we were expecting them, but we were very scared, particularly about the girls."

Not everybody left together or even went in the same direction. Some went straight through to Jordan, as did half of Fatima's family, but Fatima and a few other family members stopped when they reached the village of Halhoul on the outskirts of Al-Khalil (known as Hebron in English). The family's reason for stopping was frighteningly simple.

"We kept going until we could no longer hear shooting. We knew they were far away then, so we felt safe."

The family only stayed in Halhoul for about twenty days. The family managed to rent some houses, but accessing clean water was a major problem. This issue would plague the Al Khawajas throughout their lives.

"We had to go to the well every day. It was only about one kilometer, but we

had to stand in a queue with all the other women. Sometimes I would set off for the well at 6 a.m. and not return until nightfall with the water."

After their brief stay in Halhoul, the family headed west to the predominantly Christian village of Beit Sahour. There they rented caves in the mountains from the landowners for five Jordanian dinars (about seven dollars) a month. Up to five families would live in one cave. They stayed in Beit Sahour for about two years until they heard about camps being set up in Bethlehem for refugees.

"We heard news from others that tents were being set up in Deheisheh and Al Azzeh [also known as Beit Jibreen Camp because so many of its residents came from the village of the same name]. By the time we got there, all the tents had been taken by other families, so we had to go back to Beit Sahour. But then we heard about Aida, a new camp being set up, so we came here."

Fatima isn't good with actual dates, but given the time line of their travels, this was sometime in the early 1950s. She still remembers how she felt, and how she cried, when she first saw the tents in Aida Camp.

"I thought we were going back but when I saw the tents, I started crying; it filled me with sadness. We had left behind beautiful homes [in the villages], and now we had only tents. The UN promised us we would only stay for two or three years at the most, and then the 'strong states' [referring to Britain and the United States] would intervene and enforce the Right of Return. The Jordanian government was here at that time, but they did nothing for us."

Everybody was registered by the United Nations Relief and Work Agency (UNRWA) and issued an official refugee card. They were then given five kilos of flour, but that was all, so people needed to find work.

"We started collecting small bushes, which we sold to the bakery in the camp for firewood. The men would collect the wood into piles; we women would then carry it back to the bakery. We got paid in bread."

As in Halhoul, there was no clean water in the Aida Camp, and it was always the women who went to collect it while the men looked for work. There was some water in the camp, but it couldn't be used for human consumption as animals bathed in it and drank from it. The nearest clean water was in Ertas village, which was about four kilometers away. Each family had a small tank next to its tent in which water was stored, so the trip to Ertas was only made every three or four days. The Al Khawajas also had some small kerosene cookers

and lamps that they had bought in Al-Khalil and would sometimes get kerosene from the UN.

"We still have the cookers, but they're so noisy. They have a 'voice' like a train. You couldn't hear people talking."

There were people from twenty-seven different villages in Aida Camp, but they were all in the same situation. Fatima remembers that people generally got on well together and helped each other out as much as possible.

"We had to [get on together]. We were all in the same situation so we looked out for one another. If somebody died, we mourned together; if somebody got married, we celebrated together. We shared life together."

Not being strong with dates, would Fatima know how long the family had spent in tents before the first houses were built in Aida?

"It was six years in the tents. I know this because I had three more children, and I had a child every second year."

The shelters, or rather rooms, that the UNRWA began to build in the mid-1950s, measured just nine square meters. Each room would house a family of five or six people. Fatima's family was larger—there were twelve of them—so they were given two rooms. Some of these houses still remain in Aida Camp today. Many have had additions built on top, but two in particular remain unchanged. They are now used for storage, but they also serve as a reminder, a memory to many people, a piece of history to the youth.

There was still no fresh water supply in Aida Camp. Water didn't arrive until the early 1960s, when four taps were provided for all the camp's residents. This was certainly an improvement on the trek to Ertas, but it still had its problems.

"Often we had to wait in long lines all day to get our forty liters. The 'strong' women would sometimes try to get ahead in the queues. We sometimes fought with other women to get nearer the front."

In 1967 there was another exodus, this time from the camp itself. When Israel invaded and began its occupation of the West Bank, some people fled immediately to Jordan. Others left the camp temporarily, looking for refuge locally. The Al Khawajas took the latter option; they weren't going to be forced out again.

"There were many [Israeli] soldiers here and a lot of shooting. We went to the church near the camp because we felt safer there. After six days, we decided

to move to the mosque at Rachel's Tomb. One day a soldier came to the mosque. He was an Iraqi Jew and wanted to help us. He told us to go back to our house, and he promised us we would be safe there if we put white flags on our roof."

The family trusted the soldier; they returned to their small house and did as he had suggested. He kept his word, and the family remained in that house until 1980. It speaks volumes about the family's belief in the Right of Return that the ever-expanding family took nearly twenty-five years to build a larger house, although economic factors also played a role in this.

The years of waiting for return sometimes show in the eyes of Fatima Al Khawaja, but the belief is still there. She has visited Ajur twice since 1948, but seeing what had become of her village, and not being able to stay, seems to have added to the pain.

"We went to the well that we used to drink from, but it had been filled with stones. I started to cry. The houses had been destroyed. I hit my face, I was crying again. We didn't see any Israeli people living in the village. We sat down under a tree and ate sabar again, Ajur sabar. Then soldiers came and asked us what we were doing. [We told them] 'This is our land and we have come here to eat fruit.' They told us we could eat, but we couldn't take any fruit with us. They said it was not our land and that we must leave now. When I returned to the camp, I was sick for a long time after that. My brother refused to go with us to Ajur; he couldn't bear to see other people on his land."

For someone who has lived through so much, Fatima, like so many Palestinians, is inspirationally strong. She may not have the same good health of her younger years now, but she still knows what she has lost, what she wants, and what is rightfully hers:

"I want the youths to never forget our land and our history. They must help us return, and they must return one day. Now I am old, but I still hope to return. Maybe I can't return, but if my grandchildren can, then that is good. . . . If you told me today I could return, I would go now and sleep under the trees in my village."

According to the UN General Assembly Resolution 194, passed in December 1948: "Refugees wishing to return to their homes and live at peace with their neighbors should be permitted to do so at the earliest practicable date, and that compensation should be paid for the property of those choosing not to return and

for loss of or damage to property which, under principles of international law or in equity, should be made good by the Governments or authorities responsible."

The resolution specifies Right of Return *and* compensation; it decrees that Fatima (and every other Palestinian refugee) has the Right of Return if she chooses to exercise it. Would she accept compensation as an alternative to the Right of Return?

"We have never been offered any compensation, but if they did, if they filled a house with money, I would refuse it. I must return! Do you know how much land I had? So much . . . so much land. My land was a piece of paradise."

[The Second Mass Exodus (Part 1)]

"We were walking quickly, me and my family and many others. There was another group of refugees about two hundred meters in front of us. Then we saw two Israeli jeeps coming toward us all. We got down low and lay on the ground, trying to hide. Everybody did the same except for one boy. He was about sixteen years old, and he just started running. He had seen a small valley and was running toward it. The soldiers got their guns ready and started to shoot at him while he ran. They killed him. His family was watching everything, and they started to scream and cry. The soldiers heard them and came back to where they were hiding. They killed the entire family."

These words could easily be describing events from Al Nakba, but they are not. Far from being the only example of Zionist ethnic cleansing in Palestine, Al Nakba simply represents the most extreme and concentrated single demonstration of a policy that continues to this day. This recollection is actually from the *second* forced mass exodus of Palestinians.

Until 1967, Aqabat Jabar Refugee Camp in Jericho was the biggest camp in the West Bank. It was home to between sixty-five thousand and seventy thousand refugees who had fled from nearly a hundred different villages from as far south as Beersheba and as far north as Haifa in 1948. Many of these refugees had initially settled in other refugee camps farther west but had moved on to the Jericho area for numerous reasons. One important factor in this migration was the abundance of fresh water that came from many natural springs in the Jericho area. This water produced rich agriculture and consequently led to many employment

opportunities that were lacking in other parts of the country. In the early days when refugees lived in tents, the hot climate of Jericho was more suited to this type of living than other areas were, and the geographical location also played a role. Being alongside the Jordan Valley and the Jordanian border provided people with a feeling of greater security than living right alongside what had become the Israeli border and with the knowledge that, if they had to flee again, they didn't have far to go to reach another Arab state. Anybody fleeing the areas located farther north or west would have to walk for days through areas already full of heavily armed Israeli troops and under skies filled with Israeli warplanes. It is probably fair to say that the events of June 1967 had a greater impact, certainly in demographic terms, on Aqabat Jabar than on any other refugee camp in the West Bank and possibly in all of Palestine. In the space of just six very dark days in the camp's history, the population of Aqabat Jabar plummeted from nearly seventy thousand to between twelve hundred and two thousand people.

The above recollection is just one of many disturbing memories that are deeply etched into the mind of Hamada Salbad from the treacherous journey he made with his family and thousands of others from Aqabat Jabar to Amman in 1967. He was just fourteen years old at the time.

From 1948 to 1967, the West Bank was under Jordanian administration, but the war in 1967 saw the beginning of the Israeli occupation of this area, which continues forty years later.

The cold-blooded murder of the fleeing family was just one of many Hamada witnessed in a few short kilometers between Aqabat Jabar and the river crossing at Allenby Bridge as his family fled, looking for safety.

"We had left on the third day of the war. Thousands of others had already left the camp. We went through the Jordan Valley toward Allenby Bridge; this was the natural crossing, and everybody from the camps was heading the same way. There were thousands of people, but we saw no Arab soldiers there to protect us. As we neared the bridge, three Israeli bombers flew overhead and began to circle. They flew down very low to only about twenty meters above our heads. My family and I again lay down on the ground and tried to cover and protect each other. Then the bombs came. With my own eyes, I saw a man on a donkey; there was also an old woman who sat next to him, maybe his mother. She must have been seventy years old. One of the bombs landed right on top of them. It

killed them all. There seemed to be hundreds of people killed all around us by the bombs from this plane."

There was no time for the family to grieve. They couldn't wait for the planes to return, so they hurried on and across the bridge.

"After we crossed the bridge, the evening sun was beginning to set. We saw a small truck and stopped it, trying to get a lift. The driver was also from Jericho, but he wanted a Jordanian dinar each to take us. It was a lot of money, but we knew we needed to move fast if we were going to survive, so we paid him and got in. He pointed to the mountain behind us on the Palestinian side of the bridge and told us the soldiers were up there. We could see the tanks. There were so many people walking, thousands and thousands, but also some in cars and trucks. We had only gone about five or six kilometers when another plane came. There was a Jordanian ambulance there, but it was bombarded by very heavy gunfire from the plane, as were many people. Then the plane dropped a huge bomb that sent up a massive cloud of smoke and dust. I do not know how many this bomb killed—you could not see anything—but it must have been hundreds. . . . It was about seventeen kilometers from the bridge to the town of Al Adasia. There were dead bodies everywhere. In Al Adasia, many people who had left before us were now lying dead at both sides of the road. Everywhere you looked there were bodies. It was about 9 p.m. by this time, and we saw another plane heading toward us, but it was coming from the direction of Amman and not the Palestinian side behind us. It saw the lights of the cars and began to circle above us all. Everybody left the cars and just began to run. There were some Jordanian soldiers, and one of them began to shoot at the plane with his rifle, but everybody shouted at him to stop."

The intentions of this Jordanian soldier may have been sound, but he was hardly equipped to bring down an Israeli warplane, and he only succeeded in bringing more attention to the fleeing people below.

"The plane circled for about five minutes and was shooting flares so they could see through the dark; then it began to bomb us. I don't think they killed as many this time, but there were so many injuries from this attack. I saw one man with his stomach opened up, all his insides were spilling out, and people were trying to put them back in. We hid there in the mountains for about half an hour and then ran back to the truck. Everybody turned their lights off and

drove without lights after that. We finally got to Amman about 1:30 a.m., and the driver took us to an area called Al Wahadat, but we didn't stay. I had a brother in another area called Al Jaffi, so we went straight there."

It was the school summer holidays, and the newly arrived refugees were housed temporarily inside the schools in Al Jaffi. The schools were crammed full of Palestinian refugees who had survived the trip. There were three or four big families inside each classroom. But as the beginning of the new academic year neared, the authorities began to move people out.

"The Jordanians gave each family a tent, which had been provided by the UN. Then they started to send people out to different camps. They sent us to Wadi Al Ayabas Camp, but it was right back near the border. When we got there, one of the old men said, 'Look, the Israelis are right there in front of us!' We could see their tanks in the mountains. My family was scared, and we went back to Amman, but my uncle said he wouldn't run anymore, so my Uncle Ibraheem and his family stayed. About two months later, the Israelis attacked the camp. They bombed it from planes and shelled it from the tanks on the mountains across the border. Uncle Ibraheem was hit in both legs from one of the tanks. He survived but lost both his legs and also needed facial surgery for other wounds."

The Salbad family stayed in Jordan for about twelve months before managing to return to Palestine and Aqabat Jabar. The Red Cross facilitated the return of a small number of refugees immediately following the war, but for most of those displaced in 1967, who numbered between 250,000 and 400,000 Palestinians, their future has proved to be one in forced exile rather than in their homeland. The Salbads were not going back home—home was the village of Al-Abbasiyya near Ramla that they had been forced from in 1948—but at least they were in their country. They were back in Palestine.

[The Second Mass Exodus (Part 2)]

"We refused to leave. They had already chased us from our homes once. We had escaped in 1948, but we refused to do it again. They could kill us in our house if they wanted, but we would never run from them again."

Um Nasser (Mother of Nasser) may be old now, and her face may show the signs of a life that has been a long hard struggle, but she also radiates an inner strength and a certain pride that she and her family refused to join the mass exodus from Aqabat Jabar Refugee Camp in 1967. More than 95 percent of the camp's population fled and embarked upon the treacherous journey toward Amman. Those who survived the trip witnessed inhumane scenes of death and suffering along its route, but Um Nasser and her husband had decided that if they were ever to leave the camp, they would be heading in only one direction—back to their village. Sadly, she is still waiting and living in the same house now in which she survived the 1967 war.

The years have worn away at the fine details of Um Nasser's memories. She finds it difficult to remember exact dates and figures, but she can still vividly recall life in Aqabat Jabar in the years before the Israeli occupation of the West Bank began.

"There were so many people here then . . . the market was full of shops. There were butchers, clothes shops, fruit and vegetable shops, and coffee shops, so many coffee shops in the camp. There were many houses that were very tightly packed together. In each neighborhood, there were rows of taps to get the water from. There were between seven and ten taps in a row. We had jugs that were

made from soil. Soil was mixed with water and then baked to make the jugs. We used these to collect the water in and wrapped sacks around them to keep the water cool. We women would go to collect the water and then carry the jugs back, full of water, to our houses on our heads. Sometimes we would fight in the queues for the water about who got it first. There was no electricity in the camp at this time, but we had plenty of water. The men worked on farms, and things were cheap here, so we had food."

Um Nasser also recalls that the UNRWA was very active inside the camp at this time and helped the refugees a great deal.

"They gave food and medical care to us, and also clothing. They did a lot for us before the war."

Despite Aqabat Jabar having the largest population of any refugee camp in the West Bank at that time, people recall that conditions were good compared to those in most of the other camps. But residents who can still remember those days, such as Um Nasser, also say that they never felt secure, and they were right to feel this way.

"Everything changed very suddenly. We were always afraid and never felt safe. All of a sudden planes were flying over, dropping papers into the camp threatening people, but not many of us could read. Those who could read explained that the papers were from the Israelis and said we must put white flags up on our roofs and then we would be safe. But people were too afraid and began to leave. Some had cars or trucks, but most just walked."

The war started immediately. Some people were already leaving. Memories of 1948 were still very vivid in people's minds; they knew what was coming and were not going to wait around. The mass exodus had begun.

"We woke up one morning and found everything was very quiet. Most people had left during the night. They left their goats and chickens and took just their children. When we saw it was deserted, we were very afraid."

If people had anything of value inside the camp before the war, such as gold, they generally buried it outside their house rather than risk keeping it inside. People left in such haste over those few days in 1967 that many did not even wait to dig up their gold.

Um Nasser and her family knew they would not leave, but they also knew they had no way of protecting themselves.

"We just locked the doors and came inside. We were terrified. We were just waiting for the Israelis to come and kill us."

The family had stores of food inside the house and had decided all it could do was to sit inside and pray for Allah's protection. Um Nasser says those doors were not unlocked again for a full month. They could hear planes flying over the house and bombs being dropped and knew that many people must be getting killed, but they had no real contact with anything or anyone outside of those four walls during this time. They had no idea how many people were still in the camp or how close the Israeli soldiers were, and they feared that the soldiers would burst in through the door or drop bombs onto the house at any moment. It is hard to comprehend what those weeks must have been like for them as they were imprisoned inside their own home, constantly in fear for their lives, unable to sleep, and with children to protect. They also never knew when it would end or even if they would survive through it all and ever see the outside world again.

In reality, the war lasted only six days, and Israel's occupation of the remainder of Palestine had begun. They had taken the West Bank and Al Quds (East Jerusalem), which had been under Jordanian administration, and the Gaza Strip, which had been under Egyptian administration between 1948 and 1967. They had also occupied the Sinai Peninsula in Egypt and taken the Golan Heights from Syria. Um Nasser and her family knew none of this, though; all they knew was that they were imprisoned in their house and could still hear planes overhead and regular shooting. When they finally unlocked their doors, they found a very different camp to the one they knew.

"It was horrible. There was nobody here. We didn't know so many had left. We found out some people had already come back from Jordan and dug up their gold, but then they went straight back. The camp seemed so big and empty."

Some people did come back to stay in the camp, although their number was very few compared to the huge number of residents before the war. Most didn't feel it was safe.

"After a couple of weeks, some people started to come back. We felt good seeing people coming back, but many had died on their way to Jordan. Whole families had been wiped out by bombs from the planes."

As well as the huge reduction in population, many other things had also changed with the beginning of Israeli occupation.

"Life was much harder after the war for everybody because we had nothing. There was no work anymore, and things became more expensive for us as there was less trade. We never knew what we would have tomorrow; nothing was for sure anymore. The UNRWA stopped helping as much—they became cold to us."

As well as deepening economic hardships, the refugees also began to see Israeli Occupation Forces (IOF) soldiers inside the camp regularly. This brought a new element of fear to the residents that was realized by the IOF's violent actions during these invasions.

"The Israeli soldiers would often come into the camp; nobody could leave the house after dark as it was too dangerous. There were a few Palestinian 'soldiers' [members of resistance groups] here in the camp, but the Israelis came in looking for them and would blow their houses up. They would take people away in the night for interrogation and do searches for guns. They would smash houses up, insult us, and beat us sometimes. They wanted us to feel that there was no life for us here anymore, that this wasn't our land."

As these houses in Aqabat Jabar were demolished and others were now empty after their residents had fled, people began to claim more personal space in the camp for themselves and their families. Residents no longer had to live on top of each other as the camp's population was only a fraction of its former size.

"Those who stayed here had more space after the war. Our garden here now used to have five other houses in it. They were all demolished, so we built a wall around this land, and now we have a garden. Some of those who came back used to live in one room before the war, but when they came back, they had a full house or even two."

Um Nasser believes passionately that despite everything, she made the right choice by staying and that those who left now regret their decision.

"We have some space here now, but those who left now have nothing. They live in camps in Jordan so cramped together with no space at all. They have nothing!"

Her belief that she made the right decision in 1967 also seems to reinforce a belief that she could have done the same thing during Al Nakba. She seems to feel that since she survived the second mass exodus, maybe she could have done the same in 1948. As with all refugees, Um Nasser dreams of the day she will return to her original village, but her time is running short now. It seems unlikely

that she will live to see her dreams and her rights realized because of the current political climate. Um Nasser seems to hold herself responsible for the fact that she and all her family are now refugees. She looks around the room as she speaks, looking at her son, one of the family's second generation of refugees, and at his baby daughter, the family's third generation, who sleeps peacefully on the bare stone floor of their simple thatched house. Through Um Nasser's strength and spirit, there is also sadness. It is almost as though she is apologizing to them.

"I am happy we stayed [in 1967]; I had already left everything once. In 1948 I carried only my son. I hope that one day we will go back to our land. We should never have left. I am so sorry that we left in 1948."

[War Crimes and Picnics]

O n the table in front of me, a young boy stares out from an old photograph on the back of a magazine. The strong-looking boy is around ten years old and dressed simply; the classic brickwork of the traditional Palestinian abode behind him contextualizes the image. The photograph was taken in the early 1960s outside the school in Imwas, a small village northwest of Al Quds. Imwas has a million stories to tell about colonialism and occupation, resistance, and the ongoing struggle for its people's rights over the decades since Al Nakba. It is a village with a dark history that its people are still struggling against today, although they are now exiled from their land. Imwas and the neighboring villages of Yalo and Beit Nuba make up the area known as the Latrun Enclave, a place that has borne witness to unthinkable war crimes.

Abu Gaush was born in Imwas, and although he is now exiled from his land, he continues to struggle for it. He was born just a few years after Al Nakba, during which Imwas was attacked several times by Zionist militias but never fully occupied. Around fifty thousand *dunums* (a unit of measurement equal to a thousand square meters) of the village's land was stolen, but most of the houses and the center of the village were elevated from the surrounding plains and were successfully defended by some Jordanian soldiers with Palestinian resistance groups. In 1948, Yitzhak Rabin was the Zionist military leader in Al Quds. Ariel Sharon fought and was injured in the Latrun Enclave during these unsuccessful attempts to occupy the villages, which were strategically situated on the transport routes from Al Quds to Yafa. Abu Gaush grew up hearing these stories and those

[17]

of neighboring villages that had been demolished and depopulated, but at the age of fourteen he really started to understand and feel what occupation meant.

"Two days before the war started in 1967, everybody was preparing for a war between Israel and the Arabs. Some Egyptian soldiers came to the villages, and we also noticed a lot of Jordanian soldiers moving unusually in the area. The old men were very afraid because they had seen 1948, but we youths were pleased because we thought Egypt was strong and could free Palestine. On June 5 my father asked me to work with him to make a shelter in a cave to use when the bombing started. We worked until about 1 a.m., then I went to sleep. I was very tired. At 4 a.m. I woke after hearing noises and could hear people saying that [Israeli] tanks had surrounded our village. Our house was at the eastern edge of the village and on one of the highest points, so we could see what was happening. We saw tanks in semicircles surrounding the village and advancing from the north, south, and west. Many of the men of twenty years or older went to support the Jordanian soldiers. Some of the villagers had old guns from the First World War. My brother went to defend the village, but he said the Jordanian army pulled out of the village around midnight. He had stayed with many other youths, but once the Jordanians withdrew and they saw that tanks were all around the villages, he and his men also decided to withdraw. The Israelis were searching houses. My family fled to the mountains as we were frightened that 1948 was happening all over again. We remembered what had happened in Deir Yassin [Deir Yassin was a village in which Zionist militias massacred more than a hundred Palestinians in April 1948 during Al Nakba] and other villages less than twenty years earlier. Some families went to the Latrun Ministry, believing they would be safe there because it was a Christian place, but they were not. My family first went to Yalo, then Beit Nuba, then on to Beit Ur before finally being forced to walk all the way to Ramallah. The soldiers emptied all the houses in the villages and forced everyone out onto the streets. The only direction left clear was to Ramallah, and they told us to go there. Other soldiers were saying, 'Go to Jeddah—all land before there is ours—and if you stop before Jeddah, we will kill you!'"

Abu Gaush was young and strong, but not all villagers were so able and some simply couldn't leave.

"There were ten elders in the village, including one disabled man. They didn't leave. We know they didn't leave because they couldn't, but nobody ever

saw any of them again after that night. One soldier has written a testimony that said he saw another soldier telling one of these old men to leave his house, but the man refused, saying, 'I can't walk, and I won't leave! You can kill me here, but I will not leave!'"

Maybe these ten villagers were killed and buried, or maybe they were buried alive underneath the destruction of their houses, but no evidence of them has ever been found. They never got out of the village, that much is known. Those who did leave—more than ten thousand from the three villages—took little with them.

"People took keys, small things. Some were forced to go with no shoes or real clothes; they were forced out in just their nightclothes. I saw people walking barefoot. We walked all the way to Ramallah, thirty-two kilometers, with no food or water. It took us about nine or ten hours. Four people from the village died during this journey. My family was friends with the mayor of Ramallah, and we went to live with him for two months. Some other people also came to Ramallah, but most just kept going straight to Jordan. Many of those who came to Ramallah lived inside schools or mosques when they first arrived."

About a week after being forced out of the villages in June 1967, an announcement was made over Israeli radio that all villagers from the Latrun Enclave could return to their homes peacefully. Those still in the West Bank attempted to return, but when they reached the villages, they found checkpoints and tanks encircling the village. Abu Gaush's brother made this journey back to Imwas; his parents had decided that he should make the journey alone to see if it was safe before taking all the family. Their hesitancy proved wise. Despite the Israeli announcement that villagers could return home, nobody was allowed into the villages. A ruling had been made to allow the villagers to return, but it was overruled militarily. Instead, villagers could watch the spectacle as their homes were being systematically blown up by Israeli explosive units or crushed under bulldozers, the same bulldozers that then plowed over ancient olive trees. There was no resistance in the village at this time or in the event of its occupation, and its people had been forced out days earlier. Nobody knows if the ten elders were still alive inside their houses when this happened. The villagers were forced to return to Ramallah again.

As Abu Gaush explains the story of Imwas through his experiences, I look through a series of postcards documenting the destruction. An Israeli photographer

was in the village as the Israeli explosives units carefully laid their wires before reducing each home to rubble. The images seem to show men at work; the urgency and panic of war photographs are absent. The members of the Israeli explosives unit seem relaxed, as though they could be workmen constructing a family home. All villagers, excluding the ten who were never found, were already away from the village. The houses weren't demolished until several days after the village had already been depopulated. These relaxed workmen were carrying out the orders from above. Their orders were to commit war crimes.

Two months later, villagers were told that they could return to the villages with trucks to collect their harvest, which had been stored away before they were forced out.

"My brother drove our truck. We saw everything destroyed; just the mosque was still standing. People were crying and weeping, some were just standing, looking, speechless. . . . Some had lost all their land in 1948 but had tried to rebuild their lives, and now it had all happened again. People needed anything so they took whatever they could find and put it into trucks. Some people found a sheep or a goat, but the houses were totally destroyed. We found our *cawasheen* (a traditional box containing important documents, such as deeds to property and land) but couldn't get any clothes or anything else. We knew there was nothing left, but we wanted to see what had happened to our village."

The villagers collected their harvest and what few things they could salvage before leaving once more. Nobody was allowed to stay. Those who remained in the West Bank formed a committee to oversee negotiations with Israel about returning to their land.

"My father was on the committee that negotiated with Israel. They were offering money as compensation for our land and homes. My father told them, 'We will not accept all the money in the world for one dunum of Imwas, and we will not accept one dunum in heaven for one dunum in Imwas!' The Israelis told him that he had three choices: 'One—you can go the same way as Abdul Hameed; two—prison; three—put something sweet in your mouth and keep quiet!'"

Abdul Hameed Al Sayeh was a Palestinian sheikh who vociferously spoke up for inalienable Palestinian rights, including the Right of Return, and who became the first Palestinian to be exiled by Israel after the 1967 occupation began. With these three options, the villagers were being told to accept some

compensation, give up the right to ever return to their villages, and keep their mouths shut; otherwise, they would end up either in prison or being exiled. The committee members said that they were not the leaders of the village, most of whom had gone to Amman, and that Israel must allow the leaders to come back from Amman to negotiate, but Moshe Dayan (the Israeli defense minister) refused. Those who had gone straight to Jordan after being expelled from the Latrun Enclave were not issued West Bank ID cards in 1967, and Israel would not allow them to return. In fact, Dayan had struck a deal with the Ministry of Defense and the Israeli cabinet in which he agreed that the Palestinians who had been forced out of six other villages, including Qalqilya, Habla, and Zeta, could return to their villages on the understanding that the Latrun Enclave villagers would not be allowed to return.

Dayan, Rabin, and Sharon had all been militarily involved in and around the Latrun Enclave during the Nakba years. Sharon was injured in the villages in 1948, and all three had been involved in various attempts to occupy the villages without success. By 1967 all were prominent figures in the military leadership, and all were seemingly intent on settling what seemed like personal grievances that arose from being embarrassed by the successful resistance years earlier. Dayan wrote soon after the war about the ethnic cleansing of the Latrun Enclave: "[Houses were destroyed] not in battle, but as punishment . . . and in order to chase away the inhabitants."[1]

Rabin, as the chief of staff and IOF leader in 1967, ordered the destruction of the villages. This act was in direct violation of Article 53 of the Fourth Geneva Convention that concerns property protection under occupation. Furthermore, forced displacement, as was perpetrated against the villagers, is prohibited under Article 49 of the Fourth Geneva Convention and also under customary provisions of international humanitarian law.

The Imwasees and fellow refugees from the neighboring villages continued to struggle for their Right of Return while living in forced exile.

"I started to hate them because they forced me out. I felt this from the first day they came in 1967. A feeling began to build in my chest and in my mind. First, I had heard stories about Al Nakba, but in 1967 I saw myself what they did. After years of this, we all search for a way to fight . . . for a way to struggle

1. Dayan is quoted in Benny Morris, *Righteous Victims: A History of the Zionist-Arab Conflict, 1881–1999* (New York: Knopf, 1999), 328.

against it. In 1973 I went to Beirut to study, and I became active with Palestinian groups there. What you see in your childhood gives you the feelings that you struggle with."

After completing his studies, Abu Gaush returned to Palestine and started working with a small underground resistance cell. He was arrested in 1977 and sentenced to eleven years. Not long after his release, he was arrested again in 1991 and sentenced to a further eighteen months for again being active in the resistance. Between these two spells in prison, Abu Gaush was able to visit Imwas several times.

"We would walk in the village. We collected fruits like *rumman* (pomegranate) and grapes, and *zaatar* (a mixture of thyme, salt, pepper, and sesame seeds), but it made me angry to go back. The reason I fought the occupation was because of Imwas."

Abu Gaush says he is old now, so he must struggle in different ways. Since his release from prison, he has put all his time into struggling through campaigning for the rights of the Latrun Enclave villagers and political prisoners.

"Now we see what they do, and from generation to generation this grows, and we want again and always to struggle. Now I must continue my struggle in other ways. I am still with the struggle, and I always will be. I stand with our interests; we have the right to our land!"

Now Abu Gaush devotes his time to the Imwas Human Society, which campaigns for the villager's rights through advocacy work and canvassing for publicity of the war crimes committed in the Latrun Enclave. They work to produce literature based on testimonies both from villagers themselves and from members of the IOF who took part in and bore witness to the events of 1967 in the area. They also organize annual demonstrations and other activities to raise the profile of Imwas and tell its tortured story. Abu Gaush is quite clear about what the villagers want:

"This is land occupied in 1967 and we have the full Right to Return to our land and rebuild our homes even under occupation. We refuse any compensation if it is not included with full return. We refuse any resettlement or any border modification. We have also held demonstrations against the PA [Palestinian Authority] for not actively attempting to help us get our rights. We are happy to talk to the PA, but I think they will give up our rights and give our villages away.

They are not strong enough to stand up to Israel, and I think they will agree to a land swap."

If you go to find the village of Imwas today, you will not see a traditional Palestinian village; instead, you will see Canada Park. In 1973 the Jewish National Fund (JNF) of Canada raised $15 million in order to establish a pleasant picnic area for Israelis on the road from Tel Aviv to Al Quds. The Canadian JNF still maintains the facility today and is clearly proud of Canada Park. It describes the park as "one of the largest parks in Israel, covering an area of 7,500 acres in the biblical Ayalon Valley. At peak season, some 30,000 individuals visit the park each day, enjoying its many play and recreational facilities and installations." The project to establish Canada Park began less than five years after war crimes were committed in the village. The website of the Canadian JNF goes on to proclaim, "We are proud of our role in the transformation of the land of Israel in partnership with our brethren in Israel. We remain committed to 'reclaiming our homeland.'"

The hundreds of thousands of visitors who relax and enjoy the fresh air of Canada Park every year are doing so on illegally occupied land and on the site of unrecognized war crimes for whom no one has ever been held accountable. The cemetery of Imwas remains beneath the park, and maybe somewhere down there are the ten village elders who were never accounted for. Beneath the buried layers of this park, deeper than the footprints, and among the dust of former homes are the spirits and souls of the displaced, the Imwassees. Abu Gaush knows his soul, or rather his childhood, is still in Imwas.

"I can draw every neighborhood [in Imwas] from memory, I can still see the faces of my house. Every stone, every tree means something to me. We lived in peace, but they forced us out. I left my childhood in Imwas—money or property is nothing to me, but I left my childhood there . . . and now it is a park for Israel."

The JNF was founded in 1901 to support the establishment of a Jewish state in Palestine. Today, it has branches worldwide and buys up "state land" in Israel, including land occupied in 1948 and 1967. It currently owns around 13 percent of all "state land," including the land of many destroyed Palestinian villages. Its funds have supported practices of ethnic cleansing, the destruction of Palestinian villages, and the appropriation of Palestinian land. In July 2007, the Israeli Knesset approved a bill reaffirming that all JNF land can only be allocated to Jews. Luisa Morgantini, vice president of the European Parliament,

described this move as Israel striking "another blow against democracy, fueling discrimination and Apartheid."[2] However, such nuances didn't concern Israel's staunch supporters on either side of the Atlantic. British prime minister Gordon Brown accepted an invitation to become the new patron for JNF UK only weeks later, and in the United States, Hillary Clinton, a supposed advocate of democracy and human rights, is similarly willing to support practices of racism and colonization through her work as a JNF lobbyist.

While Israel attempts to deny, bury, and erase history with the backing and support of many of the world's leaders, the people from the villages of Imwas, Yalo, and Beit Nuba continue to struggle for their rights. Through their campaigning, they are trying to raise awareness to their case, something Abu Gaush does passionately.

"We want to send a message to European people that they must stand with us because their governments stood against us and with the Zionists and caused this suffering. We want British people to correct what the British government did, and still do, and stop this suffering. We believe that Zionism cannot accomplish its ends without the support of Europe and the British government. . . . What happened in Imwas is against all standards of law, and if people talk about democracy and freedom then they must support those who struggle for them. You must stand with the Palestinian Right of Return back to our land. Israel is an occupying state, and it must respect international humanitarian law. It was a war crime, and people must be held accountable and sent to court for that. The soldiers' testimonies say they met no resistance—they forced us out and demolished our homes for no reason."

Abu Gaush is an articulate and dedicated man. His features are strong, but his face is warm; its lines hint at the struggles of life. He bares little resemblance now to the fresh-faced young boy in the photograph on the back of the magazine. But that confident and strong-looking young boy in the image still had his village, and he still had his home. That photograph of Abu Gaush was taken nearly a half century earlier in his village of Imwas, but that was before he was exiled, before his village was destroyed, before he walked thirty-two kilometers to Ramallah without food or water, and before he spent twelve years in prison. The photograph was taken before it all happened.

2. Luisa Morgantini, "Israeli Land for Jews Only, Isn't Racism?" *Liberazione*, July 20, 2007.

[Memory and Strength]

For Palestinian refugees, there is one date that is deeply etched into the mind: May 15 is commemorated as Al Nakba Day. Many activities and demonstrations are held across Palestine every year around this date. Al Nakba will never be forgotten, nor should it be, but these events are not just commemorative; they also call for progression through justice and enforcement of UN resolutions, including the full Right of Return for all Palestinian refugees. Every refugee from the elderly survivors to ten-year-old children will talk proudly about their original village. The history and the knowledge are passed on; keys to the original houses are still kept and handed down through generations by many families. Most of the houses in whose doors these keys used to turn are no longer standing; they are now just a distant memory, but the keys are kept and treasured as a symbol of *awda* (return).

The 2006 Al Nakba Day demonstration in Ramallah was marked by the IOF closing all checkpoints north of the city and preventing dozens of coaches from northern cities, including Nablus, Jenin, and Tulkarem, from reaching the event. Literally thousands of people were prevented from getting to Ramallah.

Lajee Center always runs coaches from Aida Camp to Ramallah for Al Nakba Day events, and the two coaches that were booked for the 2007 trip could have been filled several times over, such was the demand for places. As the coaches pulled up to Container checkpoint on the difficult Palestinian road to Ramallah, the audible excitement, singing, and laughter petered out; everybody knew the routine well by now. The only time on our trips that the bus doesn't echo to the

[25]

beating of drums and singing is at a checkpoint; no one wants to give the IOF soldiers any excuse to dampen our party. When the young IOF soldiers got on the bus demanding everyone's ID cards, people stayed silent, with the exception of one bright-eyed little girl.

Gangoon is two and a half years old. She is the daughter of one of my closest friends, and I am fortunate to be able to spend a lot of time with her. She is a lot of fun and often has brought a much-needed smile to my face with her boundless energy and playfulness. She is also incredibly strong. Gangoon loves to talk and has many stories to tell for one so young. Sometimes she will talk about makeup or tell me about the dove that nested on her bathroom window; other times she will talk about memories of the day her twelve-year-old cousin was shot or when her teenage uncle was arrested. Just as all children in the camp, one of the first noises she made was "toc, toc, toc" (imitating shooting), and one of her first words was *jaysh* (soldiers).

As one soldier entered the bus at the checkpoint and began collecting IDs, another stood in front of Gangoon and her parents just inside the bus door. Gangoon looked at the soldier, then up to her mother sitting alongside her. "Mama, this is the one who shot Miras [Gangoon's cousin]!"

In an attempt to prevent problems with the soldiers and relax her daughter, Gangoon's mother tried to change the subject. "OK, we can talk about this later."

But Gangoon was not satisfied with this answer; she knew she was right. She looked across to the other front seat of the bus where Nidal, Miras's father, sat. With her big brown eyes wide but unafraid, she spoke to Nidal. "Uncle Nidal, here is the one who shot Miras!"

Nidal also tried to relax Gangoon, suggesting that maybe it wasn't this same soldier who had shot her cousin. "Maybe it was another one."

The little girl's eyes widened as she considered this, then she looked up to her father, and then to Nidal again. She pointed at the heavy M-16 that the young soldier was carrying. "Look, he has a gun!"

Her father explained that all the soldiers were carrying guns. Gangoon wanted to know why. She showed no fear as she looked up into the eyes of the soldier and asked him a perfectly reasonable question: "Why do you have a gun?"

At first, she didn't receive a reply, although the soldier did seem to understand what was going on. Then a tiny smile seemed to break on the soldier's lips, and

he spoke to Gangoon in Arabic, asking her what her name was. Gangoon looked across to the other IOF soldier collecting the IDs before looking back into the soldier's eyes. She wasn't smiling as she spoke firmly, "Give us your IDs! Give us your IDs!"

She was telling the soldier that she knew who he was, that whether he spoke to her or not, she knew what he did and what he represented. She was also showing him that she was strong.

The soldier didn't respond; his smile had gone. She repeated her demand several times before her father managed to divert her with talk of a future trip to the swimming pool.

The two IOF soldiers left the bus carrying everyone's ID cards. When they returned, they refused permission for seventeen of the passengers from the two buses to pass the checkpoint. The occupiers, as always, decided who could move and who could not. When they were asked why these people couldn't pass, they replied, "Because the computers are broken so we can't check the IDs!"

This was clearly untrue as the other IDs had been checked, and other passengers were allowed to pass through, but there is little use in remonstrating with the IOF once the soldiers have made a decision.

Those refused permission trudged back to the second bus, which would be forced to return to Aida Camp. There is no other route to get from Bethlehem to Ramallah for Palestinians with West Bank IDs, such is the Israeli control of Palestinian movement. Rami, one of those turned back, asked the children still on the bus to make a big sign carrying the name of his home village, Al Malha, and to hold it up in front of the cameras of the international press. If he could not travel to Ramallah, Rami wanted to make sure that his message was still heard and Al Malha was not forgotten.

"I will go back to Bethlehem and demonstrate next to Rachel's Tomb!"

Rami would not be silenced on Al Nakba Day.

The remaining bus traveled on to Ramallah. The passengers were dejected and angry at leaving others behind but determined now more than ever to mark the day and join the call for return.

The event in Ramallah went well. A march was held from al-Minara Square to the grave of the late Abu Amar (Yasser Arafat) in the Mukata'a (Ramallah's presidential compound). Lajee's children held banners high as they walked,

including the one they had promised to make for Rami. Participants sent their message to the leaders of Palestine, Israel, Arab states, and the international community that there can be no peace without the implementation of UN Resolution 194. Al Nakba survivors stood alongside second-, third-, and fourth-generation refugees, united in their message.

The significance of Al Nakba is just as apparent in the minds of young refugees as it is in the painful memories of the survivors of the event itself. The children and youths also had a message they wanted to send by demonstrating in Ramallah. Ayah, a thirteen-year-old girl from Lajee's Dakba group, was clear about how she felt about Al Nakba.

"They wanted the Nakba to be our death, but every year we say we are alive . . . and we will return!"

Basil, another teenager, was also in Ramallah to raise his voice.

"I want to tell everybody that it's the time! We must be allowed to return."

While all young Palestinian refugees have heard many stories about life pre-1948, for Nakba survivors, it is real memories of their villages and land that are ingrained in their minds. One Al Nakba survivor from the village of Beit Jibreen once explained to me how he would feel if he was offered compensation for his land instead of return.

"They could build me a house made out of solid gold and I would not accept it! I will never give up on return!"

Gangoon's great-grandmother, who was forced from the village of Ajur when Zionist militias invaded it in 1948, has told me of her memories of her family's land in the village. When she talks about the fresh fruit they grew, their animals, and sitting to watch the sunset, there is a glint in her eye that I have seen in all Nakba survivors. These memories are sacred, as is the Right of Return. Al Nakba itself is a very dark and painful memory.

Fifty-nine years after Al Nakba, a fourth-generation Palestinian refugee named Gangoon already has memories deeply etched into her mind—memories of her cousins and friends being shot, of her uncle being arrested, of her parents shutting the windows in their house to keep out tear gas, and of violent house raids. She is a beautiful, funny, and strong, bright-eyed child who already knows what it means to be Palestinian.

Somebody once said that memories are golden. The memories of the villages,

land, and life before Al Nakba are certainly golden to the dwindling numbers of refugees who can still remember life pre-1948, but for sixty years since then, memories for Palestinian refugees would never be discussed in such terms. In the hearts and minds of even the youngest children, dark memories continue to proliferate as they are forced to grow up in exile and under occupation much as their parents were. The new generations also continue to radiate with another familiar Palestinian trait—strength.

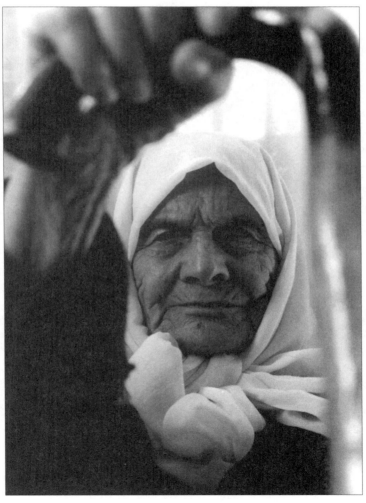

"Strength"—Al Nakba survivor from Ajur, Aida Refugee Camp

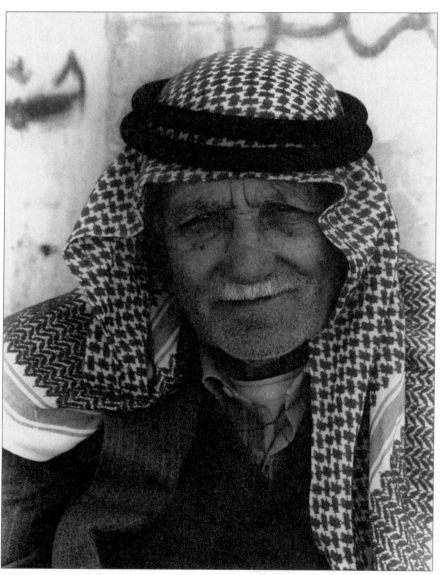

"Patience"—Al Nakba survivor from Beit Jibreen–Al Azzeh Refugee Camp

THE WALL

[The Wall Stole My Brothers]

Materialistically, the residents of Aida Camp, as is the case with most Palestinian refugees, have never owned very much. Things were different pre-1948, but those days are a memory of the past and a dream for the future now. Refugees are at the wrong end of the economic ladder in this country, which itself is at the wrong end of the global economic table. That said, Palestinian culture ensures that what people do have, they share and utilize to its fullest. A prime example was the large patch of land and olive groves alongside Aida Camp. The land never belonged to the camp, but it had always been there, and it had always been loved and shared by all the camp's residents. It was the only open land near Aida Camp.

Hazim is thirteen years old. His family's house is just a few meters from this land, but these days he cannot even see it anymore unless he stands on the roof of his house because of the oppressive, concrete monstrosity that Israel, in its international propaganda war, calls a security barrier.

"I used to spend a lot of time playing football in that land before the Wall [was built]. We would go there most days to play and would divide into two teams of six to play a match. We also collected olives off the trees. My aunt lives on the land. I used to enjoy spending time at her house, picking figs, drinking tea, and playing with her dog, Reema. In the winter, we would build small dens to play in and make a fire to keep us warm. That land was our childhood."

At the far side of the land, with its shiny white houses and red roofs, is Gilo Settlement. Gilo is one of the many settlements or colonies built illegally by

Israel inside the West Bank and Al Quds. Although within the West Bank, Gilo is referred to by Israel as a neighborhood of Jerusalem. According to Article 49(6) of the Fourth Geneva Convention: "The Occupying Power shall not deport or transfer parts of its own civilian population into the territory it occupies." There are between 400,000 and 500,000 Israeli settlers currently living in the West Bank and Al Quds.

"We would go through the rubbish in the skips (dumpsters) outside Gilo. Sometimes we would find good things like bicycles or children's toys. There were always much better things to find in the rubbish skips outside Gilo than in the ones here in the camp. One day we found a child's motorcycle outside the settlement. We stole it, but the police caught us. We thought they would take us away, but after they searched us, they just let us go."

There had been many rumors about an Israeli road being laid through the land to link Gilo to Rachel's Tomb, but in actuality they were planning to build a wall—*the* Wall that stole the land. The children wanted to stop the Wall's construction.

"Many of us children agreed that we would not let them build the Wall; we would defend our land. At first it was just like a fence. Every day after the soldiers and workers had left, we would go and destroy the fence. One day one of the soldiers asked me to go and get him some hummus and falafels from the camp. He gave me 50 shekels for the food, but I just took the money and ran off into the camp."

The children's actions were in vain as the fence became a nine-meter-high concrete wall. Every day, their view became smaller and smaller, as did their access to the land, until it vanished completely as the Wall was finished. The final piece to be put into place was the IOF watchtower, which is about two meters taller than the Wall itself and has small windows that enable the soldiers to both look and shoot into Aida Camp.

"The day they put the tower in, more than a hundred of us children went down there. We threw stones at it and filled balloons with paint, which we threw at the windows so that the soldiers couldn't shoot into the camp. We wanted to destroy the tower, and some of the children made molotovs [molotov cocktails] out of cola bottles and fuel to throw at it, but it didn't work. We tried to start fires to burn the Wall down. We thought if we made fires, we could burn a hole

through it. Some people still try this now . . . we must make a hole in it so the workers can still pass through to get to their work."

The Apartheid Wall does not follow recognized borders between Israel and the West Bank. In fact, the section alongside Aida Camp is several kilometers from the closest section of the Green Line—the 1949 Armistice Line and pre-1967 border. This so-called security barrier is in reality just another part of the Zionist land grab policy, and this fact is not lost on Hazim.

"Sharon [Ariel Sharon, the former Israeli prime minister] wanted the soldiers to move on our land without us being able to protect it. He just wanted to steal more of our land. Now I must spend all my time in the camp, but I feel like it's a prison. We want our land back, to play under the olive trees again with our footballs."

Standing on the flat roof of his house, Hazim can still see the land that he and everyone in the camp have lost. He can still see his aunt's house surrounded by olive trees, but he can't enjoy it anymore, which clearly hurts.

"I say 'shit' to the soldiers. They have closed our land. Why did they do this to us? I want to go there. Sometimes I see a man with his horse on the land, and I shout to him from my roof as though I am actually there playing with them. It makes me upset."

Hazim is both angry and sad, but like many Palestinians, he also feels that he is helpless to change the situation.

"I'm not happy with my life now. I feel trapped, like I live in a prison. We have no place left to play. I am sad now, but what can we do? This is our life."

Land is not the only devastating personal omission from Hazim's life since the Wall has been completed; two of his brothers were arrested along with many others from Aida Camp as they tried to resist its construction. Hazim has lost the land and his feeling of space, but his family has also been literally torn apart.

"I have two brothers in prison now because of that wall. They threw stones at the [Wall's construction] workers, and now they are also gone. If it wasn't for the Wall, I would still have my brothers."

[Prisons within Prisons]

Few people visit Jenin these days. Being the West Bank's most northerly city, no one passes through Jenin on his or her way to other Palestinian cities as happens with Ramallah, Bethlehem, and even Nablus, although to a much lesser extent. But much like Nablus, Jenin has become a prison within the myriad of Bantustans that is occupied Palestine.

Before the creation of the Apartheid Wall, it took around twenty minutes to drive from Jenin to Nazareth; a few kilometers more and you could reach Haifa and dip your toes into the Mediterranean. The rolling waves are now just a distant memory for most people and a seemingly mythical dream for Jenin's children.

When you add these factors to the many checkpoints, invasions, assassinations, and the IOF's closures in the city, you may begin to understand the feelings of isolation and desperation deep in the hearts of the approximately 250,000 people who live in Jenin Governate. Yet like other Palestinians, Jenin's residents are incredibly warm, hospitable, and deeply committed to seeing an end to their country's occupation.

Students across Palestine see education as a platform on which to build a brighter future free from occupation for their country, yet speaking both metaphorically and literally, they also face wide-ranging and severe obstacles to their successful scholarly progression. In 1991 the Al Quds Open University system was established across Palestine. There are now twenty branches stretching from Rafah on Palestine's southern border with Egypt in the Gaza Strip to Jenin in

the northern West Bank. Distance learning is practiced around the world, but in Palestine its importance takes on extra significance, as Dr. Hani, director of the Jenin's Al Quds Open University, explained.

"Socially and culturally, distance learning addresses the needs of many students in Palestine, especially women and young mothers, who without such programs would not be able to continue their studies. But above these social issues are many directly related to the occupation. Levels of unemployment are higher in Jenin than in other West Bank cities and much closer to those in Gaza, well above 60 percent, and we are isolated from other West Bank cities by Israel's system of checkpoints, closures, and roadblocks."

Such restrictions make the flow of trade and commerce into Jenin almost impossible; consequently, the city's economy is in ruins.

"Open University fees are only around 30 percent of those at major universities, such as An-Najah [Nablus] or Birzeit [Ramallah]. Distance learning is one way to combat the occupation and closures. Students simply cannot get into the city from surrounding areas every day because of checkpoints, which often close. Daily travel is a huge problem, and distance learning helps to address this issue. If students miss their exams here because of travel restrictions, they can simply transfer them to the next semester. We have more than a hundred students from the university currently in Israeli prisons, but when they are released, they can easily return to their studies. Just last night, two of our students who live in Zababida were arrested!"

The night previous to these two arrests, the IOF had also raided Jenin's Zababida village and arrested more than a dozen students from the city's main campus-based institute, the Arab-American University.

"We have around seven thousand students currently enrolled in courses from around Jenin Governate, but we have also seen many killed over the years. In this educational year alone, since October, four of our students have been killed by the Israeli forces."

For the residents of seven villages in particular, university education would be impossible without distance learning. These villages now sit in what has effectively become no-man's-land. They are physically separated from the rest of Jenin Governate and the West Bank by the Apartheid Wall. The Wall does not run along any internationally recognized border; instead, it cuts deep into the

West Bank, isolating many Palestinian villages and much land to the "Israeli side" of the Wall, although still within the 1967 borders. Residents of these villages are prevented from entering Israel itself as they have Palestinian ID and therefore cannot pass the checkpoints. Neither are they allowed free passage to the rest of Jenin Governate on the Palestinian side of the Wall. In some places, gates have been built into the Wall, but to pass through these gates Palestinians must first acquire a permit, which can be obtained only from the occupation authorities and is often not granted. For those who successfully obtain these permits, the gates are theoretically only open at set times for a few hours each day. In practice, the gates often remain locked even at the prescribed opening times, creating yet more prisons within prisons.

After talking with Dr. Hani, I went to see the student council, which had arranged for me to meet some students who live in communities trapped behind the Wall. However, when I entered the student council office, I found it deserted except for Ra'id, the elected student leader.

"I am very sorry, but we cannot have a meeting today."

I knew what Ra'id was going to tell me next.

"The students couldn't make it today. The soldiers locked the gates and closed the checkpoints!"

It was that simple, a clear demonstration of why distance learning was essential in Jenin Governate and another example of Israel's attempts to prevent, or at least disrupt, Palestinian education.

Ra'id continued, "They will try again tomorrow."

I returned to the university the following day, and the students from these isolated villages again tried to continue their studies. Thankfully, the students were successful on this occasion.

Manal, Rasha, and Waleed all live in the village of Dhaher al Malih, one of the seven in the Jenin Governate isolated by the Wall. Waleed explained that the construction of the Wall in this area began in 2003 and was completed by the following year. He has the required permission to pass through the gates and checkpoints into Jenin, but this often counts for nothing.

"It used to take fifteen minutes from our village to the city before the Wall; now it takes around an hour on a good day. The gate is meant to be open from 6 to 10 in the morning and then reopen at 12 until 6 p.m., but sometimes they only

open it for an hour or two. Other days it doesn't open at all! There is also another permanent checkpoint to pass through, and sometimes 'rolling checkpoints' too [these are temporary checkpoints that the IOF can set up anywhere by blocking roads with their jeeps for ID checks or to block passage entirely]."

Rasha described how she felt when she saw the construction of the Wall taking place:

"When I saw the Wall being built, I felt sad and dejected. Most people in our village are farmers; my family lost half of our land. We watched our olive trees being chopped down and our land being stolen. We felt isolated and frightened that we would lose communication with people from nearby villages. We have lost friends and family members who can no longer come to see us. Our village has lost more than half of its land. It makes me very pessimistic for the future; I am tired of seeing things disappear and being surrounded inside a prison."

As well as stealing land and imprisoning these villages, the Wall has also cut them off from the Palestinian infrastructure, including medical facilities. This has had fatal consequences according to Waleed.

"If a woman goes into labor or there is a medical emergency while our gate is shut, we must go to Batar checkpoint. This gate is meant to be open until 9 p.m. If all gates are closed, it's just impossible; we cannot get to a hospital. We have one local doctor in our village who does all he can, but people have died."

Rasha interjects, continuing the story, "Yes, one or two people have died because they couldn't get proper treatment. I remember one who had a heart attack and couldn't get to hospital, so he just died there in our village, unable to get any help. We have children with severe kidney problems. Maybe it will also happen to them one day."

I can see the sadness and desperation in the young student's face as she talks. The stories of those trapped behind the Wall are yet more living proof of the human consequences of Israel's campaigns of apartheid and colonization. If these villagers can be forced from their land because of these inhumane living conditions, then Israel will expand yet farther. Manal explained this concept:

"The Wall was built here for colonization. There is already a settlement next to our village, and they have their own roads leading to Tel Aviv and other Israeli cities that we cannot use. They [the Israelis] also have a big military camp just fifty meters from our village. They have already colonized most of our land!"

These are just some of the facts, the realities, and the effects of this Wall, which I will always consider to be a device of apartheid and expansionism. Its aim is not security; it is colonization and the expansion of Israel. It includes acquiring Palestinian water resources and dividing its people. Its construction led to the displacement of thousands of Palestinians. In these seven villages alone in the Jenin Governate, fifteen thousand Palestinians are trapped without even the most basic of human rights, such as freedom of movement and access to medical care. If it were not for the distance learning program of Jenin's Al Quds Open University, they would also have no access to higher education. This has happened in many places across Palestine.

As Zionist colonization continues, so does the creation of more Bantustans, more prisons within prisons.

[Memories]

"I will see if I can join you tonight; I am afraid it will be difficult because my father is going to *another country* tomorrow! A *country* that is located at the end of the world!"

I received this response to a message I sent to my friend Nidal, asking if he had time to join me for coffee in Aida Camp. His father, Abu Waleed, is ill and must receive hospital treatment. In reality, the "other country" Nidal was referring to is not at the end of the world, although it seems that way. Abu Waleed was in reality only traveling around seven or eight kilometers from Aida Camp to Al Makassad Hospital in Al Quds. Although Al Quds is now inaccessible to Palestinians living in either the West Bank or Gaza Strip without special permits, it is the historic capital of Palestine that is internationally recognized as the capital of the future Palestinian state, and it will always be considered the capital city by Palestinians themselves.

Abu Waleed is in his mid-seventies now. He is a big, strong man who always talks very proudly of Beit Jibreen, the village he was forced from during Al Nakba. Beit Jibreen was a large village that, to many extents, acted as a capital village in the region. The Al Azzeh family came from Beit Jibreen but is now spread far and wide. Many are here in Aida Camp. The small refugee camp across the Al Quds–Al-Khalil Road from Aida also currently hosts many of the family. That camp is known as Al Azzeh or Beit Jibreen Camp because of the large percentage of people from Beit Jibreen and the Al Azzeh family who went there at the start of the 1950s. Other family members live in neighboring countries,

such as Jordan, while more still went farther afield and are now living in the United States and Europe.

The family had known Abu Waleed would require hospitalization for surgery for some time, and Nidal had applied for permission from the Israeli authorities to be with his father in the hospital, as he needs constant care. All West Bank Palestinians must apply for permission from the Israeli authorities to pass through the checkpoints and enter Al Quds, but these permissions are rarely granted. Nidal was turned down; he was considered a security threat. He has served time in occupation prisons many years ago, but then so have most of the men in the camps during the decades of struggle. He was imprisoned for using his legitimate right, according to the Geneva Conventions, of resisting occupation. These days, Nidal attempts to raise his family and resists through his tireless work for refugee rights.

Nidal's anger was clear: "What's wrong with these people! What do they want? I just want to care for my father!"

Two of Nidal's sisters applied for permission after he was turned down. Neither of these two women have been in prison, and we all hoped their applications would be successful to ensure that Abu Waleed would not be alone through his surgery. Abu Waleed himself had been granted permission to travel for his surgery. The day the family patriarch went to the hospital, there was still no news about the Israeli decision, so he was forced to travel alone through the checkpoints and past the Wall. Later that day, we heard that while all other permissions had been granted for that day, a decision had still not been made about Abu Waleed's daughters, and their papers had been passed on from the Israeli District Coordination Office (DCO) to Acion—the Occupation Authority's administration that was located inside the illegal West Bank settlement of Gush Etzion. The family still had some hope that the permissions would be granted as the two women had no record against their names.

Nidal rang me around 7 p.m. He sounded agitated and wanted to talk. He was soon in Lajee Center's office, where I was working.

"We need your help!"

His tone and face were serious, and I immediately stopped what I was doing.

"We have just heard that both my sisters have also been refused now. None of us are allowed to go to be with my father! Somebody must be with him. My family needs your help."

The only members of the Al Azzeh family who had any chance of reaching the hospital in Al Quds were Abu Waleed's grandchildren. They were not yet sixteen years old, so they were not yet required to carry ID or apply for permission to go to Al Quds. So it was decided that Miras, Nidal's eldest son at just thirteen years old, had to take his family's responsibilities firmly on his shoulders and attempt to reach his grandfather and stay with him while he was in the hospital. Miras's parents could never have allowed him to travel alone through checkpoints and past the IOF, and that is why they were asking me to help. Nidal apologized profusely for asking me, which was unnecessary. To me it was an honor.

Miras was being as strong as ever. He grabbed his birth certificate as I found my passport, and Nidal fetched his father's car to drive us up to the checkpoint. We decided against using the main Bethlehem checkpoint. This is a horrible and intimidating place, especially for children, so I asked Nidal to drop us near the bus, which now leaves Bethlehem and goes to Al Quds through the other checkpoint at Beit Jala. As I put my arm around Miras upon leaving Nidal's house, his mother, Afaf, stopped me.

"Rich, please look after my son."

A lump swelled in my throat, not because I thought Afaf didn't trust me—I knew she did—but at the knowledge of how it must feel to have to go through this and be forced to entrust the well-being of your children into somebody else's hands simply because of the color of his passport. I smiled at Afaf and told her not to worry. My words sounded ridiculous.

The bus from Bethlehem's Bab Izkaq junction to Al Quds has only been permitted by Israel over the last few months and only since the new Terminal checkpoint on Route 60 opened, creating the illusion that transport is getting easier. Tourists can now catch a bus in Bethlehem and not have to leave it until they reach the magical city. As we boarded the bus, the Palestinian driver didn't look twice at me, but he stopped Miras. Clearly unaware of Miras's age, he asked him if he had permission. This is what it has been reduced to now, Palestinians checking IDs of other Palestinians, but this is not the driver's fault. When the bus reaches the checkpoint and IDs are checked by the IOF, if anyone is found to not have permission, he will be taken from the bus and the driver and bus company may also face severe repercussions and the possibility that the license to travel this route will be terminated. Tourists leaving Bethlehem on this route

may not understand these facts and could be led into believing that traveling was getting easier, rather than noticing the color of the IDs that the few Palestinians on this bus carry. Palestinians living in Al Quds have a blue ID and can travel to the West Bank; West Bank Palestinians have green IDs and cannot travel out of the West Bank without acquiring further permission from the Israeli authorities, which, as the Al Azzeh family knew, they rarely grant.

Miras and I spoke little in the few minutes it took to reach the Beit Jala checkpoint; our minds were both consumed with thoughts of what may happen when we reached it. I asked Miras to sit alongside the window so that I was the one who would be nearest the IOF when they boarded the bus. The soldier who boarded the bus behind his M-16 looked no more than a teenager. He glanced at my passport briefly before grabbing Miras's birth certificate. As he studied it and looked at Miras intently, I moved forward slightly, positioning myself between them in a feeble attempt to reassure Miras. These two teenagers lived just a few kilometers apart. One of them wore a full military uniform and carried U.S.-funded lethal weapons. The other wore a Brazilian football shirt and carried a birth certificate, a change of clothes, and some money for his sick grandfather. One was tall and physically strong, the other slender and carrying a scar across his stomach and back from one of these very M-16s now paraded in front of him by a fellow teenager. One had all the power, but the other had more strength than a million guns could muster.

We were stopped no more than five minutes before the bus drove off again, heading toward Al Quds. Miras and I both let out a deep breath and smiled as we spoke in unison:

"Yalla Al Quds!" (Let's go to Al Quds!)

Al Quds looks beautiful by night. The walls of the Old City are illuminated and stand like a sparkling crown of jewels. But now there are extra illuminations on these famous walls, and they tell an altogether different story. Lights have been placed on small electronic boards that simply say "40." They have been put there by the Israeli authorities to mark what Israel sees as forty years since the reunification of Jerusalem. On the contrary, for Palestinians, and as stipulated by international law and reaffirmed by the UN, these forty years are four decades of illegal occupation of Al Quds.

As we left the bus and began to walk toward Bab Al Amoud (Damascus Gate), Miras voiced sentiments that spoke volumes in their simplicity, "Now we

are Europeans!" He meant he felt free, like a tourist, now. He could walk without passing checkpoints and could no longer see the Apartheid Wall in whose shadow he lives.

The streets were busy with people: men sat smoking *nargileh* (water pipes) outside coffee shops, others cooked falafels on makeshift stalls, children played, and families strolled alongside the beautiful city walls. It felt a million miles from Aida Camp. As Nidal had said, it was like another country, one that felt as if it was at the other end of the world.

As we walked toward the bus station, Miras's eyes were wide. He was taking in the sights, sounds, and smells that alerted his senses to Al Quds. I so badly wanted to just walk with him for hours, to enjoy the atmosphere and his freedom, but we had to get to the hospital. I knew that Miras's parents and grandfather would be unable to relax until they all knew he had arrived safely. As our bus drove up Jabal Al Zaytoun (the Mount of Olives), we looked out the windows and could see for miles across the city. We left the bus outside Al Makassad Hospital, but I could see Miras was disappointed for his adventure to end, so I suggested we go and find some food. At the top of Jabal Al Zaytoun is a small garden of sorts, where men were sitting and socializing. We joined them to eat our falafels. The cool evening breeze was refreshing and so different from the stifling lack of air in Aida. We began to talk together.

Miras told me about Al Quds, "It's a beautiful city. It is our capital, and we are proud of it."

"Would you like to live here then?" I inquired.

"Of course I would. There is so much to see and do, and I would love to live here. It is our capital," he reiterated.

"So if you could live anywhere in Palestine, where would you live?"

Without a second's thought, Miras answered me, "Beit Jibreen!"

I love to spend time with Miras. He inspires me greatly with his spirit, strength, and knowledge for one so young. He talked about his village, although he himself has never been there. He has heard many stories about Beit Jibreen from his grandfather and father. These are stories that are passed down through generations, and I know Miras will also pass them on to his children if he does not realize his rights beforehand. The memories will not die. We practiced language skills together. We also talked about football and about what life is like in England. He told me about school and about his dreams for the future, dreams

of traveling, studying, and going home to Beit Jibreen. Then my phone rang; it was Nidal checking on our well-being and progress.

As I spoke to Nidal, Miras was whispering to me, "Tell him we are at the hospital, tell him we are already there."

He wanted his dad to know that he had been successful, that he had reached the hospital and was there to look after his grandfather. He felt the responsibility on his shoulders, and he wanted everyone to know he could deal with it. But he also wanted to sit and talk all night and enjoy his time. I did as he asked me. I asked him if he wanted to go to see his grandfather now, but I could see he just wanted to sit a while longer. I knew I would miss the last bus back to Bethlehem, but it didn't matter as I could see how happy Miras was. So we sat some more and enjoyed the sights together.

Eventually, we went to see Abu Waleed, and he was pleased to see us both. Miras began to tell him about Al Quds. I didn't stay long. I felt the time should be theirs, so I headed back toward Bab Al Amoud, leaving instructions on how they could contact me. I wanted to come and travel back with Miras in the morning so he wouldn't have to face the checkpoint back into Bethlehem alone. Despite these instructions, I never really expected a phone call the following morning. I had a feeling Miras would make the trip alone to show everyone that he could do it and was not afraid. Walking down Jabal Al Zaytoun, I could see for miles across Al Quds. Looking one way I could see a nine-meter-high wall in the distance and beyond that not very much. The odd light glimmered faintly beyond the Wall, but there were few signs of life; it just looked dark and bleak. Looking in the other direction, I could see skyscrapers illuminated in West Jerusalem, the Israeli part of the city. Lights were everywhere, and traffic was busy. The place looked alive. The stark contrast made my heart sink. How did anyone ever allow this to happen?

As I passed through Bethlehem checkpoint and the Wall, I knew I was back *home* again. The small IOF cabin, which stands just before you exit the checkpoint through to the Bethlehem side, was empty. Soldiers were busy laughing and playing music next to one of the watchtowers that look out over the city. Underneath the bulletproof glass window of the cabin where the soldiers should have sat was a message scrawled in red ink.

"Free Palestine!"

I passed the cabin and walked into the narrow, caged walkways that reminded me of old, black-and-white footage of entrances to the vile death camps of the Nazis' occupation in Europe. A lone taxi sat in the darkness at the end of the walkways, a driver hoping for some last scraps of business with which he may be able to feed his family. I would not provide these scraps; Nidal was already on his way to pick me up. I looked up the street ahead of me. I could not see one light. There were no signs of life at all. Boarded-up shops stood alongside permanently closed restaurants as I walked on. I eventually noticed a dim light coming from one small building; under its flicker sat an elderly woman in traditional dress with a younger woman, maybe her daughter. The way this street looked, they could have been the last two people on earth. No noises could be heard anywhere; the silence was deathly. I couldn't walk far up the road; it has been closed off by the occupiers as part of the IOF military compound at Rachel's Tomb. I turned left to walk up the small hill that has become part of the long detour necessary to reach Bethlehem and Aida Camp. As I did so, car headlights hit my eyes. I knew it would be Nidal. I turned away from the glare, and as I looked behind me, the car's headlights picked up the name on a battered sign outside a restaurant that had closed long ago. Its name seemed like a sick joke, although it was no doubt never intended this way. The sign simply read "Memories."

[Rabbits and Fried Chicken]

Sitting in the shadows of the Apartheid Wall, I watch a shared taxi drive along a small road and come to a halt in the same shadows in which I am seeking shelter from the beating sun. The vehicle is forced to stop as the road comes to a startling end. The shadows are small as it is nearing midday. The sun is high, but the concrete monstrosity that casts these shadows is anything but small. The taxi's doors open, and four men get out gingerly. They pause for a moment, surveying the scene and looking furtively in every direction before heading off in unison toward a huge, ominous, gray metal gate in the Wall. The gate is the same height as the Wall itself. The men are dressed in worn and dirty clothes, and they each carry a small, black, plastic bag. They find the gate is locked and immovable; it will not be their route out of here. They jump down from in front of the gate into a small channel that is below ground level but still visible. At this level, five dark, sinister-looking circles stand between them and the Wall. Within a couple of seconds, all four men disappear out of sight and vanish as if they had only ever been a fragment of my imagination. They have gone underground as though they were rabbits seeking sanctuary from a fox. Yet, the tunnels they entered are not rabbit burrows made for such purposes. They have just disappeared into sewage pipes.

I had come to the town of Ar-Ram after hearing stories of it being used as a route to enter Al Quds for those without the required permission. The stories were vague and unclear, and it is not a town I know well, having only visited once or twice before. As I had walked down Ar-Ram's main street an hour or

so earlier, it had seemed alive and active. Parents shopped for schoolbooks and pencils with their children for the new school term that will begin in two days' time. Elderly women sat on street corners in traditional dress with huge boxes of ripe grapes, occasionally selling a bunch or two to passersby. Men sliced meat off huge rotating joints for *shawerma* (a traditional meat sandwich similar to kebab).

Over the last few years, as the Wall has been constructed, other towns in this area, which is located on the outskirts of Al Quds, have acted as "illegal" (in the occupation's terms) passageways to the magical city. Abu Dis was one such example, but that was in the days before this modern-day symbol of apartheid had been completed. Prior to the main Wall being built, wire fences coated with razor wire or smaller blocks of concrete preceded it. Holes could sometimes be cut through the wire or makeshift climbing systems set up for people who had to reach their families or their work on the other side. These people had to do so while constantly on the watch for IOF military jeeps patrolling these areas, knowing that being caught could mean a beating, prison, or even death. But once the eight to nine meters of reinforced and heavy-duty concrete slabs that created the main Wall were laid, I hadn't seen anyone successfully find a way past or over it. For this reason, I was expecting to find a fenced wall or a shorter one than the full-sized oppressive sight that greeted my eyes and darkened my heart as I reached the end of Ar-Ram's main shopping street. I was confused as to how anybody could get past or over it. I was still confused as I sat in the shade and watched the aforementioned taxi pull up. Confusion was a feeling, along with desperation, that would haunt me all day.

I realized from their clothes and bags the four men who had left the taxi were manual workers. The bags are used to carry pita breads, hummus, and *leban* (strained yogurt), the workers' simple lunch. They were trying to get into Al Quds and find work in an attempt to feed their families. To say these men are attempting to enter the city illegally is to describe the occupation's rules. In terms of international law, things are different. The International Court of Justice has declared the Wall illegal, and Al Quds has been recognized and accepted as the capital of a Palestinian state to be based on 1967 borders, a state that has never been allowed to become a reality by its occupiers or their supporters and funders in the White House and around the world. This is why these men have been reduced to scurrying around through sewage tunnels.

As I followed the four men into the tunnels, I had no idea what I would find on the other side. Would they really lead straight into Al Quds, or would I be met by more walls, or possibly even by the IOF and their M-16s? Three of the tunnels were blocked with large, square, concrete blocks—the same blocks that the IOF use all over Palestine to block vehicular access to roads—but two remained open. I headed down the same one the four workers had disappeared into. The circular tunnel was around a meter in diameter, so getting in wasn't too difficult. The stench inside was vile. Rubbish and chunks of concrete littered the floor, and the darkness took a few moments to get accustomed to, but the tunnel was straight, and light at the far end was visible. I hurried toward the light, deciding it was better not to hang around inside as there was nowhere to hide should the IOF appear at either end. I slowed as I reached the end and attempted to look into the glaring light, searching for any clues as to what lay ahead. It was disconcerting to say the least, but I cautiously poked my head out. Relieved at not seeing any soldiers, I exited as quickly as possible and climbed out of the small sewage pool I found myself in. The tunnels themselves were dry, but thick, green sewage had collected in the pool a few meters ahead. It stood like acrid, toxic soup; bike tires, garbage, and assorted chunks of rusty metal lay in it. I doubted anything would take the risk of moving in this repugnant liquid.

Clambering out of the pool, I looked around and realized that I had indeed passed straight underneath a section of the Wall. I also saw that another section of the Wall was built at this side running at ninety degrees to the one I had passed under, but there was no sign of the workers. My confusion deepened. I passed a small building that was obscuring the view, and the sight became clearer. A few meters ahead, the main Wall ended and was replaced by a smaller section, behind which stood a metal fence that was heavily coated in razor wire. Ahead I could see the four workers, but where were we? Was this Al Quds, or were we still in Ar-Ram? Was this still considered the West Bank, or was it land now referred to as Israel? The workers ahead were climbing the smaller wall, which was around 2.5 meters tall; surveying the scene at the other side; and clearly looking for a way over the Wall and through the fencing and razor wire. I caught up with them and asked them what they could see.

"M'sakar, cullo Jedar m'sakar!" (Closed, the whole Wall is closed!)

Their eyes were heavy as they spoke, but they jumped down and moved on

a few meters before trying again. They repeated these actions several times before finally one of them stopped and beckoned the others over. He was hanging from the top of the Wall. He called the others up to have a look; they had spotted a gap that had no doubt been opened up by other people attempting a similar route. The men asked me to stand back and watch out for IOF patrols. As I moved back, I could see a checkpoint around a hundred meters up the road that was not visible to the men.

"Hada machsoom, foq!" (There's a checkpoint, up there!)

The men came back to look. Then, deciding they couldn't be seen from where they were attempting to climb the Wall, they ran back and were up and over it within a few seconds. I kept watch for the IOF, but through small gaps between the concrete slabs, I could also see the men climbing down the other side, then helping each other pry the razor wire open and try to squeeze through. Within a couple of minutes, all four had vanished again, leaving behind shreds of their work clothes snared in the blades of wire.

A few minutes later, a teenage boy clambered out of the sewage pool and headed in my direction. When he reached me, we talked together briefly. Despite looking younger, he was sixteen years old and had an Al Quds ID. He was going home over the Wall and through the wire, much as the four workers had done. He had been to see friends who were now separated from him by the Wall, sewage pipes, a secondary section of the Wall, and razor wire. As he climbed the Wall, he gave me a big smile, almost laughing at his own situation. These actions were just a part of his daily routine.

As I was taking photographs, a middle-aged man approached me. Abu Ali owned a fried chicken restaurant along the road and invited me over to sit outside his shop to have a drink and talk.

"My house is over there." Abu Ali's arm waved off somewhere into the distance, somewhere behind the Wall.

"Where?" I asked him.

"Behind the Wall. I have not seen my family in a week now. I have been sleeping here in the restaurant."

Until around one week ago, Abu Ali was able to walk from his house up to the checkpoint. He was given a number by the soldiers—not a name, as a human being is entitled to, but a number. This number permitted him to get

from his house to his place of work. However, when he got to the checkpoint one morning, he was told he now needed a number *and* written permission.

"I have a number, but they won't give me a permission."

So Abu Ali was refused passage through the checkpoint. He walked back toward his house dejected, but then decided he would not be beaten. He followed the route of the Wall until he could find his way through, past the razor wire, and over the secondary wall to his shop. He has not been home since that day, not wanting to risk his life every day. His wife and three children are still at home; he has not seen them in seven days. As we talk, four teenagers walk into the restaurant and order a portion of fries and two cold drinks.

After serving them, Abu Ali walks back to me. "They are my first customers all day. Its 2 p.m. now. I opened at 10 a.m.! What should I do? Should I give up and sit in my house all day? No, never! But there are no people here anymore."

His words trail off as his eyes look up the empty street. Apart from the four boys now sitting and talking on the pavement, there is not a soul in sight. Then a car drives toward us slowly, passes, and heads up the deserted street before stopping, turning around, and heading back to where I am sitting with my host. It slows to a halt as it reaches us, and the driver rolls down the window to ask a simple yet devastating question: "Wein Al Quds?" (Where is Al Quds?)

With these three words, my heart plummets several notches further into darkness. The driver simply does not know where he is or where the capital city of his own country has gone. Abu Ali explains how to get to the nearest checkpoint that allows vehicular access to the city. This checkpoint is Qalandia on the way to Ramallah. As we continue talking, more workers turn up, also looking for a way to get to Al Quds. They follow the route taken by the four workers earlier on after watching for passing IOF patrols. Then another car turns up, and again the driver stops to speak to us, "Wein ana? Wein Ramallah?" (Where am I? Where is Ramallah?)

Abu Ali had explained to me that this is still part of Ar-Ram, the same town that is also on the other side of the sewage pipes. The main part of the Wall cuts through the middle of the town. Al Quds is across the other side of the smaller wall and razor wire. Much as I didn't know where I was an hour or two earlier, this succession of drivers and workers are equally perplexed. Nobody knows where he is in his own country. Nobody knows what town he is in or where the

next city is. The walls are literally closing in on people, and places are starting to disappear.

More workers begin to turn up, and many stop to talk. Everyone I speak to is confused, frustrated, and justifiably angry at what is happening and what they must now endure. After another hour or so, I head off back toward the sewage pipes. As I get back within sight of them, I see more people exiting the tunnels. This time it is not workers I see emerging from the darkness; it is two women, both well into their seventies, wearing traditional dress. They are not moving with the same nervous energy as the workers; their years of raising families and struggle have taken away that edge. They shuffle along slowly, but also defiantly and strongly, out of the sewage pool and up toward the smaller section of the Wall. They have no intentions of climbing the Wall; for them it would be physically impossible. Instead, they sneak through a gap between the end of the small wall and the start of the main Wall. Maybe they know something that others don't. But within a few seconds, they are back out again, shaking their heads as they mop their brows in the burning mid-afternoon heat. There is obviously no gap in the razor wire. They walk back down into the dried-up sewage pool, and I expect them to head straight back through the tunnels. Then one of them begins to hitch up her beautiful, patterned dress. These dresses are worn to cover the feet, but she lifts it up above her ankles. I have a feeling I know what is coming next, but I hope with all my heart I am wrong. She begins to shuffle cautiously into the filthy, stagnant sewage. There is another tunnel at the deeper end of the pool that runs parallel with the small wall; she clearly thinks if she can get through there she will get into Al Quds. She takes a few unsteady steps, and I move over to offer help. Her feet have disappeared into this toxic-looking waste that only a few hours earlier I had thought nobody would risk entering. As the other woman shouts over to her, she stops walking, looks over at me, and then turns to walk out of the liquid. Cursing, the two women turn and hobble away, back underground into the dried-up sewage pipes and back underneath the Wall. Their journey has been a failure; they cannot reach Al Quds.

I myself slowly follow the two women back through the tunnels. I can do nothing to help them. Their determination and spirit are inspirational; the situation forced upon them is nothing short of inhumane. In my few hours in Ar-Ram, I watched people forced to scurry underground like rabbits and then

watched helplessly as these two resilient women searched for Al Quds. I saw drivers who had no idea where they were and workers risking their lives to feed their families. I also met Abu Ali, the man who continues to fry his chicken and is even forced to sleep alongside it now. He refuses to give up, despite the fact that he has no customers anymore.

This is life under occupation as the walls close in, with its stories of resilience and repugnance, metaphors about rabbits and fried chicken.

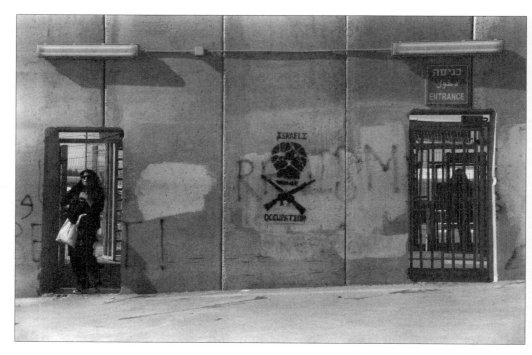

"Israeli Occupation"—Bethlehem Checkpoint

"Buried Alive"—Bethlehem

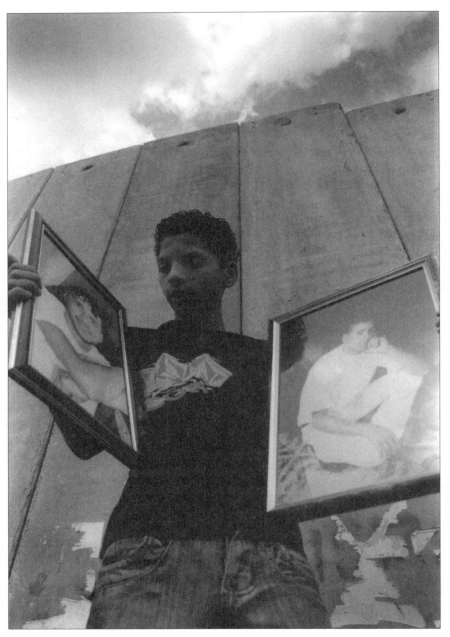

"The Wall Stole My Brothers"—Aida Refugee Camp

THE SPIRIT OF RESISTANCE

[Yasser Jedar]

Over the last year or two I have come to know Yasser. Everybody in Aida Camp knew Yasser.

In 1989 Yasser was born into a family that, even by the camp's standards, was very poor. He had just one older sister in what was an unusually small family in the Arabic world. His family life was also quite unstable and plagued with problems. Yasser's father, Abu Yasser, was a regular drug user. He mainly smoked only hash and marijuana, but attitudes to these activities are not as open in Palestine as they now are in parts of Europe. There is a distinct distrust toward people who use drugs in Palestine, and drug users are often associated with collaboration with the Israeli authorities. There have been many reported cases of the IOF using social and cultural taboos, including drug use, as tools of blackmail against Palestinians in order to turn them into collaborators, and many Palestinians also believe that the IOF has encouraged and even facilitated the spread of drugs in some areas in order to erode the social fabric of Palestinian society and to subsequently break down the resistance front. It must be stressed, however, that people in Aida Camp believe that Abu Yasser was not a collaborator. Yasser's parents split up when he was very young, and his mother remarried into a family from nearby Al Azzeh Camp, the smallest of Bethlehem's three refugee camps. Despite being only a ten-minute walk from his mother's new home, Yasser rarely got to see her and soon went to live with his grandparents in Aida Camp, an arrangement that continued through all of his free life. His sister also moved out of Aida when she got married.

Yasser didn't have that many friends during his early years and was a quiet child. He had some problems at school, but these intensified in 2002. This was the year during which Aida Camp was continuously under curfew for forty days and saw much violence, destruction, and death. It was also the year when Yasser's father died. Nobody seems to know exactly what happened to him, although it is known that Palestinians kidnapped him one night. Around this time, some people suspected of collaboration with the occupation were being taken for interrogations in this manner, but Yasser's father was not a collaborator. People in Aida Camp believe Abu Yasser was another social victim of the occupation for whom the pressure simply became too great. His breakdown under the pressure led to financial and social problems that ultimately seem to have played a role in his death. No one is really sure who took Abu Yasser away, but he never returned to Aida Camp or saw his son again. He died under torture. Yasser had always stood by his father and tried to defend him at any opportunity.

It was a lot to take in for one so young, and friends recall that Yasser's behavior at school changed dramatically. Classmates remember him getting into a lot of trouble with teachers and being very disruptive during lessons. On one occasion, he reportedly began throwing eggs at the blackboard during a lesson, much to his classmates' amusement. Outside of school, these were dark and dangerous days in Aida Camp, and Yasser started to become active against the occupation. He was just thirteen years old, and he felt that he must prove to people that his was a good family. He wanted to defend the family name, and it seems that he hoped to do this by showing his resistance to the occupation. In fact, it seems that for much of his life, Yasser felt that he had to prove something to others. He had had to defend his family all his life; now he also needed to defend himself, his camp, and his rights. The only way he could see to do this was the way of the First Intifada, through stone throwing and joining local, popular resistance.

When people ever asked Yasser why he threw stones, his answer was simple: "I have no family, I have nothing else, so I must defend. I must be active for my people!"

When I got to know Yasser, everybody knew him as Yasser Jedar. It was not his real name, but when translated into English, his nickname is Yasser Wall. Yasser was always active and involved in something near the Apartheid Wall, and it was this that earned him his name.

Invasions of Aida Camp by the IOF are a regular occurrence. Invariably during such attacks, Yasser and another youth, Mazen, could be found with other *shebab* (youths), attempting to defend the camp, using stones against bullets.

Mazen was shot during one of the IOF invasions of Aida Camp. This did not happen by chance. Somehow, the IOF had managed to get very close to the shebab, and Mazen was cornered. He was shot in the legs four times from very close range before the soldiers turned and left the area, leaving Mazen in a heap on the ground, screaming in pain. So-called rubber bullets had been used to shoot him, and Mazen's injuries were not life threatening. The rubber bullets used in Palestine by the IOF are either solid, steel balls of approximately 15 millimeters or solid steel cylinders of around 20 millimeters; both have just a very thin coating of rubber. Usually the rubber coating and shape prevent the bullets from piercing the skin, but when fired from an M-16 at close range, it's not hard to imagine the pain they cause or the severe swelling and bruising that remains. That said, these bullets can and have killed before in Palestine, and children, given their immature skull structure, are particularly at risk if hit in the head. Mazen was on crutches for a long time after he was shot, but it didn't keep him off the streets, nor did it keep him from attempting to defend the camp whenever it was invaded.

After Mazen had shed his crutches, I noticed what looked like a Fateh flag flying from the roof of one of the IOF watchtowers in the Wall. How this had got there puzzled me. Everything became clear a few days later when I came across Yasser and Mazen alongside one of these towers. This particular watchtower is not permanently manned by the IOF, and the shebab had constructed a huge ladder so they could climb to the top of the Wall and hang flags from it. This tower is out of view of the Rachel's Tomb IOF military base, which looms over Aida Camp; so provided that others kept watch up the road for military jeeps entering the camp, the shebab could clamber up the makeshift ladder quickly and hang flags from the Wall or watchtower. Yasser, true to his name, scaled the ladder and proudly hung a Palestinian flag from the top of the Wall before just as quickly descending and melting back into the maze of winding alleyways inside the camp with the rest of the shebab. During the First Intifada, raising Palestinian flags anywhere or writing political graffiti was enough to get people imprisoned or even shot by the IOF. Although times have changed now, Yasser would have met a similar fate for this act of resistance if he had been seen climbing the Wall. A day or so later,

I showed Yasser and Mazen a couple of photos I'd taken while they were raising the flag. They were so excited and immediately asked me to print them a copy each. Yasser actually asked me to make him hundreds so he could stick them all over the camp; it seemed he still felt he had to prove something to everyone. This I couldn't do, but I told them I would go down to the photographic printers I use the next day and get a print made for each of them.

I e-mailed the photos to the shop the next day and was told they would take two or three days to be printed. Those two or three days turned into a week. As one delay turned into another, it soon became two weeks. Every day during this period, Yasser and Mazen would ask eagerly where their photos were. It must have seemed as if I was making excuses as every day they seemed more and more disappointed. After a week or so, they stopped asking, probably assuming they would never get their photos.

While still waiting for the images, Yasser came to find me one day and was eager to show me something. From what I understood with my unreliable Arabic, he was trying to tell me that he was going to burn the Wall down. If I understood him correctly, I had no idea of how he planned to do this, but knowing Yasser, I knew it was worth going to investigate. On the way, he began to explain his plan. He told me that he had been setting a fire alongside the Wall in the same place for several days now and was convinced that this would weaken the concrete enough for him to create a hole large enough to fit through. What he planned if this ever came true wasn't clear, but it was just another of Yasser's remarkable acts of resistance. Written on the Wall in Aida Camp is the slogan "No Wall Will Stop Us," and this seemed to be Yasser's motto. When we followed the Wall toward the top of the camp, I could clearly see the area he had been working on from a distance. It was charred black from the flames. When I reached it, I was amazed to see a hole. It was a small hole, no more than a few inches wide, but it was a definite hole in the Wall that, with time and more work, would grow until he would see his scheme come to fruition. No Wall would stop Yasser.

Eventually, after about two weeks of waiting for the photographs, they turned up. I went into the camp, looking for Yasser and Mazen. After asking around, I eventually found Yasser, but I never found Mazen. Yasser greeted me with the usual smiles and handshakes, but I was devastated to find out that I was

too late for Mazen. He had been arrested on the previous night during a raid into the camp by the IOF. He had become another memory, another youth added to the ten thousand–plus political prisoners locked up in Israeli prisons. Mazen never would get to see his photo.

I was going to Ramallah a few days later, and Yasser asked me to take his photo to the Mukata'a and personally deliver it to Abu Mazen, Palestine's president. I explained I couldn't personally get access to the country's president. I felt he was disappointed, almost as though he was still trying to prove himself to people.

At the time, we were in the process of putting together a magazine about Lajee Center. One day we jokingly asked Yasser if we could use the photo in the magazine. He agreed instantly, even after we explained how dangerous this photo could be if it got into the hands of the Israeli authorities.

"So what! I don't care! What have I got to lose? Let them take me to their prison. It can be no worse than this life anyway!"

As usual, he said it with a smile on his face, but I sadly felt there was at least an element of belief in what he said. Needless to say, we didn't use the photograph in the magazine.

One night in the middle of June, during one of the IOF's regular invasions of Aida Camp, seven youths, all under eighteen years of age, were arrested. One of these youths was Yasser Jedar.

Yasser has not been sentenced yet. We don't know when we will see him again. But I have a feeling that, just as no Wall ever stopped him, neither will any prison. It may be a month, it may be a few years, but I have a feeling, and a very strong hope, that we will see Yasser again.

When people talk about Yasser, they do so with smiles on their faces. He is sadly missed but fondly remembered.

[The One Who Will Make Victory]

O n January 1, 1970, in a refugee camp in the northern West Bank, a woman gave birth to a child. He was to be one of five sons. He was given the name Nasser, or the one who will make victory. He was born into an area of Palestine that had fallen under Israeli occupation less than three years earlier, but the occupation of all of Palestine would prove to be the driving force that dominated his life.

Just as many of his classmates at the Basic Boys' School in his camp, Nasser became involved in acts of resistance against the occupation. He was imprisoned for the first time while still at school and sentenced to five years for throwing a molotov cocktail at an IOF jeep during one of the Israelis' many invasions into his camp.

On the first day of the first Gulf War, Nasser was released from prison but could not continue with his schooling. It had been five years since he had done any studying. Within six months, Nasser had joined an organized resistance movement called the Black Panthers. He believed that there was no justice for his people in Palestine, but he yearned for it. He wanted to improve the situation forced upon his people. This again made him a target for Israel, and he once more became a wanted man.

Two years after Nasser's release, there were student elections at An-Najah National University in Nablus. The Black Panthers were there, along with about five thousand students. The IOF got wind of the Panthers' presence and surrounded the university; a siege began. The Panthers were massively outnumbered

by the IOF and couldn't risk losing all of their members, so five of them decided to give themselves up in order to facilitate the escape of other members. Their plan worked. Nasser was one of the five who sacrificed his freedom for the others to escape. He was exiled to Jordan. In Jordan and in Iraq, where he spent some time during exile, Nasser resumed his studies. He finally passed his *tawjihi* (high school exam) while he was in exile, but he dreamed of returning to his homeland. Around this time, the Red Cross and Israel entered negotiations over exiled Palestinians. Eventually a deal was forged, and Nasser was allowed to return to Palestine, although it was still a refugee camp and not his home village that he returned to.

When he returned to Palestine, Nasser immediately enrolled at An-Najah University, where he received his degree in sociology in 2000. He was clearly motivated to study, but he was also still highly motivated to continue the struggle. He was politically active again and once more became a part of his country's and his people's fight for justice. The year 2000 was also the year in which many Palestinians had finally had enough of endless failed peace processes. The year heralded the beginning of the current intifada, the Al-Aqsa Intifada. Nasser supported the uprising. As his brother explains:

"Nasser's vision was one of freedom and independence for himself, his people, and all of Palestine, freedom for Palestine with Al Quds as its capital. He wanted to free all occupied land and people and create happiness for the people of his country. To resist is a legal right for all occupied people of the world. We are occupied by Israel, and this is the biggest occupation in the world."

Nasser decided he must be active in the resistance; he wanted to change the situation and believed the way to do this was through organized, armed resistance. He helped established a new resistance group that was affiliated with Palestine's ruling political party, the Fateh movement. Nasser's group was known as the Katab Shuhada Al-Aqsa (Al-Aqsa Martyrs' Brigade). It soon became one of the most prominent resistance movements, and Nasser became one of Israel's most wanted men.

In early 2002, the family house in which Nasser had been born was blown up by the IOF. It is a day Nasser's older brother will never forget.

"It was part of an Israeli operation called 'The Head of the Snake.' We were sitting in the house, and suddenly we heard Apache helicopters hovering above.

Then there were lasers shining down onto the house. We knew that these were the lasers with which missiles were fired. We all ran outside quickly. The *jaysh* [soldiers] were all over the camp, entering peoples' houses. Within a few seconds, the missiles were fired, and all three stories of our house were destroyed. Nasser wasn't here; he was away in hiding. Everybody knew that. I'm sure they [the IOF] also knew that, but this was a warning to us and to him. They wanted us to be scared and know that they were coming for him. Other families of fighters were given twenty-four hours' warning before their houses were blown up to give them time to leave and clear the house. We were given nothing!"

On March 14, 2002, Nasser was arrested in the town of Tubas, which lies between Jenin and Nablus, and was eventually sentenced to fourteen life sentences plus fifty years for being the leader of the Al-Aqsa Martyrs' Brigade. When he appeared in court, one of the guards insulted him and then began to beat him. Never being one who would accept this, particularly in front of his family, Nasser defended himself and began to hit the guard before being overpowered. It was this act of resistance that earned Nasser an additional six months, which was added to the fourteen life sentences plus fifty years.

Nasser's brother knows of his brother's strength and belief in the resistance. "If they freed him now, he would continue the struggle despite his sentence." He is also honest in his description of his family's loss: "The man makes the conditions; the conditions do not make the man. We can rebuild our house, but what we have lost—the prisoners and the martyrs—are much more important. They [the IOF] blew up our house, all three floors, but we don't want a big house. We just want to live in freedom."

Nasser has been moved around many Israeli prisons. For the last three and a half years, he has been in solitary confinement in Beersheba Prison in southern Israel. He is not allowed telephone contact with anyone, although he was once allowed one conversation with his brother that lasted just fourteen minutes. Currently, he has also been stopped from having any access to the *canteena*, the prison shop where inmates can buy extra food.

Nasser's brother was once given permission to visit him in prison. "When I arrived at the prison, there were many people there waiting to visit family members. The guard came in and asked, 'Who is the brother of the leader?' Nobody answered. He then called out my name and asked me to make myself

known to him. 'It is me,' I replied, raising my hand. 'What are you doing here? He can have no visits,' he told me. I explained to him that I had permission from the Shabak [the Israeli Security Agency, also known as Shin Bet]. The guard insisted, 'He can have no visits. No one can see him!' I told him, 'I will always come here just to smell the place where my brother lives.' I was not allowed my visit. Afterward, many of the other visitors came over to see me. They told me everybody talks about Nasser a lot. In Bethlehem, in Tulkarem, in Jenin, and at demonstrations, everybody talks about my brother. A woman came over to me and hugged me. She said Nasser was a good man; he was *clean* [meaning not corrupted] and a patriotic leader."

Up until mid-2006, Nasser had not been allowed to mix with any other prisoners at all. He is now allowed to do his daily exercise along with an old friend, Hussam Khader, who is serving seven years. Parliamentarians from all over the world have signed petitions asking for the release of Khader, a democratically elected member of the Palestinian Legislative Council, but to no avail.

Nasser's brother asked the Red Cross if it could help arrange a visit to see him in prison. He was told that only Nasser's mother, father, and children were allowed to visit. Nasser's mother had died a few years earlier, his father was too sick to travel, and he never had any children. There was another older brother, but he became a martyr when he was killed in 2004 during an IOF invasion of the camp. Nasser's cousin and his cousin's son are also both martyrs.

Nasser's remaining family members are unsure if they will ever see him again, even though he is just thirty-six years old. The choices Nasser made were his own, but his family's dreams are no different to those of any Palestinians:

"We want to free all of Palestine and all the prisoners. We want Israel to leave our country and end the occupation so we can live in peace. We just want to live with our families again."

[Ibrahim's Pavement Café]

Most cities and towns across Europe have one or more central squares around which the city or town is built. These vary from bustling market squares in rural England to lazy plazas in small, Spanish villages and huge piazzas in Italy's great Roman cities, but the small square of Al-Khalil (known as Hebron in English) at Bab al-Baladeyya (Gate to the City) bears little in common with these other hubs of social activity. Around the square are nineteen shop units; many of their doors are scarred with bullet holes. On top of them sits a small, cream-colored unit covered with camouflage netting from which Israeli soldiers watch the area twenty-four hours a day. Two IOF watchtowers dominate the small square; between them hangs a huge, reinforced metal gate that is permanently locked to Palestinian residents. Behind this gate are areas of Al-Khalil that have been totally occupied by settlers. Opposite the gate, another road leading into Bab al-Baladeyya is blocked with a four-foot-high yellow gate wrapped in razor wire that prevents vehicular access for Palestinians. From an abandoned Palestinian house next to this gate (abandoned because Palestinian residents were violently forced out), a blue and white Israeli flag flutters in the wind. Diagonally across the square from the flag, a newer building looms ominously over everything. This building is the yeshiva (religious school for Torah study) attached to Beit Romano Settlement, one of four extremely radical Zionist settlements located within the Palestinian city. Around twenty-five years ago, the site of the yeshiva hosted a Palestinian school. Until very recently, every one of the nineteen shop units was closed. Some had their metal doors welded shut by the settlers after

they had chased Palestinians out of the area. But just two weeks ago, one shop unit directly in the shadow of the yeshiva, within a few meters of the IOF watchtowers, opened its doors once more. Welcome to Ibrahim's Pavement Café.

"Ernesto Che Guevara." These were the first three words Ibrahim said as he brought over two cups of hot, sweet *shai bi nana* (tea with mint) for us. "He is my hero!"

Ibrahim is proud to talk about his Marxist ideology, and he is equally proud to tell his life story. It is a remarkable story that could be portrayed as one of endless suffering, but when Ibrahim tells it, he tells it proudly as one of endless resistance.

Ibrahim was born in 1958 in Ad-Dahriya, a village that lies a few kilometers from Al-Khalil. At the tender age of seven, his uncle taught him how to shoot with a British weapon left over from the Mandate times.

"My uncle trained both me and my cousin how to use a gun. We used to play in an area that the Jordanian military used for training. One day we found an unexploded bomb. We didn't realize it was dangerous. We were playing with it, but then it exploded! My cousin was killed instantly, right there in front of me. He was seven, too, and he was my best friend. I am still too [very] sorry about him until now."

By 1973 Ibrahim had joined the Palestinian Liberation Organization (PLO), a union consisting of Fateh, the Popular Front for the Liberation of Palestine (PFLP), the Democratic Front for the Liberation of Palestine (DFLP), and other smaller factions. Three years later, in his last year at high school, he was imprisoned for the first time by the occupation authorities.

"They [the IOF] arrested me for being active in the resistance. I was distributing leaflets and Palestinian flags for the PLO. I stayed in prison for two years, during which I was beaten and tortured regularly, but I never talked! I never told them anything!"

Far from convincing Ibrahim to change his ways, his time in prison actually strengthened his resolve. Upon release, he went straight to Birzeit University in Ramallah and enrolled to study political science and Middle Eastern studies. Less than a year later, in 1979, Ibrahim was again arrested and interrogated for a month. After his release, he returned to his studies at Birzeit.

In 1981 there was a minor intifada in Palestine. The occupation authorities

had been attempting to install their own choices of Palestinians on town and city councils and refusing to deal with any elected mayors or representatives who supported the PLO. There was political discussion about Israel giving around 60 percent of the West Bank back to the control of King Hussein of Jordan; the remainder would be considered Israeli territory, so Israel attempted to install either Palestinian collaborators or Palestinians loyal to King Hussein to all representative posts to support this idea. Zionist settlers were playing their part by carrying out attacks against elected Palestinian representatives. Bassam Al-Shaka'a, the mayor of Nablus, lost both his legs when settlers placed a bomb underneath his car in June 1980. Karim Khalaf, the mayor of Ramallah, suffered a similar fate, losing one leg during another attack. Settlers also targeted several other elected representatives during this period, assassinating some. Palestinians responded by staging a mainly student-led intifada. It was this intifada and other similar uprisings that eventually led to what is widely termed the First Intifada, which began in 1987.

"I was active in this small intifada. I was arrested, and that time they kept me for three months. I was put inside a tiny cell, more like a secure cupboard. I was strung up from a wall with my arms stretched far apart, handcuffed to the wall. My legs were also spread apart and my feet chained to the wall with my feet off the ground so I was hanging from my wrists. They used a heavy stick to repeatedly beat me on my head and between my legs. They kept saying, 'You have guns and you organize people.' They tried to get me to talk, but I still told them nothing."

Small uprisings continued over the next year or two. In 1983 Ibrahim was again arrested and held for three months. By this time he was working as a writer for an underground communist newspaper called *Al-Talia* (The Vanguard), producing regular articles about the situation in Al-Khalil and about workers' rights. Ibrahim would continue in this role for nearly ten years.

In 1988, during the First Intifada, Ibrahim was married to the headmistress of a local girls' school. This was also the year in which his closest friend was killed after being shot in the heart by occupation forces while leading a demonstration in their home village of Ad-Darhriya. He left behind three children who were named Guevara, after Che Guevara; Thouwri, which translates as revolutionary; and Maysah, named after the daughter of the PFLP leader, George Habash.

Watching Ibrahim, I can see that he still clearly feels the pain of this event today, much more so than when describing his own experiences in and out of occupation prisons. Three months after the death of his closest friend, Ibrahim found himself locked up and being beaten once more. It happened again the following year, and during this three-month captivity, he had most of his teeth smashed out with rocks and clubs during torture. Ibrahim still refused to speak.

After Ibrahim was again released, he opened a small office in Al-Khalil from which to write independently, and he also began to write for another communist/Marxist newspaper called *Al Katib* (The Writer). Within three years, Ibrahim had moved to a better-equipped office in the Bab as-Zawiya area of Al-Khalil. The office was fitted with computers and copy machines, and he worked long hours producing leaflets and literature supporting the intifada. Although he is a PFLP activist, Ibrahim produced literature for all Palestinian factions because he is first and foremost a Palestinian, and he firmly believes in anything that he sees as for the good of his country.

When the Oslo Accords were signed in 1993, many Palestinians initially welcomed the deal, believing it could lead to the end of occupation. Very few people now believe it was ever constructive or beneficial to Palestine. Ibrahim believed right from the outset that it was corrupt and was never afraid to voice these opinions.

"I believe in two states. A Palestinian state must be established in the entire West Bank and Gaza Strip that is free from occupation and all settlements. The full Right of Return must also be granted to all Palestinian refugees. Oslo did not offer us these rights, and anything less than this is just not acceptable and is corrupt."

Ibrahim continued his work, producing literature challenging the Oslo Accords, and this eventually brought him into conflict with the newly established Palestinian Authority. In 1996 he was producing literature for the Islamic Jihad movement, which, like the PFLP, had also rejected the Oslo Accords right from the outset.

"I found out many of the secrets of Oslo, and I knew it was bad for Palestine even then. I was copying and distributing leaflets for Islamic Jihad in which these secrets were revealed. The PA found out about this and arrested me. In their prisons, I was beaten on my head and stomach. Eventually, I collapsed

and was taken to Deheisheh Hospital in Bethlehem. I stayed in that hospital for three weeks."

Ibrahim had friends in high places, including Palestinian Communist Party leader, Bashir Barghouti, and Fateh leader, Jibreen Rujoob. They worked to have him immediately released, knowing that he had always been an active revolutionary, and his work was for the good of his country. Although released, his family still suffered because of his outspoken opposition to Oslo. Ibrahim believes that it was the PA Ministry of Education pulling strings against him that led to his wife being demoted from her role as headmistress back to a standard teacher's position. The couple had five children by this time, and the reduced salary hit them hard. Ibrahim was forced to look for paying work, which he eventually found laying water pipes for the Al-Khalil Municipality. Only three months into his new job, a work accident saw a one-ton pipe slip from machinery, crushing his knee. It would be fifty days before his release from the hospital following this horrific accident. The doctors were unable to rebuild his knee, and this marked the end of Ibrahim's manual work. Up until two weeks ago, he had not worked since that accident, and his family had had to survive on his wife's salary alone.

"Two friends who I used to write with came to see me. One of them owned this shop unit and told me their ideas about opening a coffee shop here. They told me it was next to the soldiers and the settlers and that the settlers want to take all this property."

Ibrahim saw this as his chance to become active and resist once more. When the coffee shop first opened, it had just one table. He now has four, including one outside in the square itself. There is no electricity, but he is working to get this changed. Every day at 8 a.m., Ibrahim opens his doors, and he stays there until late afternoon. He says business was very slow at first, but it is gradually starting to improve. On Saturdays, the Jewish Sabbath, the whole Bab al-Baladeyya area is filled with settlers, who are escorted by IOF soldiers. It is on this holy day that the settlers have often been at their most violent in Al-Khalil; consequently, the area is virtually deserted of Palestinians, except for Ibrahim, who refuses to close his shop or be intimidated.

I enjoy spending time with Ibrahim. He is an incredibly strong and passionate man. As he talks, his head permanently twitches from all the beatings he

has received. He also suffers almost continuous headaches and is now diabetic. His sight is poor, walking distances is difficult after his work accident, and when he smiles, he reveals his almost toothless gums. Ibrahim has paid a very heavy price for his principles, but the physical suffering has not damaged his resolve for struggle. Instead, it has merely redirected the form of his resistance.

"This [coffee shop] is our resistance against the settlers and soldiers! We have very little business, but we struggle to survive through our resistance. They are all angry to see me open here, but they don't scare me!"

As Ibrahim talks, an IOF patrol walks past his shop and stops just a few meters away, watching us with their guns raised. Ibrahim doesn't even pause for breath; if anything, his voice becomes slightly louder.

"There is a good day coming, but it is not here yet. It will come one day. I want to see a Palestinian state in the West Bank and Gaza Strip, free from all settlers and occupation soldiers, and all refugees return back to their lands."

Ibrahim looks past me at the watching and listening soldiers. His mouth opens and his two or three remaining teeth show into his crooked smile. Then he continues:

"I am happy now. I am fighting again."

[We Won't Accept No Thought Control!]

Because of the severe and wide-ranging restrictions the occupation places upon every aspect of Palestinian life, the refusal to lie down and the very act of life itself become forms of resistance. The continuation and development of life take no small amount of strength, both individually and collectively. Education is one example of such resistance, and the importance placed upon it in Palestine should be respected.

Over the last ten days or so, since the beginning of the IOF's abhorrent Operation Hot Winter in Nablus, Israel's attempts to crush this educational resistance have been clearly demonstrated. While Palestinians continue to strive for increased knowledge through education, Israel knows that this will only enhance the national resolve and infrastructure from the grass roots up to the leadership level. This is something Israel appears to be intimidated by.

An-Najah National University, located in the Rafidia district of Nablus, is the largest educational institute in the West Bank. The university is the educational home to some fifteen thousand students. For three days last week, An-Najah was forced to close its doors to its eager students as IOF jeeps and soldiers surrounded the complex.

Operation Hot Winter was the largest military operation in the West Bank in more than two years. Literally hundreds of soldiers flooded Nablus and laid siege to an estimated three thousand families in the Old City area. Schools were occupied and turned into military bases and interrogation/torture centers, and hospitals were surrounded and closed down. The curfew placed on the Old

City closed all shops and made residents prisoners inside their homes. Many people were denied access to food and medical supplies. When the siege spread to Rafidia and the university, fifteen thousand students were denied their right to education.

On the first day of the siege, Muhammad, a twenty-year-old medical student, had just returned to Nablus after visiting his family in his home city of Al-Khalil.

"When we heard the soldiers were coming to the university, some students decided to leave the city and return to their homes in Jenin, Tulkarem, and Qalqilya. I had just arrived back that day, and it is expensive to travel, so I refused to leave again, but I was very frightened. We all were! In Al-Khalil, there are always soldiers, but I had never seen this many in my life."

It was not just the university building that was under siege. During the second night of the IOF operation, the troops also surrounded the dormitories and student accommodations in the area.

"We thought we were safe in our houses until we saw them entering our building. They were searching people, taking our IDs and mobile phone numbers. They entered one dorm where some students who support Islamic Jihad live and started beating people. They arrested three students from there, and we haven't heard from them since. They also entered another dorm, which is mainly Hamas students, and started beating students in there, too. We came here to study because we have hopes and dreams for the future, but in one minute they can take it all away. We cannot study like this. How should we study?"

Although the Rafidia district wasn't officially under curfew, the size of the IOF deployment in the area meant shops remained closed and residents stayed indoors.

"We could not go out, so [we] had no fresh food. We couldn't study, so we were just watching TV. We were watching what they were doing to the city."

The university is open again now, but no one is sure how long it will remain this way. The IOF pulled out of Nablus after three days but returned with renewed force a day later. It then pulled out again a couple of days later but has still not announced the end of the operation.

"Many people believe they will be back. If they come back, I think I might leave. If I have exams, I will not leave. I will not miss exams for them, but if I do not have exams, I will not stay here just to study. I cannot study like this!"

Under normal circumstances, the university is closed on Thursdays and Fridays, but because of the three lost days last week, lectures have been rescheduled for the next three Thursdays. If, or when, the IOF return, and An-Najah is forced to close its doors again, no one is sure how the precious lost time will be made up.

Muhammad is studying medicine. He hopes one day to become a doctor; his reasoning behind this desire again demonstrates his resistance. He knows such a profession will earn him respect in his community, which is important to him. He also believes that it will enable him to successfully provide financially for his family, but above all else, it seems that one issue is the driving force behind his will to succeed.

"The most important reason for me is that I believe this is my mission—to help my people. I can help look after my people and care for them. When people get shot or injured, I will be able to help. I can be responsible for my people; this is my duty. I want to stay here in Palestine despite everything because I love my country, and I must help my people."

Another of An-Najah's students, Nasser, was equally resilient in his desire to continue his studies, but he has also seen friends leave Nablus since the IOF operation began. "There is no chance to study under these conditions. Many students have left, but they will be back soon. What is the cause of this, and what is the result? They will continue with this attack, but we all have hopes to finish our studies. They will not stop us studying! The soldiers want to stop us from studying, from living; they want to stop our lives!"

Before leaving the university, Muhammad takes me to meet one of his professors. Professor Samir had refused to stay inside during the heaviest days of the invasion. His actions were a demonstration of the reasons Muhammad feels that medicine is his duty.

"I broke the curfew to take food into the Old City with some other doctors. Nobody in the Old City could leave their houses. People had no food, no bread; they could not eat! The soldiers stopped us and asked why we were there, so we told them we were delivering food. They didn't give us problems. They wanted to show us a nice picture of them, that they cared, as though they want to kill us in peace, to bomb and destroy our lives in peace. They had blocked all our hospitals and surrounded them, but I don't know why. These are humanitarian places, not places of war. We know they will be back; we don't know when, but they will come."

While Israel can and does control many aspects of Palestinian life, it seems the one thing it cannot always occupy is people's minds. Written on the Apartheid Wall in Bethlehem is a line from a very apt Pink Floyd song, "Another Brick in the Wall": "We don't need no thought control."

The graffiti was written by band member Roger Waters on a solidarity visit to Palestine. To more accurately reflect the Palestinians' spirit, maybe it should be rephrased, "We won't accept no thought control!"

"Ibrahim's Pavement Café"—Al-Khalil

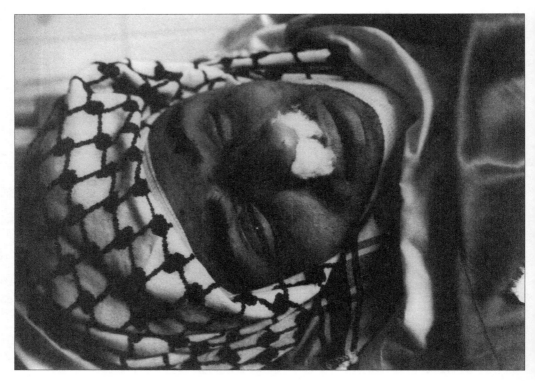

"Another Martyr"—Bethlehem

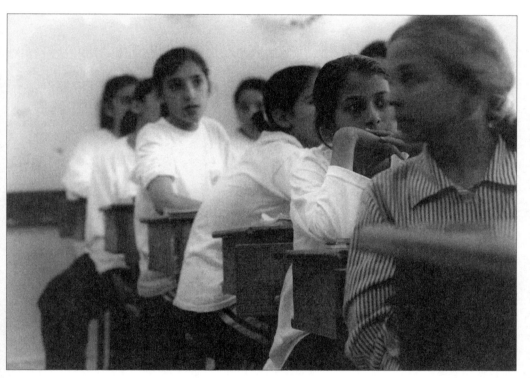

"Building a Future"—Aida Refugee Camp

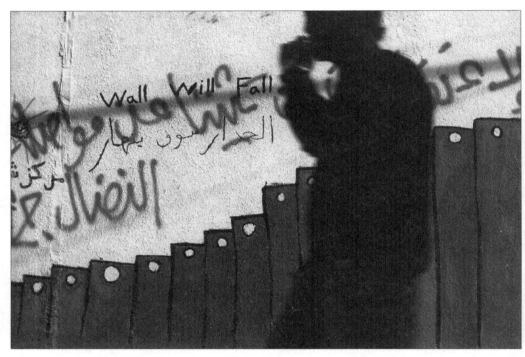

"Wall Will Fall"—Deheisheh Refugee Camp

PURITY AND LOVE

[A Child and a Balcony]

"On Friday, December 8, 2006, I was shot."

Miras is unemotional as he tells his story; he has done it many times. It is a story that no child should ever have to tell. Sadly, it is also a story that many children can relate to in Palestine. Miras Al Azzeh was twelve years old when he was shot.

"The day before [the shooting], my parents asked me and my brother and sisters to start to study hard, because the final exams for the first semester would start on the following Monday. I asked them to let us play on Friday, because we would be under exam pressure for the next few days. They agreed."

Miras's parents, Nidal and Afaf, always take an active and supportive role in their children's education; they both believe in its importance and value. However, they also know that children are children and they need time to play. Every child in the world has the right to play.

"Friday morning, around nine o'clock, my sister, Athal (ten years old); my brother, Rowayed (eight); and my cousins Maysan (eleven), Sadeel (eight), Zayed (seven), and Ansam (three) started to play on the balcony of our house. It was warm, and we started to play Jaysh and Arabs (Soldiers and Arabs). Maysan and I were the [Israeli] soldiers, and the others were the Palestinians. They had to make a demonstration, and we had to prevent and arrest them. I had a plastic toy gun, which I bought during Eid al-Fiter [a religious festival that falls at the end of Ramadan] a month ago. I used it to arrest Zayed and Rowayed. We, Maysan and I, put them in the prison we had made in a balcony corner. Maysan was the

guard. They managed to escape and became wanted. We started to chase them. All the others were running, and Maysan and I were chasing them. They entered one of the rooms and closed the door. I started pushing the door. Maysan helped me, but we couldn't open it."

Jaysh and Arabs is one of the most popular children's games, particularly with boys. It is a simple game that must be put into context to be understood. As a child growing up in the United Kingdom, I spent all my time watching football on TV, and there was always a football by my side. All my friends talked about football, my family liked all sports, and it was what I dreamed about. I was surrounded by sports, and this environment reflected the games I played. Children in Palestine grow up in a world where their lives are consumed by the effects of the all-encompassing occupation and its many facets. Children in the camps have grown up seeing and hearing shooting on an almost daily basis for their entire lives. They have seen friends and family members arrested or shot; consequently, all this is reflected in the games they play. But it must be remembered that these are children's games, and in the same way that my sporting youth did not turn me into a football star, a childhood playing Jaysh and Arabs does not turn any child into a violent adult. I have often noticed, as in the case of Miras and Maysan, that the older or more confident children will play the role of the IOF arresting the younger children, who play the Palestinians; the children know who is the stronger. Jaysh and Arabs is realistic only in the fact that the Jaysh invariably win by arresting or shooting the Palestinians.

The children had always played this game, but they did not realize that the game would become only too real on this particular day.

"Then I heard shooting. The glass of the window shattered. The other kids escaped and started to shout. Maysan, who was standing just next to me and helping in pushing the door, started to shout, too. The door was opened and my legs led me in. I do not know how . . . a lot of dust was inside the room. I walked a few steps to the sitting room when Athal said, 'Miras, a lot of blood is on your shirt!' All that happened in one moment or less!"

Miras did not instantly realize that he had been shot; the shock and adrenaline pumping through his body delayed his reactions for a few seconds.

"I put my hand on my abdomen and said, 'I am injured.' Athal started to cry out, 'Miras was shot . . . Miras is injured!' I wanted to go downstairs, but at the

same time my mother was coming upstairs. She was asking, 'What happened . . . what happened?' She and my aunt Nisreen helped me walk; they were looking for a car. I was lucky since in front of our house was a taxi that had just brought somebody to the camp. My mother put a towel on the injury and pressed it to stop the bleeding. She told the driver, 'Do not go to the governmental hospital; there is a strike. Go direct to Al-Yamamah.'

The government hospitals were striking. It had been months since the staff members had received their full salaries, owing to the international blockade put on Palestine after the world's elite did not agree with the democratic choice of the Palestinian people during the 2006 elections. The blockade also seriously affected medical supplies and, subsequently, available health care nationwide. When a medical emergency occurs, many factors must be taken in consideration, such as which hospitals are open, which hospitals have supplies, and which hospitals can be reached even if they are open.

Miras was in shock, and the first thing he remembers talking to his mum about was school. "At the beginning, I asked my mother whether I would be able to do my exams. She replied quickly, 'Yes, yes, you will do them!' Then I started to feel pain in the car. I felt something in my back. I told my mother there was something in my back, too. My aunt moved me a little bit and put her hand on my back to check. She pressed my clothes and said, 'There is some blood, too, just a little. Keep awake. Do not be afraid; you will be OK. Just try to talk with me and forget the injury.' I told her it was hurting me. . . . In the emergency unit at the hospital, the pain became unbearable. My dad came into the unit to see me. He put his hand on my head and said, 'You will be OK.' I heard the doctor telling him that the bullet entered from my back and went out through my abdomen. Another doctor came and checked me quickly and said, 'Prepare the operation unit now.' I asked my aunt Sana, who is a nurse, too, if I was going to die. She said, 'No, no!' and started to cry. My father heard me and said, 'Believe me, you will be OK. Dr. Sufian, who is going to do the surgery for you, is the best in the area. . . . Just bear some pain for a while. I am sure you are strong enough and will come through this . . . one day you will tell others about this, believe me.'"

When Nidal heard Miras ask if he was going to die, a million thoughts flashed through his mind. "His question killed me! At that moment, I saw visions

of the faces of fathers whom I have seen participating in the funerals of their martyred sons. Then I started to speak to him, or maybe I was speaking to myself, assuring him that it would not happen. I did not cry, but my mind was very occupied by questions and pictures I hate."

Nidal did not know if his son would survive or not; there can be few things more painful in the world for a parent. He knew he must remain strong for everyone, but his head was swarming with thoughts. He also knew there was little else he could do. Nidal was putting the survival and life of his son into the hands of the doctor. Miras was also thinking about others, trying to be strong himself to reassure his dad and his family that he would survive.

"The minutes before taking me to the operation unit were hours! At the beginning, I tried to show my dad that I was strong, but then I started to shout from pain. He went out. The operation, as I was told later, took two and a half hours. The doctor told me that he had to remove about one meter of my small intestine and ten centimeters of my colon. I heard him telling my mother, too, that I was very lucky, since the bullet did not go straight inside my body; it made a curve. It was less than one centimeter from the main vessel that goes through my abdomen and about three centimeters from my liver."

Miras was more than lucky. Had the bullet not curved, or had it been a few millimeters either way, he would not be telling his story now.

The doctor told Miras that he must not eat fried food, hummus, or falafel for the next three months, as they are not easy to digest. The Al Azzeh family eats hummus or falafel regularly—they are staple foods in Palestine—but Miras had far greater concerns.

"I did not care too much because for four days, I was stopped from eating and drinking anything. Then I was allowed to take small amounts of soup and boiled vegetables. All I wanted in those days was just to remove the tube that they had put into my nose and the one that came from my stomach and ended in a bag full of yellow liquid and blood."

The children had been playing in the room for about three hours when the shooting started around noon. It was a clear day with good visibility. The IOF soldiers were not inside Aida Camp; they had shot Miras from one of the watchtowers in the Wall. Those towers look straight into the front rooms, kitchens, bathrooms, and bedrooms of many of Aida's residents. Since they were

built, many times I have sat in friends' apartments, discussing the fact that we were now being watched while drinking our coffee and the fear that the IOF's precision weapons could target even one of the tiny Arabic coffee cups cradled in our hands. The watchtower from which Miras was shot is one of the newer ones built alongside the Rachel's Tomb complex, and it is probably around a hundred meters in direct line of sight from the upstairs balcony on which Miras was shot. There was nothing happening at the time in the camp, no demonstrations or any unusual activity at all. Everything had been totally quiet until the IOF opened fire on these children playing on the balcony of their own house. The other children were also treated in the hospital for wounds from flying glass and shrapnel, but they were not kept overnight.

In the modern world, we are made aware only too often of the fragility of the thin line between life and death. Palestine's children balance precariously on this precipice, and twelve-year-old Miras came literally within millimeters of being pushed over the edge. Many other children have not been so lucky. They are not safe anywhere, not even inside their own houses. Miras is far from the only child who has been shot in Aida Camp. Other children have been killed by the IOF here, and many have been injured. The walls of houses are scarred with bullet holes, and the young bodies of children bear similar evidence of evil.

I have known Miras since I first came to Aida Camp in 2005. I initially came to the camp to run a photography project, and Miras was one of the young artists I worked with. In fact, Miras was the youngest artist I have worked with, and his images are quite different from many others that were taken during the project. While other children photographed the Wall and effects of the occupation, Miras chose to look for beauty. He photographed light and abstract shadows. One of his strongest images is an abstract shot of railings' shadows on a house wall in the camp. I have shown this image to people around the world at exhibitions. The irony of this image cannot be escaped now. When Miras took this photograph in 2005, he photographed something quite beautiful, a shadow falling from the railings of a balcony. In 2006 Miras's own blood fell from the railings of another balcony in Aida Camp.

[The Pain of the Prisoners]

I have heard one answer given many times by Palestinians when they are asked why they, their sons, their daughters, or other family members were in Israeli prisons: "Because of the occupation." This is sometimes said very matter-of-factly, other times with a mischievous smile, knowing that the person asking the question was seeking more information. But the simplicity of this answer should not disguise its significance. There are nearly eleven thousand Palestinian men, women, and children locked up in the occupation prison system. They are political prisoners; they would not be there without the occupation itself.

The number of prisoners continues to rise daily, but over the last month or so, Aida Camp has also welcomed back three or four prisoners. While talking to Sa'id, an eighteen-year-old who had just been released a few weeks earlier, about his time in prison, I found out that he also had a twin brother who was in another prison. Abu Sa'id, Sa'id's father, explained the sadness at seeing his children taken away and locked up.

"I have another son, Sa'id's twin brother, Hamza, who is also in prison. He was sentenced to thirty months. . . . It is very difficult to be without your sons."

The family celebrated Sa'id's return from prison, but they knew the real party would be when Hamza was also released and the twins could be back together again. Hamza's release was scheduled for April 17, Palestinian Prisoners' Day.

Hamza had served two and a half years in prison, and both he and Sa'id had turned eighteen during their captivity. For the last six months of Hamza's

sentence, he was in Al Damoun Prison near Haifa. In the nights leading up to his release, Hamza hadn't been able to get much sleep.

"I was thinking about seeing my family again, but I was also sad to leave friends behind. I hadn't been able to sleep because of thinking about everything."

The night before Hamza's release, none of the eight young men locked up together in the small cell in Al Damoun got any sleep. They sat together all night talking until about 5 a.m., then they decided it was time to start the party. The men put music on in the cell and danced and laughed together while they still had the chance. People form incredibly strong bonds in prison, and it is hard to see friends left behind. At 7:30 a.m., the guards came to Hamza's cell.

"I hugged all my friends. At that stage I didn't want to leave . . . I didn't want to leave them behind. I was sad to leave people. We were crying, *manaha*."

Manaha refers to a very deep, emotional form of collective crying between very close friends or family members. After kissing his friends good-bye one last time, Hamza was taken from his cell and held until around 10:30 a.m. in a small waiting room. He signed his release papers during this time.

Around the same time in Aida Camp, the children were already out in the streets, preparing for Hamza's homecoming. Hamza is a member of the PFLP, and its trademark red flags were flying in the streets near his house. A huge, red banner had been placed over the front of the house; Palestinian flags and flags of all political factions flew higher up. Posters of Ahmad Sa'adat, the imprisoned leader of the PFLP, adorned the outside walls of houses and the nearby school, and a hand-painted Che Guevara flag hung from a high wire crossing the narrow street. The children were bringing chairs outside to line up along the front of the house. Many carried their own flags, and all their eyes gleamed with a rare glimpse of excitement.

As Hamza was put into a van and finally taken away from prison, he was still full of mixed emotions at having to leave so many people behind. He soon arrived at Al-Jalama checkpoint near Jenin. It was while waiting there with four other released prisoners that Hamza's release really began to sink in.

"When I saw the sky, I felt that I was free!"

Before he had left prison, one of Hamza's friends had joked, "You will be able to see God without looking through a fence!"

It was not being stuck at another checkpoint, which side of the checkpoint

he was on, what papers he was carrying, or the monitoring guards that controlled Hamza's thoughts, however; it was just being able to see the blue sky again.

Around 4 p.m., Hamza finally passed the checkpoint and immediately found friends from Nablus waiting for him. He was first taken to one of Nablus's refugee camps, where more friends waited to greet him, before heading on to Nablus's major southern checkpoint, Huwara. Hamza had to wait about half an hour to pass through Huwara, after which he found that many of the taxi drivers had been collecting money to pay his onward fare to Qalandia checkpoint near Ramallah. At Qalandia, a private taxi was waiting to bring him back to Aida Camp, a journey of around one to one and a half hours depending on the checkpoints.

By 6 p.m. the atmosphere was building in the streets of Aida Camp. The sound system was set up, flags were flying everywhere, and young boys were running around excitedly. People got into, and on top of, an assortment of vehicles as young boys complained because their big brothers wouldn't let them get into their cars. There were only about ten vehicles at first, and far more people than could possibly fit in them, but soon more cars began to turn up. Children began to attempt ever more ingenious ways to sneak into cars. When one taxi could finally accommodate no more passengers, a succession of men pulled each other onto its roof, where the rack provided further makeshift seating. The cars were all driving down to Beit Sahour, only ten minutes or so from Bethlehem, to wait for Hamza's taxi from Qalandia. By the time they reached Beit Sahour, many other cars had joined the procession with blaring horns and flying flags. As they pulled up, doors flew open and the occupants emptied. Then people jumped down off the roof, and the car boot would open and little children would pop out, flags in hand. Fireworks were being released into a night sky alive with the sound of beating drums.

After Hamza's taxi passed through Bethlehem's northern checkpoint and drove toward Beit Sahour, it met his father's taxi, which had driven down to collect him and take him back to Aida Camp. When his taxi finally entered Beit Sahour with flashing lights and screaming horns, the hundreds of gathered men, shebab, and young boys mobbed the taxi, and fireworks exploded. Red flags and *kufiyas* (head scarves) flew from all cars, and jubilant passengers again perched precariously on their roofs. Hamza sat on the roof of his chariot, surrounded by family again, smiling and waving at his welcoming committee.

"I didn't believe I was free. I didn't believe what had happened. In a long time I hadn't seen anybody close to me. To see everybody [in Beit Sahour] made me feel that a lot of people cared and asked about me. I was happy to see everybody."

The convoy of vehicles then toured the Bethlehem area. Many came out of shops or houses to wave or watch; motorists sounded their horns and flashed their lights. The convoy eventually reached Aida Camp, where it was received by the hundreds of other people who had not been able to get down to Beit Sahour. More fireworks were set off, and then Um Sa'id, Hamza's mother, took the microphone and began to sing a series of short verses about her son's homecoming. While the narrative flow of these short verses is lost in translation, her convictions were still clear.

"Your return for me is like the moon in the sky." Through this simple sentiment, Um Sa'id extolled her joy at seeing her son again, but she continued to explain that her joy was tinged with heartache. "If *all* relatives came back, it would be more beautiful than the moon in the sky." Even among the celebrations, no one can ever forget those who are left behind.

When Hamza was lifted above the crowd on a chair, he was carrying a red PFLP flag, but he shouted down to friends below to pass him more flags. He wanted three more: a green flag, a yellow flag, and a black flag. As he resumed his position in front of and above all the gathered people, he was holding a flag representing each of the political factions. His sentiments were clear: "We are all Palestinian, and we are all together." Others also waved assorted political flags, and music of each movement was played. The dancing and singing went on until late in the night.

"I didn't think about anything that night. When I lay down it was like I had died."

For once, Hamza went straight to sleep, undisturbed, and in his own bed.

Hamza is remembered as a very good football player. People say he was maybe the best in the camp when he was arrested. He grew up playing football with his friends on the piece of land that is around fifty meters from his house, the land that has disappeared behind the Wall since Hamza has been in prison.

"I had seen the Wall on TV while I was in prison." As he talks about the Wall, Hamza pauses, struggling to find the words to clearly articulate his feelings, before finishing off succinctly, "We *all* live in a prison now."

Hamza's family house is full of relatives, friends, and assorted well-wishers. The door constantly opens as more guests arrive to welcome Hamza back. Each comes in, shakes the hands of all men in the room in turn, and then, as a sign of respect, kisses Hamza on each cheek with the words "Al hamdullila assalamah" (Thank Allah for your safe return). Each is offered coffee, tea, and an assortment of sweet cakes and chocolates. Some guests bring gifts of sweets. Visitors stay for five or ten minutes to talk with Hamza and his family and to give thanks for his safe return, and then they leave as more guests arrive. This process often goes on for days. Many people will also inquire about news of other prisoners from the camp who have not yet been released.

To see how much joy is brought to so many people when just one prisoner is released serves as a stark reminder of how much pain is caused by the issue of political prisoners across Palestine. Everybody has been affected in some way. Everybody has a story; many people have enough for several books.

It is good to see Hamza back with Sa'id and to see Abu Sa'id proudly sitting between both of his sons once more. And it is also good to know that ten-year-old Munder won't have to wait until his next prison visit to sing his favorite pop songs to his big brothers anymore.

On the same day Hamza was released from prison, another child was arrested by the IOF in Aida Camp. On the same day Abu Sa'id welcomed his son back, another father was grieving less than a hundred meters away after having watched his child being dragged away into the night. Another family scarred, as it seems virtually every family is, by the pain of the prisoners.

[A Park, Not A Prison Cell]

Mahmoud is fourteen years old. He was in seventh grade at school. He is a child, or at least he was until three and a half months ago.

One day Mahmoud was playing in Aida Camp. His father is a manual worker, and he keeps a large stockpile of wood in an area near the Apartheid Wall. Children sometimes go there to play with the wood and sand; Mahmoud also kept his dog there. He lived for his dog and his collection of doves that he keeps in a loft on the roof of his family home. On this particular day, IOF jeeps and soldiers had been in the camp. Some shebab had attempted to repel the invasion with stones, but this didn't interest Mahmoud; he was too busy playing with his dog. Then, Mahmoud's fun was shattered, and his childhood changed forever.

An IOF jeep spun around the corner and was driving toward him and his dog, the brakes screaming as it stopped sharply. Before Mahmoud knew what was happening, he was being dragged into the back of the jeep as blows began to rain down on him. These were not just slaps; he was being beaten with sticks. The jeep drove to the Israeli military base that looms over Aida Camp. He was dragged out and thrown into a cell after his hands and legs had been bound with cuffs.

Mahmoud was alone when it happened. No one saw him being taken, so people around the camp were busy searching for him when he didn't return home later that night. It wasn't until after midnight that the family finally got word through the Israeli District Coordination Office that he had been arrested.

For the next two days, Mahmoud spoke to no one and had no idea what had happened or why he was there. He didn't even see the soldiers apart from when they came into his cell after they'd finished eating to offer him a plate of leftovers—half-chewed food and bones. He refused the food and was given nothing but water during the time he was kept there. Two days later, soldiers entered Mahmoud's cell and blindfolded him; he still had his hands and ankles bound. He was thrown into another jeep. The young boy had no idea where he was going and was understandably terrified. He was taken to what he later found out was Acion Detention Center, where he was immediately interrogated.

"Why did you go to an Israeli military area?"

"I didn't! I was inside the camp on 'our side' of the Wall, playing with my dog!"

The questions were repeated continuously for about an hour before Mahmoud was taken to a cell. He was not interrogated again in Acion, where he spent nine days in a large cell full of children. Mahmoud says that the youngest prisoner in the cell was ten years old. He was then transferred to Ofer Military Detention Center, again blindfolded and bound with restraints for the journey.

In Ofer, Mahmoud and the other prisoners were not given adequate food. The children decided they must protest their treatment and went on a collective hunger strike. After two days, the soldiers came to the cell and threw in "knock-out" grenades that released a form of gas that rendered many of the children unconscious. They then entered the cell and anybody who was still conscious, such as Mahmoud, was hit with a large stick that released an electric current. The current from this stick also causes its recipients to lose consciousness.

"We were then all put in the *zinzana* [a metal box used as a punishment cell]. The zinzana measures about one meter by two meters, and many of us were put in each one."

The children were brought food in small iron boxes. They were terrified and very desperate. They began to use the iron lids on the boxes to cut themselves as a protest because, as Mahmoud explained, "we were children, and we just wanted someone to care." The scars on Mahmoud's arms bear evidence to this protest of self-mutilation.

They were taken out of the zinzana after two days of this inhumane suffering. Soon Mahmoud was transferred to Telmond Prison inside Israel.

The cells in Telmond varied in size and held between five and thirty children each. Each cell had a bed, a television, a toilet, and hot water to make drinks with. There was a tiny window, but immediately on the other side of it was a wide iron bar. Small shafts of light would creep around the sides of the bar, allowing some light into the cell while still ensuring that none of the children could see outside. It is an adult prison, although the children were kept in separate cells. They were given just one meal a day; they were also given one exercise period.

"We were taken out into a large cage once a day for exercise, but sometimes the soldiers would cover the open roof of the cage so we couldn't see the sun."

The Palestinian political factions send money into the prison once a month, and it goes straight to a small canteen. The children affiliate themselves with one of the factions and are allowed to visit the canteen monthly to choose some extra food or sometimes cigarettes paid for with the money that their associated groups sent. Mahmoud was not political before he went to prison, but he decided to affiliate himself with Hamas. The reason for this decision was quite simple.

"They [Hamas] sent 250 shekels [around $60] a month to the canteen for me to spend on sweets and chocolate! We would split the sweets among a group of friends and ration them so we had something nice every day. I didn't smoke, but we sometimes got chocolate cigarettes."

Mahmoud was taken to court three times during his time at Telmond. At his first court appearance, he was told he was being charged with throwing stones at soldiers and carrying a knife. The prosecutors produced a vegetable knife as evidence, but Mahmoud had never seen it before in his life. He was ordered to pay a 20,000 NIS (around $5,000 at the time) fine or remain in prison.

"From where would I get this money? I was angry and crying. My family was in the court, and I told my father not to pay anything as I had done nothing."

This process was repeated each time he was taken to court until he was finally sentenced to a total of three months and ten days on the third occasion.

Mahmoud's parents regularly applied to the Israeli authorities for permission to visit their son in prison. The prisons are inside Israel and therefore cannot even be reached by Palestinians from the West Bank or Gaza without first acquiring Israeli permission. They were turned down on every occasion. There was no access to telephones. The only time Mahmoud had any contact with his family was when his younger brother, Khadr, came to visit one day. Khadr is only ten

years old and too young to acquire a Palestinian ID card; consequently, he is able to enter Israel without permission, although permission to enter the prison itself is still required. The night before the trip, Khadr couldn't sleep. His mind was filled with thoughts of seeing Mahmoud again.

"I just wanted to see my brother again, to touch him, to hug him, and to kiss him."

During the journey to Telmond Prison, the bus Khadr was traveling on was attacked near Efrat Settlement by settlers throwing rocks and stones. Nobody was seriously hurt, but it was a frightening episode for one so young and only added to the tension of the day.

When the brothers finally got to see each other, Khadr realized his dreams of hugging his brother again would not come true. The two brothers were forced to communicate via the telephone through a thick glass window. Mahmoud asked about the family and how everybody was at home. Khadr explained that things were difficult. "Everybody misses you terribly. Mum cries a lot."

Mahmoud tried to be strong and positive. "Tell her to be strong, I will be home in forty days now. Don't worry!"

Khadr had taken his parent's phone number so Mahmoud could contact them as soon as he was released. Khadr also had some advice for his big brother:

"Don't become politically active inside prison; *they* are always watching. You must just study and do arts."

When it was time for Khadr to leave, the two young brothers raised their hands on either side of the reinforced glass window and put them together as if touching each other. Khadr wouldn't leave, and the soldiers had to physically drag him away.

"I was very angry and upset because I couldn't touch my brother after all this time, but I was also happy because I'd seen him."

When Mahmoud was eventually released, he was taken to Jebara checkpoint near Tulkarem in an IOF jeep. He found a taxi and asked the driver to take him back to Aida Camp. When he finally reached the camp, the driver asked for 450 NIS (more than $100). It was a lot of money, especially for a fourteen-year-old, newly released prisoner, but his family collected the money from friends and relatives and paid the fare. They were just glad to have their son back. There was a big party with fireworks when Mahmoud got home, and for once the

explosions in Aida Camp were those of celebration and not the sound of the IOF bombarding the camp with gunfire.

Mahmoud doesn't go out much now. Sadly, his dog died while he was in prison, so he spends most of his time in the loft with his birds. He doesn't want to go out anymore; he doesn't want to be taken again.

If you ask Mahmoud what he wants and needs in his life, it is clear that despite everything, deep down inside he is still a child.

"We need a place to play in the camp, a park or a garden. We children enjoy these places, not the inside of prison cells."

[They Cannot Stop Our Dreams]

This is a story about two people who were raised in houses less than three hundred meters apart, but they were not raised in their homes as they were born in exile. They both lived in the vicinity of Aida Camp and have known each other for their entire lives, growing closer with the passing of time. Neither of these two young people have moved from their houses, yet as time has brought them much closer together, circumstances have also separated them.

Mahadi and Susu are cousins and refugees from the village of Al Malha, which is located no more than five or six kilometers from Aida Camp. Mahadi lived inside the camp itself, sandwiched between other houses with nothing green in sight, while Susu lived in a house that stands alone among olive groves and fruit trees and was built long before any of the houses in Aida Camp. Mahadi is now twenty-six years old, and just as everybody else of his generation from the area, he had spent much of his youth in the large expanse of Bethlehem land adjacent to Aida Camp and around Susu's house. This land once offered space and fresh air that was startlingly evident only in its absence among the cramped streets and alleyways just meters away. But over the last few years, this fresh air has become hollow, and the spaciousness has turned to emptiness as the Apartheid Wall took route around Aida Camp, isolating Susu's house and a large swath of Bethlehem into the "Israeli side" of this grotesque creation.

In the early stages of construction around Aida Camp, the Wall was just a fence. Often Susu and her sisters would speak to the IOF soldiers guarding the work site, and they would sometimes let them pass on their way into Aida

Camp. A refusal meant a detour to a section not yet complete, but usually they were still able to get to their school, their friends, and their other family members inside the camp. Susu studied at the UNRWA Basic Girls' School in Aida Camp, but it educates children up to only ninth grade. After 2005 Susu studied in a government school in Bethlehem while her younger sisters continued to study in the camp. By that time, any chance of passing by the Wall and going straight into the camp had vanished, as the structure was eight to nine meters of reinforced concrete with no gate.

The darkening completion of the Wall was not the only vivid development for Mahadi and his younger cousin. Susu's journey to school now involved a much longer walk than the hundred and fifty meters or so that stood between her house and the gates of the Basic Girls' School. Every morning, she was forced to follow the Wall's route up the hill to the large gate at what had effectively become the new entrance to Bethlehem, despite the fact that Bethlehem actually stood on either side of the gate. Mahadi still saw her most days after she had walked back down on his side of the Wall to bring her sisters to school. He began to notice her more and soon realized he was falling in love. Following tradition in Palestine, it is not unusual for cousins to marry, so Mahadi spoke to Susu's grandfather, with whom she lived, and asked for his blessing.

"He was very happy because he said I was a good man and he knew me well. He told me that I could see her when they came into the camp because his son—Susu's uncle—lives in the camp. He knew that I couldn't go there, to their house, anymore."

Both Mahadi's and Susu's houses are inside the West Bank; consequently, both have West Bank IDs, but once the Wall was completed, things changed. Mahadi was unable to walk from the camp straight to his fiancée's house, and when he tried to walk through the gate at the checkpoint, he was stopped by the IOF and told he couldn't pass because he didn't have permission to enter Israel. Israel was now claiming that this part of Bethlehem was part of Jerusalem and part of Israel, so separate permission was needed, and it could be obtained only from the occupation authorities themselves. As easily as that, Israel had grown almost overnight as it stole the land and claimed it as its own, much as it has been doing since 1948 when the two young lovers' parents were chased from Al Malha.

Soon after Susu's grandfather had granted them permission to marry, he came to Aida Camp and sat with Mahadi's family to read "Al Fatiha." "Al Fatiha" is the first verse in the Qur'an and is traditionally read to seal or make sacred an engagement.

"After Al Fatiha, I saw her for ten minutes, and we talked together. We were both so happy. Then she went home, and I didn't see her again for three months. . . . This was in 2005, and they had put the big gate in the Wall near the checkpoint and wouldn't give her permission."

Susu's West Bank ID meant she didn't need permission to be in Aida Camp, but in a stark and vivid demonstration of the Zionist land grab policy, the Israeli authorities were now claiming that the land on the other side of the Wall where Susu's house stood was no longer part of the West Bank or Bethlehem, despite every internationally recognized resolution saying otherwise. According to this unilateral reclassification of land, Susu now needed permission, meaning permission to be inside "Israel," to be inside her own house. When she applied for permission, it was refused. So even with her West Bank ID, she couldn't get into the West Bank since Israel had moved it, and the Israeli authorities were claiming she was now living in Israel but wouldn't give her permission to be there. She was truly stuck in no-man's-land. This situation sounds ridiculous, but it was Susu's reality for a full three months, during which time she was unable to leave her house. Had she tried to pass the checkpoint and enter the West Bank, she could have been arrested for being in Israel without permission, or she could have been thrown into the prison that the West Bank had now become and banned from returning to her own house. Had she been caught in Al Quds itself, she could also have been arrested. While this sounds incredibly complicated, it was devastatingly simple for Susu, who was now unable to reach her fiancé and was a prisoner within her own house, terrified that she would be arrested for being there if the IOF raided it.

Mahadi was distraught and tried every way he could think of to reach her.

"I tried to pass the checkpoint many times, but they always refused me. I tried to get Al Quds permission, but the only way was if I could get a hospital appointment in the city. I only wanted the permission so I could get to her. I didn't want to go to Al Quds. I went to see a doctor in Bethlehem and managed to get a referral to Al Makassad Hospital [in Al Quds], so I took that to Acion

[the Occupation Authority's Administration in Gush Etzion Settlement that is responsible for issuing permissions]. They told me to come back in three days, which I did and was then told to see the security, who said I didn't need the referral to Al Makassad as I could get the treatment in Bethlehem."

He spoke to Susu on the phone every day and had tried every official route possible to reach her. He began to look for other ways.

"I had heard that some workers had been getting through a drainage tunnel near the camp and passing underneath the Wall. I found the tunnel, and the gate was open, so I entered it quickly. It was about fifteen meters long, but as I got to the other end, I found it was blocked. I was so sad and depressed. I kept asking myself why it was not open and wondering what else I could do. Then one night, workers told me it was open again and that they had got through. I ran there as quickly as possible, but I found this end was now blocked. I thought to myself, 'Not even a mouse could get through here!'"

A laugh echoes out of Mahadi as he tells me this before he stops himself and rephrases his metaphor, "No, not a mouse, not even a fly could have got through there!" He laughs again. The desperation of Mahadi's attempts is clear, and for many people it would not be the source of humor, but for Mahadi it's probably better than the alternative, and anyway he likes to laugh. I know that from our conversations in the streets around the camp or here in Lajee Center, where we sit together now as he describes his struggle for love.

During the three months that Susu did not have permission, Mahadi would often go up to the rooftop of a friend's house in Aida Camp near the Wall. From there he could see Susu's house, and she would stand outside of her house next to the front door so they could see each other as they talked on the telephone. Her house, surrounded by olive trees and fresh air, looked like paradise compared to the camp, but it had become even more of a prison for Susu than Aida Camp was for him. Mahadi says he couldn't see the land though.

"I couldn't see the trees or the land; I was blind to it all, all I could see was her. . . . We would wave to each other; it made me so sad and angry. I wanted to find ways to pass the one hundred and fifty meters that separated us. I thought about climbing the Wall somehow, about making a ladder, but the Wall is covered with cameras and watchtowers, and it would have cost me my life! She would tell me that she dreamed about me visiting her house so we could be together, she could

cook for me, and I could take her gifts. It made her so sad that we couldn't be like normal engaged couples. I just wanted to drink tea that was made by her hands."

Eventually, Susu was given permission and was able to leave her home and visit Mahadi in Aida Camp again, but they continued to face problems. She could walk from her house directly to the checkpoint, which didn't take too long, but when she left the camp, the IOF would not let her walk the same route back, claiming it was a military area. She was forced to take a huge detour that sometimes took up to three hours. Susu was understandably frightened to walk alone when there were so many soldiers around and often didn't want to take the risk. Instead, they would both walk from their respective sides of the Wall up to the gate and stand on either side of a metal fence, with two and a half meters separating them, so they could at least see each other and talk.

"We often talked about the Wall and how it made us feel bad. I couldn't even touch her hand, but we talked about other people, too, and how some people couldn't even get this close to each other. I hate this Wall and what it does to people!"

On occasion, Mahadi would wait for Susu at the gate for hours if the IOF chose to keep her away or blocked her path for some reason. He particularly remembers two occasions during the autumn when he had gone dressed in just a shirt, only to see the heavens open and heavy rain begin to fall. As the rain soaked through to his skin, Mahadi kept thinking he would stay just five more minutes, then five more minutes, and five more minutes. He later found out that the IOF had refused to allow Susu to approach the gate.

Susu completed her tawjihi this summer and is now nineteen years old. She comes into Aida Camp once a week but leaves early because it is dangerous in the dark. When the IOF imposes closure on the West Bank, all permissions become invalid. If Susu is in Aida Camp when this happens, she must stay here until the closure finishes. If she is at home, she must still stay indoors because she could be arrested for being inside Israel without permission. She is currently receiving permission papers that are renewable every three months. When they expire, her grandfather goes to Acion to renew them.

Another restriction on Palestinians is that they are not allowed to take local grocery products out of the West Bank through the checkpoint. Susu has tried to do this several times, and the IOF tells her she must buy her food inside Israel,

which means paying Israeli taxes and much higher prices as well as having to pay for transport to get to the markets in Al Quds and back.

Earlier this year, I went to Mahadi and Susu's engagement party in Bethlehem. Mahadi is currently working as a lorry driver to save money for their marriage, which is planned for May 2008. He is also preparing their future apartment; he wants everything to be perfect when the couple finally does get married. She will then leave the olive trees and fruits of her land and come to live in Aida Camp, but according to Mahadi, his fiancée is not worrying about what she is leaving behind.

"She spent all her life there before the Wall. Now she has space there but no people. Paradise without people is not paradise."

The struggles that Mahadi and Susu have been put through for their relationship are abhorrent, but as Mahadi himself said, "Others cannot even get this close." Families and relationships all over Palestine have been torn apart by the Apartheid Wall, travel restrictions, permission denials, family reunification denials, and myriad other forms of separation. It is part of an ongoing policy of sucking the life out of people and of making it so desperate, miserable, and intolerable that they are forced to leave. It follows the patterns of ethnic cleansing that began more than sixty years ago as Zionist militias began "cleansing" Palestinian villages even before the "state of Israel" was officially declared in 1948. The inhumane actions and restrictions of the occupation control many aspects of Palestinian life, but some things are unstoppable. The undeniable human spirit of Palestine's people is one such factor. The Wall may prevent movement and physically imprison and separate people, but some things can fly. Some elements of humanity simply cannot be shackled.

Ask Mahadi what he thinks about giving up, about if he ever thought it was just an impossible relationship, and you will see a glimpse of this irrepressible spirit.

"We have faced difficulties, but this makes our love stronger. It makes me love her more because the Wall will not stop our dreams. *They* cannot stop our dreams."

[Thirty Minutes]

Talking to Aisha, it is clear that two things stand head and shoulders above anything else in the ranks of importance in her life. One is her children. The other is her village, the village her family was forced from during Al Nakba. Her hazel eyes have a shimmering sparkle to them, and her face bears a gentle and reassuring smile, but when discussing either of these two issues, her eyes take on a new intensity and her smile broadens. For a few minutes last week, Aisha was able to relish both of these sentiments again. In telling her story, Aisha's energy and deep love for both radiate from those emotive eyes that have witnessed and shared in so much over the years.

Aisha's eldest son, Ameer, was another of Aida Camp's child prisoners. Now he is an adult prisoner because he turned eighteen in an occupation prison called Nakab. Ameer was arrested in March 2006 at a relative's house in Ramallah; he was seventeen at the time. Since his arrest, Aisha had seen her son only once, at his court date in September last year. On that occasion, she was not allowed to speak to or touch Ameer, but Aisha made a dash for him as he was led from court, pushing soldiers aside and embracing her son before being pulled away by his captors. Her husband, Abu Ameer, has not seen his son in more than twelve months now. The reason Aisha has not been able to get permission to visit Ameer from the Israeli authorities before this trip, and the reason why Abu Ameer has never visited his son, is another bizarre example of occupation lies. The authorities have claimed that neither Aisha nor Abu Ameer is related to their son in any way. According to Israel, Abu Ameer is not Ameer's father, and

Aisha is not his mother, or at least she wasn't, but apparently she is *now* so they have granted her permission. As ridiculous as this may sound, this is not the only example of such practices. Another man in Aida Camp has a son who is serving a long sentence; he and his wife have visited their son in prison for the last seventeen years without a problem. A month ago when they applied for permission, it was turned down. The reason given was, "You are not related to the prisoner."

When Aisha and her daughter Amira woke at 5 a.m. last Tuesday, their weariness at having a shortened night's sleep was offset by the excitement of their day ahead. They were going to see Ameer in prison.

The two women first needed to go to the Red Cross office in Bethlehem. Prison visits can only be arranged through the Red Cross, and relatives must travel to the prisons on buses provided by the organization, for which they are charged a shekel (about twenty-five cents).

"There were many people at the Red Cross office, well over a hundred men, women, and children of all ages. Everyone was excited, thinking about meeting their sons and brothers again. Everybody boarded the buses, and we set off about 6 a.m."

The bus had reached Tarkumia checkpoint near Al-Khalil by 6:30 a.m.; it was here that the prison's visitors would cross into Israel. Everybody was made to wait on the three Red Cross buses for one and a half hours as the IOF checked IDs and permission papers.

"They then took us off the buses and through the checkpoint to the Israeli side, where three more buses were waiting for us. We all got on [the buses], but Israeli army jeeps drove around all three buses and surrounded them; they wouldn't let us leave. They stayed there for another hour and a half before they finally let us leave."

It was 9:30 a.m. by this time, already four and a half hours after Aisha and Amira had awoken, but their spirits were still high with thoughts of seeing Ameer. The atmosphere on the bus was one of eager anticipation; everybody was talking about seeing their relatives again. Some women sang songs; food was being shared. The three buses made their way south toward the Egyptian border as the heavens opened and the rain began to pour from the skies. Nakab Prison is very close to Israel's southern border with Egypt, only around five or ten kilometers north of the border, according to Aisha.

"It was 12 [midday] by the time we reached Nakab. They took us off the buses and made us stand outside. The rain was pouring down, and there were some small shelters but not enough to keep all of us dry. The gifts we had brought with us for Ameer were taken from us to be checked by the soldiers. We had taken some underwear for him."

For such gifts to be taken to the prison at all, the prisoner himself must first request them in writing through the prison authorities and the Red Cross. The Red Cross will then pass the information on to the family members before their visit. The prison authorities refuse anything that has not been requested in writing in advance through this system. Amira explains how they also had to be careful what color underwear they took for Ameer.

"They don't let us take anything blue because the prison guards wear blue. What do they think, that he will escape disguised in just blue pants?"

Amira and her mother both laugh at this comment, but their tone changes as Aisha describes the search they were subjected to before entering the prison.

"The soldiers took us one at a time to be searched. They took me into a very small room, and I was made to take all my clothes off by a female soldier. I was totally naked. They checked all my clothes; even my shoes went through a machine [x-ray and explosives check]. It all made me so angry, so mad!"

Aisha shakes her head in disgust as she remembers the humiliating experience. Amira, sitting next to her mother, looks down at her feet as she talks. "It's just disgusting being made to undress like this, in front of soldiers . . . even after this they still run a machine over our bodies."

At 4 p.m. the two women were taken into a room with two chairs, one for each of them, placed in front of a table with a telephone and a thick plate of reinforced glass. Ameer was brought to the other side of the glass where he also had a telephone. This was how they would communicate. When I ask Aisha how Ameer looked after nearly a year and a half in prison, her big grin returns, and she slaps her face as she sighs, "Oh! He has become even more handsome."

The two women had just thirty minutes between them to share the phone and talk to Ameer.

"We asked how he is, if he is okay, if he needs anything else. Just stuff like this. He asked how everybody is in the camp. And he asked about you, Rich; he sent you salaam (peace)."

I remember Ameer fondly from his time before prison. I miss him and all the other friends I have seen disappear during my time in Palestine, but the bond between Aisha and Ameer is something much deeper, one of mother and son. Aisha explained her frustrations at being forced to see Ameer through thick, reinforced glass.

"I wanted to smash all that glass between us, but I couldn't. Soldiers were watching us all the time. I just wanted to touch his face again, to hold him, to hug him like a mother should."

It was hard for the women to leave when the time came. Their allotted thirty minutes had seemed to vanish in a matter of seconds, but they had at least seen him and spoken with him again. Amira felt the pain at having to leave her brother once more.

"I was so happy to see him again; I miss him so much. I didn't want to leave him. I wanted to bring him home."

Both Aisha and her daughter knew their visit was over, and it was time to board the bus for the long trip back to Aida Camp. The bus was abuzz with conversation for the journey back toward Bethlehem. Stories were being exchanged and the last of the days' sandwiches being finished off, but not everyone had been able to see their loved ones.

"Some people had been through all this, all this traveling, this humiliation, and still hadn't seen their sons. Another man from the camp, Mohammad, came with us to visit his son. He had been given permission by the Israelis, passed all checkpoints, and passed all checks in the prison. He stood in the queue, waiting to meet his son, when a soldier walked up to him and said, 'Mohammad, I know you! You were in prison twenty-three years ago! You cannot visit your son. Go, get out!' Mohammad was thrown out of the prison immediately!"

The bus journey back followed the same route, but while nearing Tarkumia checkpoint, the buses got held up in a traffic jam. Out of the bus windows, Aisha saw a sight that made her heart race. There was a small sign that read "Bet Guvrin." Despite the name change, both women knew where they where. Aisha didn't need road signs to remind her. She had not visited her home village of Beit Jibreen in almost twenty years, but she still recognized it as though it were yesterday.

"There was a new gas station there, an Israeli one. I hadn't seen this before.

But I saw our grass, our land, our trees. I wanted to jump out of the bus and lay there on our land among the cows. I didn't care; I just wanted to be there again. I wanted to smell the air of my village and taste its fruit once again. I wanted to stay there forever."

When the traffic cleared and the buses began to move again, Aisha was banging the windows and shouting for the bus to stop, but the IOF escort kept them moving. As she talks about Beit Jibreen, Aisha isn't looking directly at me but more through me, as though still picturing her beloved village.

Aisha and Amira arrived back in Aida Camp just after 9 p.m.; they had been gone nearly sixteen hours. They were both exhausted but also full of smiles. They had succeeded in seeing Ameer, even if only for thirty minutes, and they had gotten an unexpected fifteen-minute glimpse of Beit Jibreen. Aisha knows why the whole visiting procedure is made so difficult for them.

"They put us through all this traveling and humiliation to try to make us not want to go through it all again, to make us feel it is too much hassle. It makes me so angry that I have to go through all this just to see my son for thirty minutes, and I couldn't even hug him. We do all this to support the prisoners and cheer them up. We must be strong! They will never stop us from seeing our children . . ." Aisha stops for a minute as though she has finished. Then she looks up at me and smiles, "And our villages!"

[I Thought It Was Chocolate]

Ibraheem is eight years old and one of about twenty-five thousand people who live in Balata Refugee Camp, Nablus. He lives in a large house, but as with any other house in the camp, it extends vertically as there is no land or space in which to build in any other direction. The various floors of the building all house members of Ibraheem's extended family.

Ibraheem is no different from any other child in the camp; he attends the Boys' School and likes to play with his friends. On the roof of his house in Balata, there is a circular bathing pool that is about two meters in diameter. He loves splashing around in the water with his brothers. Just as any other child of that age, Ibraheem is inquisitive; this is how children learn. He also loves chocolate.

One day Ibraheem and his five-year-old brother decided to go exploring when his friends were called home for lunch. They walked up to the main road that backs onto his family's house. This road is Sharea Al-Quds (Al Quds Street) and leads from Huwara checkpoint, Nablus's infamous southern checkpoint, all the way into the city center. Scattered along Sharea Al-Quds are several large rubbish skips. Local children can often be found picking through them. Sometimes the children will find discarded (and often broken) toys and games that they will take home and attempt to patch up for themselves. On other occasions, they may find clothes. For Ibraheem, this was all part of the adventure of childhood. On this particular day, Ibraheem didn't find anything of particular interest among the assorted trash in the skips. Since things were often just dumped on the side of the road, Ibraheem walked along, looking around for

anything interesting. Something brightly colored caught his eye. He walked over to it and picked it up. It was approximately ten centimeters long and bright green with some other smaller patches of bright colours.

"I picked it up and smelled it. Then I tried to open it, but I couldn't. It was hard at the end, so I tried to burn it with a lighter to get it open. I still couldn't, so I tried to hit it with a stone. Then it just started to burn and make a funny noise. It didn't hurt that much at first. It was just very hot."

As Ibraheem's skin started to burn, panic began to set in. The two brothers ran home as quickly as possible, and he tried to hide what had happened. He was afraid that his family would scold him. "I was shocked and scared. I didn't want anyone to see because I thought I would get in trouble."

When Ibraheem got home, he ran straight upstairs to the roof instead of telling his mother and older brother what had happened. His hand was really burning by this time, and all he could think about was cooling it down. When he reached the roof, he went straight over to the bathing pool and plunged his hand deep into the water, trying to cool it down and stop the pain. At the same time, he heard his oldest brother, Abud, calling from downstairs that their lunch was ready.

Ibraheem replied, trying to hide what had happened, "We are on the roof playing. We'll be down in two minutes."

But Ibraheem's little brother was shocked at the events and at seeing his brother in so much pain. He ran downstairs to tell Abud what had happened: "My brother has found a bomb, and it has burnt his hand!"

His face was yellow with shock. Abud's heart sank when he heard the news. He set off running upstairs and found Ibraheem with his hand in the pool. "What's happened? Show me your hand. What have you done?"

Ibraheem did as he was told and showed Abud his hand, but he was still worried about getting in trouble and again attempted to conceal the truth from his brother. "I was just playing. I was playing with a lighter and it just exploded."

Abud is a trained medic working with the Palestinian Medical Relief Service. Having done this work for five years in a place like Nablus, he has seen more than anyone's fair share of hideous sights, ranging from decapitations and bullet wounds to bombing victims and chemical burns. He could see this was not a wound from an exploding cigarette lighter and told Ibraheem this. Their

youngest brother was still very much in shock and couldn't keep his knowledge secret. "It wasn't a lighter. He found something—maybe it was a bomb—and he was playing with it, and it just exploded!"

Abud immediately took his injured brother to the medical clinic in Balata Camp, which is not far from their house. By this time, Ibraheem's pain was constantly intensifying. "When I reached the clinic, it was really hurting, and I started to cry."

The medics at the clinic treated the young boy immediately. They dressed the wound and gave him antibiotic injections, a tetanus shot, and painkillers. The chemicals released from the device had caused second degree burns over the entire back of his hand. They stretched from his fingertips to his wrist.

After finishing the treatment and taking Ibraheem back to the safety of his mother, Abud went with a friend to Sharea Al-Quds to see if he could find the bomb.

"We found the exploded one, the one that had injured Ibraheem. We also found another five or six, which were unexploded. We called the police, who sent some men from the Bomb Disposals Unit. By this time, it was dark and they had to search by flashlight. They looked at the ones we had found; there was some small writing on them in Hebrew. One of the policemen could read Hebrew, and he told me it said 'Warning—Explosive Chemicals.' They told me that when these bombs are warmed, they go off. Body heat is enough to set them off, or if you try to open them, they will also become active."

The police went on to say that they had found more of these devices in the Old City of Nablus, and there were rumors that some had also been found on a school playground. Later on that night, rumors circulated that someone had seen these being dropped from an Apache helicopter.

Ibraheem will survive. He is, as are all of Balata Camp's residents, a survivor. Currently, he must go to the clinic every day for treatment and redressing of his wounds, but hopefully the bandages will be off within a few weeks, and his scars should heal with time. He has also learned a valuable lesson that could one day save his life: "If I find anything again, I will never pick it up! I am too scared now!"

The facts described by Ibraheem and his family suggest that these devices could be specifically aimed at targeting children: they are small, brightly colored,

and left in areas where children often go rummaging around. They are most certainly intended to indiscriminately target civilians, which in itself is a war crime. While the occupation never fails to disgust me in its inhumanity and sometimes I do feel that there is little that surprises me anymore, I have never come across these kinds of actions before in Palestine. Targeting civilians with toxic chemicals that will be absorbed and become active with body heat is something that can be described as nothing short of pure evil in my mind. What kind of people can carry out such actions? What kind of state can sanction them?

The effectiveness of this inhumane practice was clearly demonstrated when Ibraheem explained why he had decided to pick the device up and tried to open it: "I thought it was chocolate!"

[What Kind of Peace?]

Sena and Mahmoud grabbed their three children and rushed to the bathroom. Once inside, the young couple closed the door quickly and laid their beloved children in the bathtub. The children, aged four, two, and just one year old, screamed hysterically. Sena closed the toilet lid and sat on it; at least there she was not in direct line of the bathroom's fragile, wooden door. Mahmoud collected what little food was in the house and brought it into their hiding place. The family had little in the way of stocks because it was the holy month of Ramadan when fresh food shopping is usually done daily. Back in the bathroom, Mahmoud perched on the edge of the bath in front of their children and next to where his wife was sitting, making sure to not be in line with the door. They did not leave the bathroom for the next two days, except when the Medical Relief Services entered their house with some meager, but much appreciated, supplies of bread and tomatoes.

Al Ayn Refugee Camp in Nablus houses about seven thousand refugees. They live cramped together in small houses that are built along either side of the main road that bisects the camp into upper and lower sections. From the early hours of Tuesday morning until the early hours of Friday morning, the cramped living conditions of every family in Al Ayn were reduced to just one room. The particular room chosen depended on which room offered the greatest level of protection against the barrage of high-caliber bullets and heavy artillery that were raining into the houses from every conceivable angle and direction.

When the IOF invaded the camp on Tuesday morning, it met a determined, if small in number, resistance that was led by members of the PFLP. A handful of activists attempted to defend the camp and its people. In the ensuing clashes, the resistance was heavily outnumbered, and the IOF had a huge advantage in firepower. The first *shaheed* (martyr) was soon claimed. Eighteen-year-old Muhammad Khalid Rida was not the only death on Tuesday in Al Ayn; an IOF soldier was also killed as he and his compatriots invaded the camp. After the death of this soldier, the IOF called in huge numbers of reinforcements, and the siege of Al Ayn began.

By Wednesday, every explosion and house demolition reverberated right across Nablus, such was the intensity of the IOF's destruction. From my base in Balata Camp, about three kilometers away, I could hear and feel the explosions; Nablus was literally shaking. Wednesday also saw the second shaheed as Adib Damuni, who was confined to a wheelchair, died instantly after being shot in the head by a sniper while he sat inside his own house. I attempted to enter Al Ayn on Thursday, but the closure was skintight. There was no way past the blockades and bullets of the IOF. The camp was entirely surrounded from every side, and all entrances and exits were blockaded. The IOF manning these blockades were in no mood to talk and opened fire on anyone approaching. From vantage points around the camp, IOF foot patrols were visible carrying out house-to-house searches. Armor-plated lorries and bulldozers, personnel carriers, and jeeps filled every street, and foot patrols could be seen entering the narrow alleyways behind a barrage of their own gunfire. At one point, the jeeps and lorries manning an upper blockade pulled away and moved thirty or forty meters down into the camp to a large building. Along with two journalists, I was able to follow them cautiously as soldiers dragged two men from the house, blindfolded and handcuffed, and unceremoniously kicked them into the waiting lorry. We were soon seen and ran back for cover as the M-16s were turned in our direction. The shell casings that littered the ground and the two men who had already been killed evidenced the lethal munitions these guns were firing.

Around 10:30 a.m. on Thursday, an intense barrage of gunfire filled Sena and Mahmoud's house. Mahmoud tried to shout to the IOF soldiers who were carrying out this attack on a civilian family inside their own house, "We are here in the bathroom; we have no guns! Our children are in here!"

The bullets entered every room in the house, including the bathroom, where they passed through the flimsy wooden door like a hot knife through butter. "Our children are here; please stop shooting! There is no one else here!"

After a few minutes of this uninterrupted barrage, the IOF entered the house. Mahmoud again shouted to them to stop shooting, begging them not to kill his family.

"They ordered us out of the bathroom. My children were screaming. They told us to get out of the house and took us into the house next door. As we left the bathroom, they filled it with bullets."

Looking around the remains of the bathroom, it is quite clear how heavy the firepower was that bombarded this tiny room. All walls, the door, the floor, the ceiling, and the bath, toilet, and cabinet are all filled with huge holes. Every other room downstairs is exactly the same; there is not a window or wall left intact in the house.

"I knew they wouldn't find anything because there was nothing to find! I hoped they would leave when they realized this."

The soldiers did leave. The patrol left the house and went to the neighboring house where Mahmoud was trying to reassure his family that everything would be all right. "The commander told me to cover my ears . . . then they blew my house up!"

Explosive devices had been placed around the upper floor of Mahmoud and Sena's house. The detonation brought screams from everyone. They were given no reason for these actions and were not questioned or arrested, as would have been the case if the IOF had any suspicions toward them. This was simply a show of force, a hideous example of an occupying power demonstrating its might. The IOF is an occupying force that knows it is answerable to no one and is free to continue unabated with war crimes against a civilian population while the world is silent—discussing only forthcoming "peace conferences" and long-redundant road maps.

On Friday, after the IOF had pulled out of Al Ayn, UNRWA officials began visiting families in the camp and assessing the damage. When they visited Sena and Mahmoud, they told the young couple to leave their skeleton of a former house immediately as it was in imminent danger of total collapse. They are now staying with Sena's brother, whose house was not bombed, although it too is

littered with bullets holes, much as his sister's and virtually every other house in Al Ayn were.

The story of one of Sena's neighbors differed only in the room that was chosen for the family to hide in. Ahmed, his wife, and their ten children huddled together in an upstairs room without an outside window. Their house was similarly devastated. "My children were terrified, ten of them hiding for their lives. I felt like I was just waiting for *them* to come and kill us."

I ask Ahmed if he was also leaving his house.

"To where? I have nowhere else to go."

In the room adjacent to their hiding place, a small, wall-mounted corner unit displays framed photographs of his children smiling. On the bottom shelf stands a brown teddy bear with a red stomach. Its smile seems hopeful at first, but inches from its fluffy ears, dozens of deep holes in the white walls paint a different picture. Small, plastic Palestinian flags have been laid out around the room and hung from the windows. They are not only signs of resistance and sumoud (steadfastness) but also marks of respect for another neighbor who lived in a house that used to stand only a few meters away. In the place of this former house now are just huge mounds of rubble; all four floors were blown up. Looking closer, it was evident that this was not just rubble. Scattered among the concrete are specks of color hidden behind the layers of thick concrete dust. A child's yellow sandal, a copy of the Qur'an with a brown cover, a red and yellow children's book, and a gold-painted coffee pot are reminders that this rubble was not that of a building site but rather a destruction site. In the middle of the rubble stands a large, proud red flag flapping in the wind. Its color is symbolic, and it marks the spot where a PFLP activist was killed on Tuesday. As a Marxist movement, the PFLP always uses the color red, but the vivid hue also seems to symbolize the blood that was shed here.

A middle-aged man sifting through the debris turns to talk to me. He offers his hand and welcoming greetings, despite the fact that he has seen his house blown to pieces and his brother killed in the last few days. He notices me looking at the flag. "He was my brother . . . forty of us used to share this house, five families in total. Now look what we have left."

There is literally nothing left except memories. From a neighboring house, a washing line that was previously strung across the front of the demolished house

just hangs down limply. No doubt washing was done on Monday and hung out overnight to dry. Three small school uniforms hang from the line, washed and dried but never worn.

Farther down the same street, I find a woman sifting through rubble, trying to salvage more children's clothes. The walls to the bottom floor of her house have been blown away. Four beds and their mattresses lay among the rubble. She is picking up small dresses and clothes one by one, dusting off the debris, and checking what is still in one piece.

In the narrow alleyways, mounds of rubble covered the paths. People are climbing where they used to walk. I watch three children pushing an elderly man in a wheelchair down streets that are only just wide enough to accommodate the chair. I go over and offer to help as they pull him from his mobility aid and attempt to carry him every time the path is blocked with the remains of house walls. Children stand in the streets, comparing empty tear gas canisters, remains of explosive devices, and assorted bullets that they have collected. In another part of the camp, people tell me that their neighborhood had been totally cut off during the siege and not even the Medical Relief was allowed access, so they had been without fresh food or medical supplies for the sick or injured. Another man explains how the IOF has severed water pipes and that people who have water in their rooftop tanks are just waiting until that runs out or bullets penetrate the tanks before they have none at all. The whole camp is a literal wreck. I doubt there is a house that remains undamaged in some way. The funerals of the two martyrs are not held until Friday morning; this was the first day that people have been able to leave their houses to bury their dead.

Just outside the camp, an empty cardboard box lies discarded alongside the road. On the front is writing in English—"UN Practice Grenades. Property of the Government of Israel." Another small white label on the back of the box reads "Combined Systems Incorporated. New York."

What happened for three days in Al Ayn Camp was no practice session. This was planned and organized inhumane destruction of civilian property and lives. These actions were war crimes, and if the discarded box was a true indicator of used munitions, they were carried out at least in part with UN munitions and certainly with U.S.-funded and made weapons. The occupation's war crimes are making millions of dollars for the U.S. economy. Condoleezza Rice had been in

Palestine earlier in the week to discuss the November 2007 "peace conference." The peace conference, promoted by George W. Bush, the same George W. Bush who had agreed to the Memorandum of Understanding U.S. military aid package to Israel. This aid package offers levels of financial support for Israel's military to the tune of $30 billion over the next ten years. While Condoleezza Rice spoke of *peace* for the assembled media in Ramallah, around thirty kilometers away in Nablus, lives, houses, and families were getting blown apart by weapons funded and, at least in some cases, made by her own country.

What kind of *peace* is it she wants?

[Family]

Jameela looked radiant in orange and blue. She wore a beautiful denim dress with an orange shirt finished off with a huge bow at the front. Her brown leather shoes also carried a bow that stood out from the folded down lace of her tiny white socks. On one side of her head, a red and yellow bobble secured a bunch of brown hair firmly in place. Raghda had chosen leopard print trousers and a matching, long-sleeved shirt, over which she wore a black T-shirt emblazoned with the words "High Rock Girl." A small, matching, leopard print handbag hung on her shoulder. As always, her huge, sparkling, brown eyes and glistening smile illuminated any room in which she stood, as though she were a beacon of light. Jameela's smile was equally heartwarming as we all walked down the street hand in hand. It was clear from the throngs of smartly dressed people out in the streets that everyone had made a similar effort to don their finest wares. It was a special day; it was Eid al-Fiter, the festival that marks the end of the holy month of Ramadan.

Jameela was three years old. Raghda, at eight years old, was one of Jameela's four older sisters. As we walked in the sun through the narrow streets of Balata Camp together, slowly on account of Jameela's little strides, Raghda told me proudly that she had shekels in her bag today. Adults give children gifts of money for the festival, often either a half or one shekel, and Raghda was excited that she had her own little supply. She asked me where I wanted to go, but I didn't really care; I was just happy spending time with them. She wanted to show me the little park that was open with four swings and an ancient-looking, creaky Ferris wheel

that went little more than two and a half meters high at its uppermost point. The girls went on the swings together and posed for some photographs, smiling as always. Raghda wanted to go on the wheel; she wanted me to see her at the top. I tried to pay the shekel for the ride, but she refused immediately. As the wheel turned, two young faces beamed down at me and then disappeared again as it rotated before bouncing back as full of life and hope as ever. Raghda waved and clapped every time she saw me. Jameela grinned and gripped the rusty metal bar of their little carriage as though she were riding a Disneyland rollercoaster.

We left the tiny, fenced-in sandpit that was providing so much fun for the camp's children and walked down to the lower end of Balata Camp, which backs onto fields before running toward Nablus's hills. Jameela chattered away to anyone who was listening, and Raghda and I communicated as best we could with my broken Arabic. Children looked quizzically at us as we walked. Some knew Raghda and asked about her family. Others looked at me, and then at the girls, before nodding at me, "Ajnebi?" (Foreigner?)

Before I could answer, Raghda would always interject, "La, hoo falasteeny, hoo ahoy!" (No, he's Palestinian, he's my brother!)

As she said it, she would look up at me proudly, squeeze my hand, and smile. Every time we neared one of the many small grocery stores around the streets of Balata Camp, Raghda would stop and turn to face me, "Rich, Shu bidak? Shu bidak, Rich? Chocolata, cola?" (Rich, what do you want? What do you want, Rich? Chocolate, cola?)

I would politely refuse and offer to buy the girls a drink, but my little guide would not allow it. Each time I did this, she seemed disappointed and, frustrated, would put her little collection of shekels back in her miniature handbag. After this was repeated two or three times, my stupid stubbornness, or whatever it was telling me to refuse, crumbled. Raghda's face lit up as I accepted her offer of a cold drink, and she meticulously picked through a cool box full of soft drinks in a cramped little grocery store, searching for the coldest. I bought a couple of small chocolate cakes, and we stood together in the shade of alleyways no more than a meter wide, enjoying our treats. Jameela ended up wearing more of the chocolate cake than she ate, but she was happy anyway. Raghda's smile was even wider once I had accepted her offer of a drink. It was a rare day for her to walk around the

camp in fine clothes with a couple of shekels in her pocket, much as it was for any child in Balata Camp, and all she wanted was to share her treat with me.

Balata Camp has become a second home to me in Palestine over the last few years, and much of that is because of the family, Abu and Um Abud and their seven children, with whom I have had the honor of staying in the camp. The girls and their siblings have become like brothers and sisters to me. Jameela was very young when I first stayed with them, and it took us a while to get to know each other. Now she happily runs me in circles, playing hide-and-seek. I love to spend time with her as I do with all the family. There were only six of the children in the house when I first began staying there. One of the two sons, Abud, was in prison along with so many others from Balata Camp. He was fifteen years old when he was imprisoned. When Jameela was born, she didn't know her brother, she couldn't see him, and she never knew him in person until he was released from prison a year or so later. When I first met Abud, he had only just been released. I had seen many photos of him, and it was good to see the family back together, but I could also see how confusing it was for Jameela. She just didn't know him. Things are different now, and their relationship is just as loving and affectionate as all the others in this tightly knit family unit.

A few days before the Eid al-Fiter Festival, we all sat together in the family living room. We had just finished watching *Bab Al Hara*, the Syrian television series that captivated people across Palestine with its nightly tales of the Syrian resistance to French occupation. Raghda and I had been playing a game when the phone rang; it was the girls' uncle. As on many nights, Abu Abud chatted away eagerly with his brother. Then Jameela came to speak to her uncle on the phone. Her father held the phone so she could talk, but instead she began to sing "Shater, Shater" (Clever Boy, Clever Boy), Nancy Ajram's pop song, which has been *the* hit of the summer in Palestine. She clapped and sang away, smiling as we all laughed. Here was another family relationship she was trying to build with a relative whom she had never met. She knows her uncle's face from the huge prison portrait that hangs behind the television in the living room, and she talks and sings to him regularly on the phone, but she has never met him. Jameela will be a few years older yet before she gets to meet her uncle, if he is released from prison on time. This is how children are forced to grow up in Palestine, building relationships with family members through photographs and, if they

are lucky, telephones. Thousands of children are living like this, separated from their relatives because of prisons, bullets, or the Wall.

I share a room with Abud when I stay in Balata Camp. Many nights we have sat up until all hours in his room, sometimes because of the deafening barrage of IOF automatic gunfire and explosions bouncing off the walls around the house. Other times we were just talking, but more often than not it was a disturbing combination of the two. We have talked about his arrest and time in prison and looked through his old photograph albums of the friends he grew up with. As he flicked through the pages, he would comment on the young boys in the photographs, his childhood friends: "Fi sijin, fi sijin, mayiet, fi sijin, mayiet." (In prison, in prison, dead, in prison, dead.)

He has also shown me his collection of prison letters and drawings. He still keeps the little notepads he drew on while imprisoned. Most of the images are in ink. They include sketches of hands wrapped in barbed wire, a map of Palestine bleeding, Che Guevara, and a Palestinian flag. Occasionally, odd pieces of text float somewhere on the page, usually just single words. One recurring word is *hop* (love) and another is *huriya* (freedom). Abud would often laugh when he saw hop. "Ay hop? Wein el hop? Wein mumkin inlaqi el hop fi sijin?" (What love? Where is the love? Where do we find love in prison?)

One night Abud gave me a small bracelet and ring in the colors of the national flag that he had made while in prison. I didn't want to accept something that I thought would be so personal, but he insisted and often checked that I wore it. Abud would also ask me about life in Europe and about how it felt to travel and to live without occupation, checkpoints, and martyrs. He can only dream about living with such basic rights. Because Abud was imprisoned by the occupation, he is now blacklisted, meaning the IOF will not allow him through any of the checkpoints that surround the city. He cannot leave Nablus.

By mid-November, Abud, Jameela, Raghda, and all the rest of the family were eagerly awaiting the birth of their new sibling. The time finally came, and Abu and Um Abud left Balata Camp in the direction of the hospital. Everybody was very excited. The birth went well, and around 8 p.m. the two proud parents returned to the camp, cradling a new baby daughter named Tasbeeh (Always Thank God). She was a beautiful ray of hope for everyone, but in the first few hours of her life, Tasbeeh's peace was shattered.

Around six hours after the parents and baby had arrived in Balata Camp, their house was surrounded by dozens of heavily armed IOF soldiers. Sound bombs exploded, and the butts of M-16s pounded on their metal front door. As Abu Abud opened the front door just after 2 a.m., more sound bombs were thrown into the house. Tasbeeh was crying among all the explosions as the IOF barged in and began questioning her father. Then, amid the explosions, somebody went quiet; Tasbeeh had stopped crying.

"My wife ran to her. Her mouth was filled with blood. My wife turned her over and tried to get her to breathe; she was massaging her back and chest and trying to get the blood from her mouth."

Within a few seconds, Tasbeeh's little chest began to move again. She was still in the first few hours of her life when she had her first encounter with the IOF, and it nearly killed her.

Abud and his brother were forced outside into the dark night and were made to stand against the front walls of the house while the IOF smashed their way through the property. When the IOF withdrew from the house, it left behind destruction, devastation, and an imprint on a child's life in her first day that will stay with her until the last. In their actions, the IOF also guaranteed that another little member of this family must now grow up separated from her brother. When the Israeli soldiers smashed their way into the house, they were carrying their usual array of lethal munitions. When they left, they took with them part of the family. They arrested Abud again; he is now eighteen years old.

Tasbeeh's parents were still very worried about her. When Um Abud later checked on her new daughter, she found blood coming from one of Tasbeeh's ears. They immediately rushed back to the hospital, fearing some kind of injury from the explosions. Tasbeeh had blood cleaned from inside her lungs by dedicated doctors in a Nablus hospital. The doctors also fear that Tasbeeh has lost one of her eardrums because of the explosions but prefer to wait until she is a few months older before beginning to run further tests.

When I heard the news about Abud and Tasbeeh, I felt sick. The day had started with so much family anticipation and excitement. I thought about how we had all enjoyed Ramadan and Eid al-Fiter together less than a month earlier and how we had talked about the coming birth of a new child. I remembered how when I was hospitalized after being involved in a car crash in October, Abud

was the first person I rang, and how they all came to collect me from the hospital and took me home to care for me. I remembered Jameela's phone call to her uncle in prison and her first years without Abud, and I thought about how the whole cycle was now being repeated. I thought about one dark night in Balata Camp that began with a beautiful new arrival and ended with a sickening loss; about a new life that began and almost ended among the explosions, bleeding, and separation of her first night in this world; and about a new baby who may or may not have had the chance to lay eyes on her big brother before he was dragged away for a length of time dictated by no law other than that of his captors. I thought about guns and sound bombs, and about telephones and photographs.

And I thought about family.

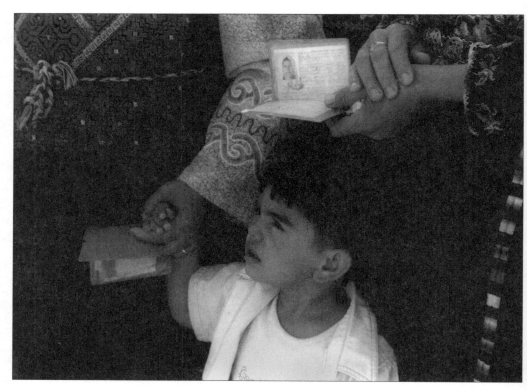

"Identity"—Bethlehem Checkpoint

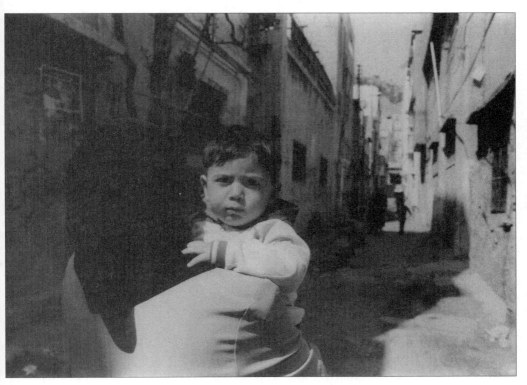

"Mother and Child"—Balata Refugee Camp

"Uncertain Future"—Balata Refugee Camp

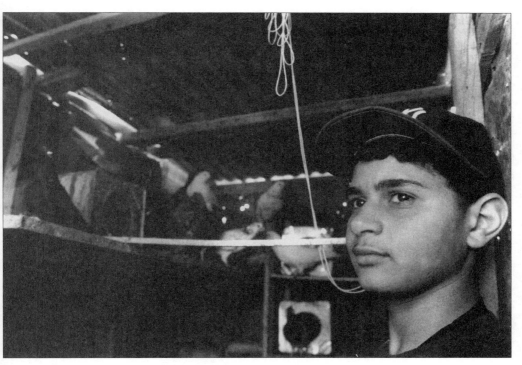

"Former Child Prisoner"—Aida Refugee Camp

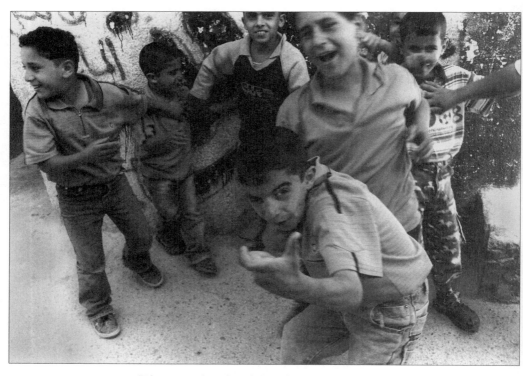

"Playing Jaysh and Arabs"—Al Azzeh Refugee Camp

"The Living Room"—Al Ayn Refugee Camp

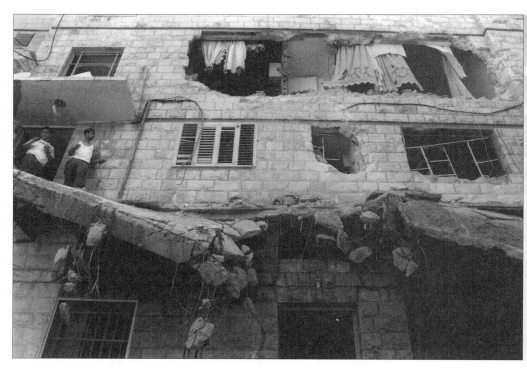

"A Family Home"—Nablus

LAND OF PALESTINE

[The Blessed]

Palestine is a country steeped in symbolism. The four colors of the Palestinian national flag—red, white, green, and black—are those of many Arabic nations, but the national symbolism associated with these colors here in Palestine is not necessarily shared by all the other states. The red represents the blood of the martyrs and, to some, the spirit of resistance; the white portrays purity and love for all people; the green symbolizes the land of Palestine; and the black embodies strength and sumoud. Flags and colors are not the only important signs of national symbolism; the country's flora and fauna also carry a deeper significance. Much as the cedar tree is strongly associated with Lebanese culture and history, so the olive tree is deeply entrenched in all that is Palestinian.

For Palestinians, the olive tree holds much significance for the soul of their country. It is seen as a sacred tree, owing to Qu'ranic and biblical references through which the olive branch is widely regarded as a symbol of peace. It is also considered to represent life, longevity, and survival for the tree can grow and live happily in any of the country's environments, much as the people will flourish in every corner of Palestine. The tree's roots grasp the earth tightly and resiliently in the same way the people will always fight to hold on to their land and their country. Simply put, Palestine would not be Palestine without the olive tree.

Historic Palestine—that is, Palestine before the creation of the state of Israel—stretched from the Jordan River to the Mediterranean Sea. The 1947 UN Partition Plan proportioned around 56 percent of this land to the Zionist state, leaving around 43 percent as Palestinian land. The remaining 1 percent

was Jerusalem, which was to act as a shared capital under international administration. However, the Israeli colonization and ethnic of cleansing of Al Nakba consumed about 78 percent of Historic Palestine, leaving just 22 percent to the Palestinians. It was further divided into two unconnected regions: the West Bank, which was administered by Jordan, and the Gaza Strip, which was under Eygptian administration. Subsequently, both the West Bank and Gaza Strip fell under Israeli occupation after the 1967 war. With the continued colonization of settlement expansion and the building of the Apartheid Wall, there is now no more than 12 percent of pre-1948 Palestine remaining as Palestinian land. As more land is stolen and greater numbers of Palestinians become displaced, olive trees are increasingly uprooted, chopped down, and destroyed.

The finest olive oil in the country is said to come from Beit Jala. The Abu Aisha family has cultivated and nurtured olive trees on its land in Beit Jala for longer than any living person can remember. Their trees have been handed down through the family from generation to generation. Abu Saleem is now eighty-five years old and can still remember the stories about tending the trees that his grandfather had told him as a child. Such is the longevity of the olive tree that the Abu Aisha family's land in Beit Jala is thought to hold trees that date back to the Roman times. There is one tree in particular that is the biggest of them all and was always accepted to be the oldest.

"I remember working in the fields as a child with my father and grandfather. Every day we would sit underneath that tree to drink our coffee and eat bread. My grandfather talked a lot about that tree and made me solemnly promise that I would always look after it and protect it." This particular olive tree was known as Al Mabroukah (The Blessed).

Abu Saleem has tended and loved these olive trees for all of his life. If you ask him when this work began, his answer demonstrates his deep spiritual attachment to his trees: "From the day I was born!"

When he talks about his family's trees, Abu Saleem does so with passion; the depths of his devotion are clear.

"The roots of these trees are my family's roots; these trees are our history. They have lived through Roman times and Turkish times; they have lived through everything. The trees and their history make me breathe; they gave us all life. They are our history, and I must always protect them."

Despite the sturdy nature of olive trees, Abu Saleem recalls the hard work that he has dedicated to them throughout his life.

"I have weeded around the trees and plowed the land in which they grow. I have trimmed the branches and removed the dry ones. Before the winter rains came, I would build and restore stone walls and fences to prevent soil erosion. These trees take more care and love than your own son!"

However, on one dark day in 1993, Abu Saleem was not there to protect his beloved olive trees. The IOF came down to his land with heavy machinery, bulldozers, and diggers. The soldiers were preparing the land for the creation of the infamous Route 60, which would later become a settler-only road, clearly demonstrating Israel's policy of apartheid. Israel was building this road through the West Bank to link up the illegal settlements built on stolen and occupied land. (Currently, the section of Route 60 between Bethlehem and Al-Khalil is open to shared access for both Palestinians and settlers, but there is discussion about a new road being built to reinstall and solidify the apartheid road system in this area of the southern West Bank.) Abu Saleem had twenty-four dunums (about twenty-four thousand square meters) of land in Beit Jala. He had 406 olive trees on the land. On their first day of work in 1993, the soldiers ravaged his land, destroying many of his trees. By the time he heard about it and got down to his land early the next morning, it was already too late for nearly a hundred of his trees. They lay strewn across his land like discarded corpses. He remonstrated with the soldiers, argued, and finally begged them to spare his trees, but the IOF didn't care about his protests.

"They told me, 'This is our land, and we must take it!'"

Many other local landowners came down to support Abu Saleem; eventually, the soldiers offered him a deal. They told him they would bring trucks and move the trees across to his other piece of land, where he currently lives alongside Aida Camp, so that he could replant them there. In total, the IOF dug up 191 of Abu Saleem's beloved olive trees. More than a thousand years of life and history were destroyed in just a few short days. They did transport the olive trees over to Abu Saleem's land next to the camp, but around half of them were already beyond replanting; these were the trees that had been unceremoniously ripped from the land on the first day. Israel had stolen what land it needed for this section of the construction of its road system.

This was not the last of the destruction of Abu Saleem's trees or theft of his land. Israel had built its road, which is still being used today, but Abu Saleem continued to care for his remaining trees in Beit Jala and the trees he had replanted in the land next to Aida Camp. He continued this work for more than ten years before the IOF returned to his Beit Jala land in 2004. This time it was not building a road but another symbol of Israeli land theft and colonization—the Wall. Again bulldozers came and began to rip up Abu Saleem's land, but the resilient and dedicated man was present on this occasion.

"When I saw the bulldozers again crushing my trees, it was like I was 'drunk without drinking.' It was like a horrible dream. I really couldn't believe what was happening."

Abu Saleem again protested and argued with the soldiers but couldn't get them to stop. He knew they would eventually get to Al Mabroukah, but he could never let this happen. He had made his promise all those years ago to his grandfather, and he intended to keep it. Abu Saleem stood by the sacred tree all day long. Night came, but the soldiers didn't stop working. He knew he would have to stay there for as long as it took to keep his promise and preserve at least some of his family's history.

"I stayed by that tree all night. I didn't sleep; I just sat under it. The bulldozers worked all night, and the soldiers were all over my fields, but I wouldn't leave Al Mabroukah. I had all my documents with me, and I screamed at them, 'This is my land; I have all the papers. These are my trees!' They dug up many of my trees that night, but they did not get Al Mabroukah!"

The following day, after a heartbreaking and sleepless night, Abu Saleem was glad to see neighboring landowners come to support him again. Some internationals (those who do not hold Palestinian ID) also came this time. Eventually, their joint protests stopped the soldiers' work. The IOF left and moved on to neighboring land.

In the face of such military might and heavy machinery, Abu Saleem could not save all his trees. The pain ate away at him as he watched his family's history and its roots being destroyed, but he never gave up on his promise to his grandfather. Most of his family have now died, and many of their roots—their trees—have also died, or rather been killed by the occupation, but Abu Saleem

was determined this would not happen to his beloved tree. He was prepared to die for Al Mabroukah if it came to it. Fortunately, it didn't.

Abu Saleem and his sacred tree live to fight another day. Leading the struggle for his trees, Abu Saleem has embodied the symbolism of the olive tree with his longevity, his resilience, his survival, and his life.

[Village Stories]

The balcony of Bilal and Jameela's beautiful house in Battir village feels a million miles away from the cluttered, crowded refugee camps of Palestine. Looking out across the valley, I see the village itself, a combination of small, traditional houses and larger, newer constructions, most of which are made of traditional local stone. Smoke rises from the roofs of many houses from warming fires attempting to keep away the cold winter air. A train track snakes through the bottom of the valley; alongside it stands the village school. I can see children in the streets playing together, men talking and smoking, and women carrying bags of bread and vegetables. I cannot see any Israeli soldiers. But the things that strike me most, since most of my time is spent in the camps, are the fresh air, the space, and green; everywhere I look I can see green. The typical red roofs of Ora Settlement, as always, constructed on a hilltop, are also visible in the distance, but in Palestine, a landscape free of any obvious signs of occupation is very rare.

To uninformed strangers, this may at first glance seem like an idyllic environment, a village contented in its traditional and relaxed pace of life. But if these visitors were to talk with residents and understand what they were really looking at, they would feel very differently.

The thousands of trees that cover the far side of the valley, across the train tracks, are also on the village's land, although the villagers are no longer allowed access to this area. They cannot cross the tracks. This land has all been stolen. In Israeli terms, it is now considered Greater Jerusalem. The train track itself does not transport Palestinians to nearby villages; there is no station here or anywhere

else in the West Bank for Palestinians. Instead, it transports only Israelis or tourists on their scenic journey through stolen land from Jerusalem to Tel Aviv. So the green fields, rolling hills, and wooded valleys are out of bounds to their rightful owners. They have been stolen and are all considered as part of the Zionist expansion of Greater Jerusalem. The school that stands next to the train tracks has lost half its playground through this modern-day colonialist project.

While not yet built in Battir, the Apartheid Wall will run between what's left of the village and the tracks. People will no longer even see their stolen land, and the entire school is at risk of demolition as the Wall's planned route plows straight through the building. The Wall is designed to encircle Battir and neighboring Hussan, surrounding the two villages entirely and placing them inside a walled prison. There will be just one gate allowing some villagers, but only those who obtain the required permission from Israel, to leave the villages and travel to Bethlehem and the rest of the West Bank.

Sitting and talking with Jameela and her friend Rowa, it is very clear that no one is content with life in Battir. Rowa is from a very poor family. Her father died many years ago, leaving behind a wife, four daughters, and one son, none of whom are married. It costs money to marry, and the family literally has none. Rowa's brother has no work. He has previously been arrested while looking for work without permission in Al Quds and now cannot pass checkpoints. The family survives on the bimonthly UN food handouts they receive and the support of friends and neighbors. Three months ago, their electricity supply was cut; the bills had not been paid in a long time. Jameela and other friends spoke to the company and agreed to pay the bills off over time in order to get their power supply turned back on. Rowa constantly asks me how she can escape this life.

"How can I leave? I want to tear up my ID card and leave. I will go to America, to Europe, anywhere! I don't care! I don't ever want to come back here. I am bored with this life!" Rowa explains that she hardly ever leaves the village. During Ramadan last year, she was "lucky" to obtain permission to go to Al Quds for one day so she could pray in Al-Aqsa Mosque. She once visited Saudi Arabia years ago, but apart from that trip, Rowa has never left Palestine. She would like to travel in Palestine, too, to see her own country.

"Can I come on trips with Lajee Center? I will volunteer; I will do anything to escape, even if just for a day. I want to travel, to move, to see different things.

How much money would I need to go abroad, to go to England? Would I need a lot, like a thousand dollars?"

When Rowa mentions a thousand dollars, her eyes open wide as if she were discussing several billion; she cannot comprehend this amount of money. She tells me she wants to learn English so she can talk to me. "I would like to invite you to stay at my house, to sleep there, but we have no beds! You could sleep on the floor near my mother!" Rowa laughs at her joke. She clearly likes to laugh, but the smiles are only skin-deep. "I am laughing on the outside, but inside there is just pain. I am waiting for the grave."

Rowa is just thirty-eight years old.

Jameela's door is always open to friends. As we talk, others drop in to say hello and pass the time. Bilal's friend Ahmed stops by. He likes to talk politics.

"I am a nurse. I work at Al-Hussein Hospital in Beit Jala, but we still are not getting paid."

Al-Hussein is a state hospital and therefore funded by the PA. Since the international blockade of Palestine began last year, staff members at PA-funded institutions have not been fully paid.

"I have received just three months' salary in the last twelve months. Maybe the new government can make things 50 percent better for a while, but then they will get worse again. Abu Mazen [Mahmoud Abbas] cannot support us and hold us together like Arafat did. Everybody followed Arafat. All the parties listened to him. He was strong, and he united us. There is no one like Arafat; we were in his blood and he was in ours."

If these salaries can be fully paid, things will become brighter for Ahmed. By the standards of other villagers, he is fortunate to have work at all. There is no work in the village, and people survive by helping each other with what little they have. Jameela's neighbor Iman has no work at all.

"I was arrested working in Israel [without permission] four months ago. They sent me to prison for two months, fined me 2,000 NIS (around $500), and made me sign a paper saying I would not enter Al Quds again. Now I just stay at home all day; there is nothing for me to do. If they caught me there again, they would sentence me to years, not months."

Battir's close proximity to Al Quds and the fact that the Wall has not been constructed in the village yet means many men still take the risk of trying to

find work in the city. This dispels one of the many myths of Israel's so-called security barrier. Israel claims that the Wall prevents "terrorists" from entering Israel, and, according to the Israeli propaganda machine, that is why there have been hardly any operations inside Israel since the construction began. In fact, in the southern West Bank, many sections are still not complete and people do still enter Israel without first acquiring permission. The Palestinian populace is not aspiring to carry out operations inside Israel; people want to provide food for their families. On most nights Palestinian men take the huge risk of trying to bypass security cameras and IOF patrols to get to Al Quds so they can look for work either in the city or farther afield. Those who successfully make this perilous journey will often stay there for many weeks or months, leaving their families behind, and try to make money to take back to their loved ones.

Bilal soon returns home from Bethlehem, where he currently works as a policeman in the city. He is unsure if this work will continue after the Wall is completed around Battir. Once the Wall is in place, he will need to acquire permission from the occupation authorities to leave his village. He has served six years in their prisons and is unsure whether he will receive permission. Bilal has also lost family members, including his brother, who was killed by the IOF. Bilal's brother is one of eight shaheeds from Battir.

Later that night, Bilal invites me to go with him to visit friends. There is little else to do in the village other than to make social calls on friends to talk, drink endless cups of coffee, and smoke countless cigarettes. During the short walk to Bilal's friend's house, I ask him if there is a cafeteria or coffee shop in the village; he just gives me an ironic look and smiles. When we reach our destination, Hadr's house, Bilal opens the door.

"This is our coffee shop!"

Through the dense smoke, I see four men huddled around a small gas fire. On the walls are two cheap copies of landscape paintings; they show open meadows with flowing rivers and snow-capped mountains and are of a style seen widely in houses across Palestine. They represent a better life, dreams, and freedom.

I had met Hadr earlier in the day but didn't know much about him other than he is the brother of a friend I have known since I first came to Palestine in 2003. Much like everybody else, Hadr also has a story to tell.

Hadr has been married for eight or nine years now. His wife was originally from Battir, but her family fled to Jordan during the second mass Palestinian exodus in 1967, when the West Bank fell under Israeli occupation. He is one of only twenty people out of the five thousand residents of Battir who has permission to work inside Israel. Hadr went to Jordan to get married; the couple stayed there for a while and had one daughter. They then decided to return to their homeland and their village. They lived together in Battir for two years and had another beautiful daughter.

"My wife's father became very ill, so she returned to Jordan to care for him. I stayed here with my daughters as we didn't think she would be gone for long."

When Hadr's wife attempted to return to Palestine, she was refused entry by the Israeli authorities at the Allenby Bridge border crossing. She explained that she now lived in Battir and her husband and children were there, but it made no difference. She was told she would never be allowed to return to Palestine and was given no reason for this refusal. The family was devastated. They had set up a home in Battir and wanted to stay there, but there was no choice for Hadr and his daughters except to leave their home and move to Jordan. When they reached the border crossing, he passed through the Israeli side without problems, but upon reaching the Jordanian side, Hadr was told he could no longer enter Jordan. Like his wife, he was given no reason for this.

So now Hadr is still in Battir with his two daughters. One is seven and a half years old; the other is four and a half. They haven't seen their mother in four years. One doesn't know her mother at all; the other cannot remember her.

"They now call their grandmother 'mum.'"

So just as everybody else I meet in this tortured country, and despite the outward appearance of a relaxed, tranquil, countryside environment in the village, when you scratch the surface, you will find that the people of Battir have many stories to tell—stories written for them, by the occupation.

[Bread and Water: The Struggles of Survival]

As a child, I was often told, "Tomorrow is a whole new day" and "After darkness comes light." In Palestine, I have often heard a different interpretation of what the future may bring. One night, sitting with friends as the sun dipped and bats fluttered in the early evening sky around Aida Camp, I once more heard a Palestinian version of this theory repeated: "The day that is coming is always worse than the day that has passed."

I have known Yousef for three years now. Known for dancing at any given opportunity, his rhythmic drumming on the tabla, and his cooking skills, he is invariably seen with a huge, toothy grin on his face. But as most people in Palestine, his smile and spirit mask the struggles that he endures daily, struggles that have become even darker over recent years as he attempts to raise his family while the economic situation in Palestine continues its rapid downward spiral.

Hubbus (bread) is the staple of all meals in Palestine. It will be eaten for breakfast with *zeit* (olive oil) and zaatar, a fine powdered mix of thyme, salt, pepper, and sesame seeds. Lunch is the main meal of the day, and hubbus will accompany a traditional hot meal of vegetables and possibly meat. In the evening, salad, hummus, and other light food, such as eggs and cheese, are shared with copious amounts of hubbus. A few weeks ago, a packet of ten fresh pita breads could be bought for around 2.5 shekels in Bethlehem. Here in Aida Camp, the hubbus is made with lower quality flour and is lower in weight, making it cheaper to buy. Until recently, it cost 2 shekels in Aida's stores. Today in Bethlehem's bakeries, the same packet of ten pitas costs between 4 and 4.5 shekels. In Aida

Camp, it is at least 3 shekels. These figures equate to a rise of between 50 and 80 percent, depending on where the bread is purchased, its weight, and its quality. A price rise of these proportions on basic foodstuffs can be accommodated into a family's budget only if wages rise in unison. Yousef, along with more than 50 percent of Aida Camp's population, has no work and therefore no wages.

"Before the intifada, I worked in Israel, but my brother was killed by the Israeli army. Since he became a shaheed, our family name has been blacklisted."

Yousef has never been in an Israeli prison, but having one brother martyred and having four other family members currently in prison are justification enough in the eyes of the occupation, with its norms of collective punishment, to ensure he will never again receive permission to seek work on the other side of the Wall.

"A year ago I worked with UNRWA for three months, but since then I have had nothing, no regular work at all."

The UNRWA has an employment scheme inside refugee camps that offers work placements to people from the camp's poorest families, but as there are many people in such economic desperation, these placements are non-extendable. People may have to wait years to be given another chance of work through the program.

Hubbus is not the only food to see a dramatic price increase.

"In the last year, a kilo of lemons has risen from 2 shekels to 6. Chicken used to be 7 shekels. Now it is at least 9."

Palestine has seen drastic reductions in the amount of fresh food it can produce. Gaza has become totally cut off and isolated from the West Bank economically as well as physically. As the West Bank continues to be colonized by Zionist expansionism, its agricultural land and produce also continue to diminish. These factors mean that more and more food is imported from Israel since it is Israel that controls all of Palestine's borders and decides what trade can enter the country.

Yousef lives with his elderly mother, who is a Nakba survivor from Al Malha village, as well as his wife and their five children. There are eight mouths to feed in his household, and as the economy plummets, so do his family's dietary habits.

"We used to eat meat three times a week; now it is nearer three times a month! I also can't pay any bills with no work. I haven't paid my electricity and water bills

in years. I owe 15,000 shekels [around $3,700] to both the water and electricity companies. I'm afraid they will cut off the supplies soon."

If Yousef lived in Bethlehem and not in Aida Camp, he would no doubt have been cut off from both supplies a long time ago, but inside the camps, the companies and the police are reluctant to attempt such things, knowing people will immediately amass to defend their property. People look after each other here. Less than a week ago, around twenty armed Palestinian police attempted to confiscate a vehicle inside Aida Camp. They were quickly outnumbered by angry residents who were prepared to defend their property; the police withdrew empty-handed.

During this incident, a youth turned to me with a smile on his face and said, "The police don't make the rules here. *We* do!"

So Yousef's water has not been cut off by the company yet, but this doesn't mean he has a regular supply. Over the last two years, the water supply to Aida Camp has deteriorated. This has coincided with the completion of the Apartheid Wall around the camp. The route of the Wall not only places many settlements on the "Israeli side" but also annexes many of Palestine's major underground wells and water aquifers. Water supply in Aida Camp is far from constant. In theory a supply of water is sent to the camp once every six or seven days. It is then distributed within two to three hours and must be stored until the next delivery. Through the hot summer months when water is at a premium, it is often much longer than a week between water deliveries. Most summers the drought stretches into weeks or even months before any fresh water is sent to the camp. Palestine's water supply, as with most aspects of life, is controlled by the occupation and sold at inflated prices to the PA to be distributed within the country, but the supply never fills the demand. Palestinian water usage per capita falls well below the minimum standard of a hundred liters per day that is laid out by the World Health Organization. Israeli settlers consume around seven or eight times as much water per capita as Palestinians do.

Aida Camp is built on a steep slope, and Yousef's house stands right at the top of the camp. When water does arrive in Aida, it is supplied to houses through very old, exposed pipes and stored in tanks on the rooftops. For people like Yousef, who live in the higher sections of Aida Camp, the flow is not of sufficient

pressure to pipe water up to the rooftop tanks. Yousef, along with many people in his neighborhood, has set up a makeshift system of his own. The bare pipes pump water into two large, plastic drums outside his front door. From there he pumps it up to the tanks on his roof by way of a small generator, which he had to buy himself. Many neighbors often pitch in to buy this pump and generator system; each costs around 800 shekels (about $200). Families will then pump water up to their rooftop tanks before disconnecting the system and passing it on to their neighbors to do likewise. But for Yousef, as with all of Aida Camp's residents, the lack of water presents a major concern.

"Until four weeks ago, we had gone nearly a month without water. I had to go to collect it every day in buckets from the taps in Beit Jala. I would spend all day worrying about it and having to go collect water."

These public taps alongside Aida Camp in Beit Jala remain from when the first water supply was set up for the camp in the early 1960s.

Yousef's house is down a very narrow alley that is no more than a meter and a half wide. From the upper floors of his house, he could reach out and collect the washing that hangs outside the house opposite in which live another twelve members of his extended family. In such cramped living conditions, no conversation is ever private. As we talk, another neighbor walks past and, hearing our discussion, interjects, "I can tell you about water! Farther down in the camp, they have water, but up here we have nothing! I have had no water in two weeks now!"

In little more than a week, a new school year should begin, although continued strike action is being muted. Of Yousef's five children, four are of school age and attend the UNRWA schools in Aida Camp. They provide a more basic standard of education than Bethlehem's private schools do, but it is a free education, which is essential for many families.

"I want my children to work hard at school and go to university. I don't want them to end up like me. They struggle in English and maths, but I can't pay for extra tutoring for them. . . . Really, this life means shit to me! I want to live on an island like Robinson Crusoe, with no children, no houses, no shops or bills. I would just hunt and kill animals to eat!"

Laughter echoes out of Yousef as he says this, but the sentiments ring with desperation, and the new school year clearly brings with it extra worries.

"To start school, they need new clothes, bags, books, pencils—I don't know where I can get these from. I should call George Bush and ask him for a thousand shekels a month to pay for my children! My nephew has six children, but he can't even buy milk for them. If I wanted to steal from people, what could I steal? No one has anything!"

Earlier in the year, one of Yousef's daughters was sick; she had picked up a severe eye infection. He was told she must go to the children's hospital in Bethlehem since UNRWA does not provide medical facilities in Aida. UNRWA offered to pay 70 percent of the hospital fees, given the necessity for treatment, but Yousef had no way of finding the other 30 percent, so she remains untreated.

Since the international blockade of Palestine began after last year's elections, poverty and unemployment levels have soared. Yousef's struggle for survival for himself and his family is desperate, and he is one of many hundreds of thousands of people in this position. He survives on support and handouts where and when he can get them.

Many of Aida Camp's residents are languishing in Israeli prisons. They survive on the meager sustenance of vile prison food and the strength of their spirit. Yousef is not one of the occupation's thousands of political detainees, yet he must raise his family in a world where he cannot be truly considered a free man. It is a world where he faces a struggle for survival to find the most basic of necessities—bread and water.

[When the Pumps Dried Up Again]

Today Abu Osama drives his taxi, but he is uncertain about tomorrow. He has seven children, three of whom are currently at university and three of whom are of school age, but they have no schools to attend. The current national strikes were brought on by nonpayment of teachers' wages owing to the international blockade of Palestine. According to the United States and the European Union, the Palestinians made the wrong democratic choice.

Children currently have no state education, and today the fuel has also dried up. There is nothing left in the pumps. This happened in Palestine a few months ago, but everyone hoped we had seen the end of this particular problem. DOR, the Israeli company that controls the fuel coming into Palestine, closed its pipelines overnight. When it happened before, it began in Gaza and spread first to Ramallah and the northern West Bank; the following day the crisis hit Bethlehem. This time it has been much more sudden and has affected the whole country simultaneously.

Nobody was expecting this. By chance, Abu Osama had filled up his taxi's fuel tank last night; many people haven't had such luck. Alongside the Rachel's Tomb complex, two gas stations exist in the virtually permanent shadow of the section of the Apartheid Wall that snakes into the city of Bethlehem. These two gas stations stand right next to each other. At the first one, I found a *servees* (shared taxi) parked. The driver told me he had been there since this morning. His car had run out of fuel. When he went to fill up his fuel tank this morning, there was none. He had driven around most of Bethlehem looking for fuel, but every station gave him the same answer. The fuel stations alongside the Wall were

the final ones he could try, and this was his last chance to continue working for the day.

"There is no fuel anywhere—nowhere in Bethlehem and nowhere in Palestine except in Acion. I cannot get there, and even if I could, they probably would not sell it to me. So what can I do? I am stuck here for the moment. I have rung some friends who are bringing me a little from their cars. This will get me home, but I cannot continue working today."

Acion is in the illegal Israeli colony of Gush Etzion within the West Bank, and Palestinians often also use the name Acion to refer to the surrounding settlement. Because Gush Etzion is an Israeli settlement it is connected to Israel's fuel supply instead of Palestine's, and as the driver explained, the gas station there still has its usual supply of fuel. Some Palestinian bus companies have a contract allowing them to refuel at Gush Etzion, but Palestinian civilians are normally not allowed to do so. Maybe Acion will open up to cash in on the Palestinians' plight. Maybe it won't. No one is sure. Nor does anyone know how long this will last. It lasted just a few days when this happened earlier this year, but it was devastating to see how quickly everything ground to a halt. The roads were almost deserted.

Seven years ago, Abu Osama used to work in Israel and could earn a hundred dollars a day in the ceramics factory where he worked. Since the intifada began in 2000, he has not been allowed into Israel anymore; so he started driving taxis. He does not own his taxi; it is rented. Palestinians, certainly most of those who travel alone, generally travel around the city in a servees rather than private taxis. A journey anywhere in the city costs just 2 NIS (around 50 cents) in a servees while a private taxi will cost at least 10 NIS. Thus taxi drivers aim to ply their trade with tourists.

"I wait at the Wall and hope to find tourists coming through the checkpoint who want a one- or two-hour tour around Bethlehem. I will take them to the Nativity Church, the Shepherds' Fields, the Milk Grotto, and maybe Herodion. I charge 100 shekels [around $25] an hour for tours, but we hardly ever get tourists these days. I haven't had a single tourist in my car for three and a half weeks now, not even for a 10-shekel journey. This morning I got to the checkpoint at 5 a.m. It is 3 p.m. now, and I have made just 60 shekels ($15) in all that time. That's 60 shekels in ten hours' work, and from that I need to take out petrol money and rent for the car."

If Abu Osama is busy, his fuel consumption will average one full tank a day; currently, a full tank is lasting him over three days owing to the lack of business.

"It was lucky that I filled up my taxi last night so I should be all right for a couple of days. After that, if there is still no fuel, I don't know what will happen, but I can't work without fuel. I cannot move."

I have come to know Abu Osama quite well over the last few years. He always greats me with a smile and tries to be optimistic.

"If there is still no fuel, maybe someone will bring some from Al Quds or somebody will make a trip to Acion. The fuel is a bit more expensive in Acion, but it is much better quality. *They* give us the low-quality stuff and keep all the good fuel for themselves. Inshallah [God willing], they will find a solution to this problem today."

I hope that he is right, but it's difficult to share his optimism. It is Ramadan at the moment. The holy month is meant to be a time of reflection but also of celebration. This year, trade and commerce in all Palestinian cities are down; the streets are not as busy as they usually are during Ramadan. The holy month is always an expensive occasion because although people fast throughout the day, when the sun sets, the fast is broken, cries of "Allah Akbar!" drift out of the mosque, and people traditionally gather for large family feasts. Gifts of money to family members and to the poor during Ramadan also follow custom, but this practice has been severely restricted because of the current economic climate.

Eventually, Abu Osama's optimistic nature seemed to crack at the edges.

"What am I to do if I cannot work? I have seven children and a wife to provide for. Three of my children are at university, but how can I keep sending them money and paying fees if I cannot move or work? Three of my other four children should be at school now, but they have not been in over four months; the strike put a stop to that. My youngest son, Mohammad, keeps asking me every day when he can go to school. It makes him very sad. He has never been yet; it should have been his first year at school this year. He should have started in September. They are just sitting at home all day now with nothing to do, and I can provide nothing for them if I have no work. What am I to do?"

I am once more left feeling there is nothing I can say to a friend; I feel helpless to assist. All I can do is the same as Abu Osama and hope that a solution is found and the fuel begins to flow again—inshallah, as he says. If this doesn't happen,

Palestine will continue to grind toward a total standstill. Next, the cooking fuel will also be affected, just as last time, until people can no longer cook hot meals on their gas stoves or even make coffee.

Palestine's industry has all but ground to a halt because of the occupation. Tourism has plummeted massively. Agricultural land has been colonized by settlements and lost to settler roads and the Apartheid Wall. Workers can no longer find work in Israel or even reach Israel, for that matter. The Palestinian economy was sustained only by the trap of international aid money, and once Palestinians dared to vote against the wishes of the suppliers of that aid, the money stopped. Without the economic structure to pay bills, and with resources and energy supplies controlled in any case by the occupation, the walls were built, the gates were locked, and now the screws are being turned.

"Abu Osama"—Bethlehem

"Abu Saleem"—Beit Jala

"Food Handouts"—Battir

STRENGTH AND SUMOUD

[Still Laughing]

As I sit in the small office of Jenin's Creative Cultural Center listening to Nariman talk, it is hard not to be in awe of her strength. At times she laughs and giggles, at others her tone is more matter of fact, but at no time do I sense fear in her. Nariman seems to be of the belief that "what doesn't kill us makes us stronger."

When the IOF came for Nariman in late 2003, it was, as is often the case with such military operations, the early hours of the morning. The size of the military force that surrounded her family's house in Jenin was immense. Apache helicopters hovered above; there were tanks, dozens of jeeps, and more soldiers than anyone could count. Nariman was barely out of her teenage years, unmarried, and living at home with her family.

The IOF again disregarded all respect for humanity and international law when it first entered the house of one of Nariman's neighbors and demanded that one of them, a thirty-five-year-old woman, leave her house at gunpoint. She would be forced to act as a human shield—an illegal practice under international humanitarian law and the Israeli Supreme Court's declaration in 2005, yet the IOF often used it in occupied Palestine. (Recently, this IOF practice has been highlighted again during Operation Hot Winter, when the IOF used Palestinian children, including an eleven-year-old girl, to walk in front of their patrols through Nablus's Old City.)

"It was 3 a.m. when I answered the banging on our door and saw my neighbor surrounded by the soldiers with their guns, tanks, and Apaches. I was still in my

pajamas. They wouldn't even let me dress but forced me out of the house and took me to my neighbors' house, which was also full of soldiers."

The IOF soldiers present were all male, and Nariman immediately demonstrated her substance to them.

"The soldiers wanted to take me to prison straight away, but I refused because there were no female soldiers. I told them I would not go. I told them to kill me there and then because I would not get in the jeep with just men."

For Nariman, this stance was an act of resistance; for the soldiers, it was a demonstration of the resolve they would face throughout her confinement. Eventually, the IOF agreed to let Nariman's brother accompany her in the jeep as far as the military base since there were no female soldiers present. They were driven to A'rabi, a military compound, where she remained for just an hour before being moved to Salim, a compound next to the Green Line. At Salim, Nariman's hands and legs were cuffed, and she was locked in a cell until she was transferred to Al-Jalama Interrogation Center around 10 a.m. For the next fifteen days, Nariman was interrogated continuously.

"They said I was planning to send a girl to carry out an [resistance] operation inside Israel. They kept questioning me about this, but none of it was true."

Nariman was not physically beaten during these interrogations, although that would come later; instead, she was blasted with ice-cold air from the air vents followed by very hot air, constantly alternating between these two extremes. This process is intended to cause stress and disorientate its victims. In her cell, raw sewage was pumped around the floor until it was flooded.

"I thought the sewage pipes were broken. I told the guards, but they said, 'You are in a five-star hotel. Look, you have a swimming pool, fresh air, and a view. You have everything!'"

Nariman, now twenty-four, laughs as she tells me this. It is clear that whatever techniques the interrogators used in their attempts to break her failed miserably. She was kept in these inhumane conditions for a full two months. During this time, she was taken to court every fifteen days. At court, the interrogators were always granted another fifteen days for "questioning." After her court appearances, Nariman would be immediately taken back to her "five-star hotel."

This incredibly strong young woman was eventually sentenced to three years' imprisonment, another indication that the Israeli authorities had nothing

against her. Many other Palestinians accused of similar crimes have received at least one life sentence.

"I was sent to Telmond Prison. There my cell measured about three meters by three meters. Three of us shared it, but there were only two small beds with the third person forced to sleep on the floor. We also had a toilet and were allowed three hours' exercise daily in a large area with other women prisoners. There was fencing and a roof though, so we could never see the sky. Men were also imprisoned at Telmond; we could shout to them sometimes, but we never saw them. We were given food three times a day, but the meals were very small and disgusting. Three of us would share a few white beans and some *lebenah* (yogurt)."

Nariman was allowed visits from her family, which was another sign that the Israeli authorities knew she posed no security threat, but these visits didn't always go well.

"One day a guard came to tell me my mother was here to visit me and took me from my cell. I could see my mother waiting to see me, but a female guard began to wave an electronic stick all over my body. I told her to stop because these machines can cause cancer, but this just made her do it more. I told her three times to stop, but she just kept repeating it so I pushed her away. Because of my dignity, I pushed her. I have dignity, and I will never let them take that away!"

The guard immediately sounded an alarm as though she was being attacked. Within seconds, many soldiers—described by Nariman as "Special Forces"— appeared who were armed with huge shields and heavy clubs.

"They attacked me and beat me severely. They split my head open. I was covered in blood!"

All of this happened in full view of Nariman's mother, who was forced to watch her daughter being savagely beaten. After beating Nariman, as she lay half conscious in a pool of her own blood with her head split open and badly swollen, the soldiers took photographs of her. When she regained consciousness, she was sitting with her hands tied behind her to the back of a chair. As she opened her eyes and tried to focus, the first things she saw were the photographs being held up in front of her eyes by her captors. Nariman says this caused her deep psychological trauma, and her depression lasted for a long time.

Nothing much ever changed during the time Nariman spent in Telmond; these were the conditions forced upon her, and she could do nothing to change

that. She was finally released in September 2006, but after three years of incarceration, her readjustment to family life was not easy.

"At the beginning when I got home, things were very difficult for me. Despite all the love my family showed me, I felt like a stranger with them. Things are much better now; with their help, I am adjusting back to normal life. I am now back at university studying, and I recently got engaged. I am rebuilding my life now."

A tall, attractive, blond-haired girl named Suha sits next to Nariman as she relates her ordeal. Throughout the conversation, she constantly joins in. The two young women laugh a lot together, and they are clearly very comfortable in each other's company. Suha's part in the conversation is not based on secondhand information; she is also a former prisoner of the occupation.

Suha's prison experiences are similar to those of her friend. She was also accused of planning operations inside Israel, for which she served seven months. Also like Nariman, when Suha talks, she does so very matter-of-factly, running through experiences as though reading a shopping list or menu.

"My experiences are very similar [to Nariman's]. I was tortured both physically and mentally, fed inedible food, and I also spent time in isolation. I was never allowed visits, though, during my entire time in prison. I was beaten several times, including in the courtroom itself. I was hospitalized once after a particularly bad beating."

Suha was in Ramallah at the time of her arrest. Her father was a driver and had recently purchased a new car in the city. Ramallah had been under curfew, and when this was finally lifted, Suha offered to travel there to make the final payment on her father's new car. She was stopped by an IOF patrol that searched her and, after finding the 5,000 Jordanian dinars, immediately arrested her. The IOF claimed that the money was to fund a military operation, an accusation Suha scoffs at. Suha shows me a newspaper clipping of the arrest that she keeps in her purse. The photo shows her being led away surrounded by IOF soldiers. Suha also tells me, between giggles, that she was also traumatized while in prison, but it wasn't the isolation cells or the beatings that got to her.

"Cockroaches! That was the worst thing. My cell was filled with them. I got a skin disease from them; they were everywhere! Now I have a phobia about seeing cockroaches."

The two girls burst into laughter then and again after Suha's next interjection. "It wasn't the first time they had arrested me, either; that was during the First Intifada when I was eleven! Eleven years old and they just picked me up outside my house and took me away to the Mukata'a!"

The First Intifada occurred before the PA had been formed, and each West Bank city had a Mukata'a that was used by the Occupation Forces as an interrogation center or prison. After detaining Suha, an eleven-year-old child, at the Mukata'a for a few hours, she was released and placed under house arrest for one month.

Both girls have immense strength, and they love to laugh. Humor is a coping mechanism that is often used in Palestine. They are both survivors, and Nariman says her experiences have only strengthened her resolve.

"I feel it has made me stronger; I kept my dignity through it all. I am proud and determined, and whatever they tried, they couldn't make me crack. I am not easily defeated."

These sentiments cannot be doubted. I wonder if Suha feels the same way. When I ask her, she just looks at me and smiles. "Al hamdullila!" (With thanks to God!)

By this, Suha means that she has survived with God's help. She may have been physically beaten, but she will never be broken. And she is still laughing.

[Who Else Will Protect My Family?]

The scenes I witnessed on Friday I have witnessed many times. They happen, and have happened, all over Palestine virtually on a daily basis for years. They rose to international attention through the First Palestinian Intifada from 1987 to 1993, and they are no less apparent or relevant today. But as was demonstrated by comments made by journalists at the scene, these scenes and actions are not always clearly understood and continue to be misrepresented by the world's media.

The air was thick with black smoke bellowing from burning tires and the lurid stench of tear gas. Sirens wailed and tires screeched from IOF jeeps as the sound of automatic gunfire echoed through the skies and bounced off the walls of the ramshackle houses of Qalandia Refugee Camp. Two IOF jeeps were thundering up and down the narrow dirt track that runs between the camp and its neighboring wasteland. They would pause at the end of Qalandia's narrow streets just long enough to release rounds of tear gas and gunfire. There was also a barrage of rocks raining down onto the heavily armored jeeps as their occupants sprayed their lethal artillery at children. They were clearly shooting at the shebab, and it was they, the youths of the camp, who were attempting to defend Qalandia Refugee Camp with just stones and rocks.

The gas cleared when the IOF momentarily left the area of the camp in which I stood. Heads peeped over rooftops, and voices rang out nervously, "Wein jeep? Wein jaysh?" (Where is the jeep? Where are the soldiers?)

Information was passed on across the rooftops and down into the alleyways where the shebab lurked. They began to regroup. Shopkeepers pulled their shutters closed. Mothers kept their children inside their houses, knowing from years of experience that the jeeps would soon return. Faces watched from windows. The shebab began to reappear; they were collecting stones and watching, waiting tentatively for the jeeps to come back. I spoke to some of them; they were open and friendly yet rightfully nervous. In no way were they aggressive. They described how this had all begun.

"We were waiting on the main road for someone who is being released from prison today. We were laughing and talking. Then the jaysh began to shoot tear gas at us. We don't know why."

The shebab numbered at least a hundred, maybe more, and were mostly between fourteen and eighteen years old. They were young refugees who have lived their whole lives in forced exile. They outnumbered the IOF numerically, but further comparisons between these two groups are futile.

The IOF is the fifth largest and best-equipped military force in the entire world. It receives its military firepower from the United States, from Euro-pean nations, and from others who seem happy to provide weapons to be used in an illegal occupation and for human rights abuses. This is the most advanced military equipment money can buy.

The shebab are unarmed youths who are equipped with only the rubble of the streets and, in the case of Ramallah's Qalandia Refugee Camp, the neigh-boring wasteland.

At one stage, the IOF withdrew to a road at the top of Qalandia and called reinforcements in. Soon there were four IOF jeeps, two Israeli police jeeps, and an IOF lorry filled with soldiers. From their vantage point, they could see and rain firepower into the camp. The young Israeli soldiers opened the reinforced, steel-plated doors of their vehicles and hid behind them, exposing just the barrels of their weapons as they shot at the children. The shebab refused to back down; they were defending their camp and their families.

More IOF and two Israeli police jeeps were visible across the road from the camp at Qalandia checkpoint. All these people were close enough to be reached by the shebab's stones, but no one targeted them in the three hours I was there. The shebab had no interest in people who were not shooting at them;

they were reacting to an attack and defending themselves only against those who attacked them.

One youth repeatedly got frighteningly close to the jeeps that were shooting down into Qalandia Camp. He was no more than fourteen years old, around five feet tall, skinny, and wearing a white vest with bare arms. He stood bolt upright in front of the jeeps, no more than a few meters away, trying to repel them with stones. The stones could not hurt the soldiers in their reinforced military jeeps; they bounced off harmlessly. When the ominous barrel of an M-16 emerged and pointed in his direction, he ducked, or slid, to one side behind a concrete barricade before reappearing and confronting the soldiers again.

By this time, the IOF was shooting live bullets with the tear gas. On more than one occasion, I witnessed laughing soldiers pick up rocks and hurl them back at the children, shouting obscenities as they did this. It was as though they felt they were taking part in a game and were safe in the reassurance that their firepower provided. Journalists were active near the jeeps; I heard some of them with clear English accents, describing the "violent clashes" into the camera. I asked some of them if they had seen these events unfold.

"We were waiting for the prisoner who is being released today. There were many kids around waiting, too. We bought some of them colas and sweets, then the tear gas just came out of nowhere; it was totally unprovoked."

Their story was the same as the shebab's, but their pieces to the camera rang with descriptions implying two armies were at war. This is not the story of two warring armies. This is the story of a heavily armed occupying force attacking and invading a refugee camp and unleashing its firepower onto civilians who were mainly children and who, subsequently, were trying to defend their families and lives. The children did not leave the outskirts of the camp, they were not attacking civilians in an Israeli town, and they were not attacking soldiers at the checkpoint. They were not *attacking* anyone. They were *resisting* a violent military attack against their camp and themselves. At any stage, the jeeps could have driven away, and the situation would have been finished. It was as simple as that, but they didn't; instead, they continued in their attacks.

Nobody, least of all teenagers, should feel compelled to have to defend themselves and their families in this way. Nobody should be forced to live under a brutal military occupation and its associated regime, but that is what Palestine

is struggling under. The 1993 Oslo Accords led to the creation of the PA and their "Security Services." These security services offer no defense to the Palestinian people when the IOF invades or attacks; they are not allowed to interfere with the occupation. The UNRWA administers the refugee camps, but the United Nations also fails to provide security and defense services against the occupation attacks. Neither the PA nor any international body provides any physical protection on the ground to Palestinians from the IOF. Popular resistance takes many forms in Palestine. The shebab's stones are one such example.

I have seen these incidents many times in occupied Palestine and expect they will continue as long as the denial of Palestinian rights continues. People will not accept the status quo, and neither should they be expected to. The IOF may have the firepower to end lives, but it seems it cannot break the spirit. I have heard these kids described as violent, yet it is not violence they seek. They want their rights. This is not ungrounded or inherent aggression; it is legitimate, yet undoubtedly dangerous, resistance. These are kids who have nothing but will stand up for all they believe in: justice, resistance against the occupation, their families, and Palestine.

One day in 2006, as the tear gas cleared and residents reemerged from their freshly bullet-scarred houses in Aida Camp after yet another violent IOF invasion, I talked with one of the shebab. He spelled out why he threw stones at the jeeps when they invaded Aida Camp.

"They killed my father in the camp! Who else will protect my family?"

[Medical Conditions Caused by Political Decisions]

On Christmas Eve in 1952, Father Schnydrig, a Swiss priest, was on his way to Mass at the Church of the Nativity. He had come to Palestine to celebrate in the birthplace of Jesus. He walked past a huge area filled with tents and saw a man attempting to bury a child. This was Deheisheh Refugee Camp. The man was digging in the mud to create a makeshift grave for his son, who had literally frozen to death. Father Schnydrig began to question his own place in Bethlehem and wondered how he could be in the city to celebrate at the birthplace of Jesus while children were suffering so much within a kilometer of the church. Upon returning to Europe, he began to raise funds and soon opened Caritas Children's Hospital in Bethlehem. In 1978 Caritas opened a new building; it now has excellent facilities. Conditions at the hospital have improved greatly from an initial fourteen beds in the mid-1950s to being able to treat more than thirty-four thousand babies and children in 2006. Life has also changed greatly in Bethlehem over this time. Deheisheh's refugees now live in houses instead of tents. Bethlehem itself is now an occupied city.

In 2007 a man walked into Caritas Children's Hospital carrying a small baby in his arms. The child's feet were blue; they were frozen. This time the child's life was saved.

Palestine in 2007 is geographically unrecognizable from Palestine in 1952. Go back another four years and "Historic Palestine" still existed. Now only around 12 percent of Historic Palestine remains as Palestinian land, and even that small area of land is still militarily occupied. Caritas Hospital cannot even cater to all of

this 12 percent. Children from the Gaza Strip cannot reach the hospital, owing to the imprisonment and closure of the coastal area and its physical separation from the West Bank. Children from Jenin, Nablus, and other cities in the northern section of the West Bank cannot reach the hospital because of travel restrictions, checkpoints, and the series of Bantustans into which the occupation is dividing the country. Because of these factors, Caritas Hospital can only treat children and babies from the southern West Bank, the areas around Bethlehem and Al-Khalil. Despite this massive reduction in its catchment area, last year saw the largest ever number of patients treated at the hospital.

The physical effects of the occupation are varied and widespread. Children injured by the IOF are not brought to Caritas Hospital as it has no emergency casualty unit; instead, they are taken to state hospitals in Bethlehem. Even so, a very high percentage of all children in the hospital have conditions that relate to the political situation.

Walking around the hospital, it is hard not to be impressed by the facilities and the standard of care, but another striking sight is the size of most of the children. Children suffering from serious malnutrition are regularly brought into the hospital, but as I am taken around the hospital by some of the many dedicated staff, they begin to explain failure to thrive (FTT) to me. The majority of the children at Caritas Hospital are not from the cities of Bethlehem or Al-Khalil; they are from the refugee camps and villages in the area. The economical and environmental conditions in these areas are generally lower than inside the cities themselves. Outside of the cities, poverty levels are more severe; subsequently, both diet and health suffer. Heating is insufficient through the winter, and access to clean drinking water is also a major problem.

One tiny child catches my attention, as her huge brown eyes gaze at me inquisitively. After covering myself with a face mask, gown, and gloves to prevent the spread of infection, a doctor takes me over to meet her.

"Lama is from Al Khadr village. She is ten months old but has the growth parameters of a baby less than four months old. Her mother had no milk to feed her with, so she simply couldn't grow. Her parents haven't been here in a month now."

A lot of the children are suffering from gastrointestinal problems that can manifest as sickness and diarrhea. Such problems are common in children

worldwide, but in Palestine, as in many parts of the unprivileged world, children are dying from such conditions. Parents do not have the money to pay for hospital care, so they often delay going to the hospital until it is almost too late. As another doctor explained, in some cases, it *is* too late by the time children reach the hospital.

"A few months ago, a man brought his son in. The family had no money at all and felt ashamed to beg for help, so they delayed seeking treatment, hoping the condition would improve with time. Eventually, as their child deteriorated, the parents got desperate and took him to a government hospital. When they got there, the hospital couldn't treat him as all doctors were striking due to the blockade, and they were sent here. The child died within a few hours of getting here; it was just too late."

This child died from acute gastroenteritis; he was just six months old. Had he been taken to the hospital earlier, he could have been treated successfully.

Since the international blockade on Palestine began in 2006, the staff at Caritas Hospital has found that the situation has deteriorated greatly and at an alarming rate. Doctors at state hospitals had not been getting paid and took up strike action in protest, so many more children were getting passed on to Caritas Hospital. Parents have no money, so their diets and those of their children have suffered greatly. One baby was brought in with a severe vitamin B-12 deficiency, which, according to the doctors at Caritas, is not unusual in babies here.

"B-12 is found in meat and vegetables, which very young babies do not eat. Her father was a policeman who had not been getting paid since the blockade began. He could not provide food for his family, so his wife, during pregnancy, had lived on not much more than bread and black tea. By the time she gave birth, she herself was suffering severe B-12 deficiency, and as she began breastfeeding, this was made more acute in her newborn baby as there was no B-12 in her milk. We see this a lot—mothers who cannot produce good milk because of their own dietary suffering, which is, in turn, passed on to their children."

Many of the children here suffer from some form of anemia, another condition directly related to poor nutrition. I saw one child who had 80 percent iron deficiency anemia. Iron is vital in the first few months of life for, among other things, the development of intelligence. This child had been found to be

suffering from stunted psychological development as well as physical problems. These are some of the increasing effects of the blockade policy that George Bush and British Prime Minister Tony Blair promoted because they didn't like the democratic choice of the Palestinian people.

"We found things got a lot worse after the intifada began and again, since last year's blockade, things have deteriorated greatly. Nutritional care has suffered a lot. Mothers cannot produce milk so they are using powdered milk, but it is being diluted so heavily because of the poverty levels that it has virtually no nutritional value. It is also being made with dirty water."

Further evidence of the effects of poverty at Caritas Hospital is seen in the disturbing lack of parents visiting their sick children.

"We find this to be another major problem, particularly from the camps and villages around Al-Khalil. This baby here, for example, is from Yatta [a town south of Al-Khalil]. She has Short Bowel Syndrome—a twisted intestine. She also suffers from various nutritional deficiencies, anemia, and FTT. She has been with us since just after birth, and her parents have not been to see her in more than two months now. Yatta is a very poor town, and her parents simply cannot afford the transport to get here. They have other children to feed at home."

Walking around the hospital, I see rooms and rooms full of tiny babies suffering from conditions related to social conditions and poverty. When I walk in their eyes light up at seeing a new face. Some smile up at me with the beauty of new life; others cry almost constantly. One baby is so tiny I am sure she must have been born prematurely, but as we look through her notes, we find that in fact she was born after a full-term pregnancy. She is now four months old but seems no bigger than a one-kilogram bag of sugar. The doctors go on to tell me of other children brought in, carried in their fathers' arms like babies when they are in fact three, four, or five years old. They simply cannot grow—this is FTT at its most severe.

In the winter, children are being brought in with temperatures as low as 32 degrees, particularly from the camps and villages, because their houses have insufficient heating or, in some cases, no heating at all. Not all children brought into Caritas Hospital can be treated on site. The hospital has built strong links with other hospitals inside Israel, and some children are sent to them if they cannot be treated at Caritas. This is particularly the case with major operations, but

this procedure also faces many problems. Endless paperwork must be completed to facilitate the procedure, and then the child will be put into an ambulance, but this ambulance is permitted to travel only a few hundred meters up to Bethlehem checkpoint. It can go no farther because it is coming from Palestine. Even ambulances are not allowed passage through the checkpoints to hospitals in Israel, regardless of the emergency or prepared paperwork. At the checkpoint, the patient will be unloaded from the ambulance, and an Israeli ambulance will wait to collect the child to continue the journey. In one recent case from Caritas Hospital, a baby in an incubator was held up at Bethlehem checkpoint for around two hours before the soldiers finally allowed him to be transferred to the waiting Israeli ambulance. Once the child is safely in the hospital inside Israel, his or her parents are invariably stuck on the other side of the Apartheid Wall, unable to get permission from the authorities to accompany or visit their sick child.

The doctors at Caritas have also, since the start of the intifada, found incredibly high numbers of very young children suffering from a rare strain of cancer behind the eye. They have been unable to pinpoint exactly what is causing this, and it is not being found in neighboring countries, which leads the doctors to believe it is possibly a chemical toxin being used by the occupation. They have been researching the possibility that it could be caused by a form of tear gas but have so far been unable to categorically prove this theory. Premature birth and miscarriage as a result of shock or stress caused during IOF attacks are also widely seen.

The work of all the staff at Caritas Children's Hospital is admirable. The faces and tiny, weak bodies of the patients are heartbreaking, with their wanting eyes looking out of sallow faces, pleading for help. Palestine diminishes day by day. It cannot thrive; likewise, its children are suffering, quite literally, from failure to thrive. It cannot develop, and its children illustrate that fact through their continued development of poverty-related illnesses. These are medical conditions caused by political decisions.

[Back in Tents Once More]

When the UNRWA began to establish Palestinian refugee camps in 1949, they were intended as temporary, short-term measures. They are still considered temporary as in Palestine no one accepts this to be the final destiny of the refugees. The refugees are still waiting for their Right of Return to be enforced, but, sadly, the camps have proved not to be short term. The camps were originally full of tented accommodations. Over the years this has changed, and now, nearly sixty years later, people live in tall, cramped, concrete structures. Not all refugees who remain within Palestine still live inside the camps; this would be demographically and physically impossible. Some have managed to move out of the camps into the surrounding areas, but they are still very much refugees. They still yearn for, and are entitled to, the right to return to their villages, as do all Palestinian refugees throughout the world.

One such family lived in a simple, three-story house about a hundred meters from the borders of Balata Camp until 10 a.m. one Wednesday. Walking around the house just a few days later, it still contained all the signs of family habitation. Beds, wardrobes, clothes, and food were all still in the house, but it was no longer habitable. It no longer had a south-facing wall.

That Wednesday morning, the IOF launched a huge invasion into the area. No less than forty-seven jeeps full of soldiers and two military bulldozers surrounded the house. The family of thirteen people who lived on the property was ordered outside, where they found all neighboring houses, all the surrounding streets, and the small lemon grove that sits adjacent to the house occupied by the IOF.

All the family members were ordered to evacuate the house, and it was then that the military assault on the building began, and artillery began to rain down on it from all angles. One of the sons of the family, Hazim, angrily asked the IOF commander what was going on.

"What's wrong with you? What are you doing? Do you want to destroy our house?"

The reply he received was frank: "No, we want to kill your brother!"

The brother in question was suspected of being involved with resistance against the occupation. He was not in the house. The family repeatedly told the soldiers that there was no one in the house, but their words fell on disinterested ears. The invaders were clearly bent on destruction, and looking around the house now, it is clear that they were successful in achieving these ends.

The siege on the building lasted more than eight hours, despite the fact that it was empty. Every single room was littered with holes. They ranged from two- or three-centimeter bullet holes to others that were probably fifty centimeters in diameter, these larger holes being from missiles. These missile holes passed straight through the thick concrete walls as though they were paper.

As the family shows me around the house, these scars of violence are everywhere, but there are also many smaller details that remind me that this is a family home, not a battleground. Hazim picks up a formerly very smart black suit, still on its hanger. It has been ripped to shreds by the lethal ammunition of an M-16. "Look at this, my brother's wedding suit. What are my children meant to think? How are my children meant to feel when they see this?"

A pair of old sports shoes lies on the floor, similarly shredded with holes. The mirrors on the wardrobe doors have four large, round bullet holes, and the cracks spread out like tentacles across the glass. In another room, bullet holes again scar every wall. Above the smashed windows through which the initial gunfire entered the room is one of the few things that remains undamaged: a framed photograph of Abu Amar (Yasser Arafat). He appears to be smiling proudly. It makes me wonder if he is smiling at the strength of this family, which refuses to run and hide in the face of such inhumane brutality. In the kitchen on a small table, an array of herbs and spices are arranged. There is zaatar, mint, paprika, salt, and pepper and a bottle of delicious zeit. This table is the only thing remaining intact in this room; the walls surrounding it are littered with holes. On another

wall, only a tap remains, its sink and pipes have been blown off the wall, replaced by a fifty-centimeter-wide crater. The skeletal remains of the refrigerator have been moved into another room that now has a huge vista onto the lemon grove below where the walls used to stand. Thick, metal reinforcement tubes have been put in their place in an attempt to prevent the collapse of the ceiling. A military bulldozer demolished the walls while the family could do nothing but watch helplessly.

The IOF had already sent dogs in to thoroughly search the premises well before its men demolished the walls. They knew the house was empty, and the man they were seeking was not around. For them, this was just a demonstration of power, of their physical domination over a people. Such actions are legally termed "collective punishment" and are illegal under international law. Sadly, international law plays little part in the strategies of the Israeli occupation.

After showing me around the remains of the house, the family takes me downstairs, carefully sidestepping the huge bomb crater in the stairwell. We sit in a small basement room to drink coffee. One of the young boys brings out a silver-plated tray filled with miniature coffee cups; the others in the room start to laugh, "Look, even the tray has holes in it!" On one side of the metal tray is a single unmistakable hole, courtesy of an M-16.

The family no longer has a sitting room, so outside the house, other family members gather and receive guests in a tent, much as this family did all those years ago after they were forced from their village near Yafa.

Less than a hundred meters from this tent, there are more canvas reminders of days refugees thought they had left behind: two small tents sit among the rubble of another former home.

In April 2002, a seven-story apartment block was blown up by the IOF on this site. Eighty people were made homeless by this immoral act, including twenty-three children. The fifteen families who used to call this building home have never been given any reason as to why their building was targeted.

Shortly after this incident, Abu Amar came to visit the families and assured them that the PA would rebuild their apartments. It has now been five years since the demolition, and the affected families still have not been rehoused. They continue to live with supportive friends or members of their extended families. They are still waiting for somewhere they can once more call home.

April 2002 was the same month as the infamous IOF massacre in Jenin Refugee Camp and the month in which the attack on Ramallah's Mukata'a continued, which had begun in late 2001. The Mukata'a, since the 1993 Oslo Accords, has been the headquarters of the PA and, at that time, of President Yasser Arafat (Abu Amar). When Abu Amar visited Nablus, he had also visited the rubble of Jenin Camp. By September 2002, as the IOF siege of the Mukata'a continued, Abu Amar would not leave it again until he was eventually flown to a Paris hospital on October 29, 2004. On November 11, less than two weeks after leaving Palestine, Abu Amar died in Paris. Looking back, some Palestinians believe that their hopes for a secure Palestinian state died with him; many seem to believe there is no other leader who can unite Palestine.

Five days ago, family members finally decided they had had enough. It was time to be proactive. They brought two canvas tents down to the site of their former homes and erected them once more among the rubble. On top of the tents, as with the tent erected at the other targeted house, Palestinian flags fly proudly in the brisk wind. This is often done after a house demolition; it is a way of saying that while Israel may destroy Palestinian houses, they will never destroy the spirit of the people or Palestine itself. There are also two photographs attached to the exterior—one of Abu Amar, the other of the current Palestinian president, Mahmoud Abbas (Abu Mazen). Next to the photos, a large banner has been erected. Written in Arabic, it roughly translates as, "Five years of occupation in Nablus and you don't care for us! Enough! We want our rights!"

This highlights how the families feel. This is not so much a protest aimed at Israel; rather, it is aimed at what they feel is a lack of support under occupation provided by the PA. A family member explained this to me as we talked over coffee in their cramped little tent.

"Israel destroys our houses and the PA doesn't help us to rebuild. We are just left here, stuck in the space between the two of them. No one asks about us. No one helps us. No one will rebuild our home. We had a beautiful house, but now we must stay with friends and rent rooms; this is not life! We have no money. We can't pay anything. We have no choices."

The family has appealed to the PA and Abu Mazen many times since Abu Amar's death, but to no avail. The PA did start some work on the site in 2006. The foundations and most of the ground floor are in place, but then they stopped work, saying there was no more money.

"Abu Amar would have rebuilt our house! But Abu Mazen says there is no money, and that there is nothing he can do."

So this is why the family came back here and erected their tents on the site again; they are trying to stir someone into action. Sharea Al-Quds is the main road from Huwara checkpoint into the city of Nablus, so everybody entering the city this way sees their tent and their protest. They have received many visitors and a fair amount of media attention. On Thursday the families are all going to see the mayor of Nablus and appeal to him for help. They are taking with them friends and all the people who used to live in this apartment block. Local television stations and the media have also been invited in an attempt to raise the profile of their case.

The strain on the family is clear. My host doesn't need to articulate his family's emotions.

"If you want to know how this makes us feel, you can write that from my mother's eyes."

I look up at his mother, who has been sitting silently in the back of tent. She wears a gray, traditional dress and white hijab. Her eyes are a sparkling blue. But while her lips smile softly at me, I can see that her eyes are not smiling. They look back at me strongly and without flinching but reflect only deep sadness.

These families are not spending their nights in this tent. They go back to the houses they are staying in with friends every evening and return here the following morning to continue their action. I ask how long this protest is going to last, and the answer radiates with typical Palestinian sumoud.

"Until they rebuild our house! We will come here everyday until they do so. We are going nowhere!"

Sitting cramped together in the tent as we talk, I am reminded how fragile this style of living is. The piece of land that is the site of their former apartment block sits above Balata Camp on higher ground and is therefore very exposed to the elements. A gust of wind hits the tent, and the pieces of wood holding the canvas in place collapse. The tent immediately starts to fall in on itself. The *nargileh* (traditional water pipe for smoking tobacco) that has just been painstakingly prepared smashes on the hard floor, coffee cups go up in the air, and the little boy sitting next to me screams. I stand up quickly and manage to catch some of the wood before it crashes onto the heads of my hosts. Within a

minute or two, we are able to erect everything again with the help of a couple of large rocks for added stability. When I turn to look at the man with whom I have been talking, everybody starts to laugh; dark coffee trickles down his forehead. Laughter aside, this demonstrates something about how life in Palestine's camps must have been all those years ago when people had nothing but canvas to protect themselves from the elements. It was a fragile and precarious existence. Life has changed in the camps as people have constructed concrete accommodations for themselves and their expanding families, but this has brought with it more severe overcrowding. The land that Balata Camp was originally intended for has not expanded. In the early 1950s, around five thousand people lived in tents in Balata Camp; currently, there are around twenty-five thousand people living literally on top of each other on the same patch of land. But for some families, such as the two described here, they find themselves back in tents once more.

"Girl on Roof"—Jenin Refugee Camp

"Who Else Will Protect My Family?"—Aida Refugee Camp

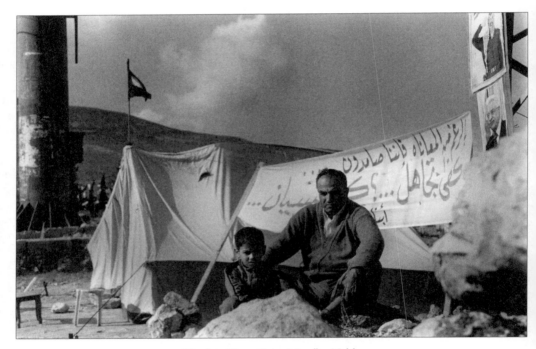

"Back in Tents Once More"—Nablus

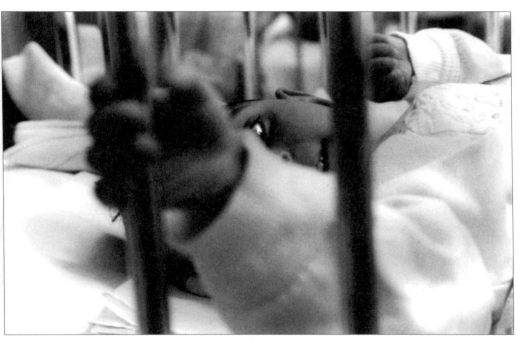

"Medical Conditions Caused by Political Decisions"—Bethlehem

DREAMS OF RETURN

[Going Home (Part 1): However Long It Takes]

"I could see only an Israeli settlement instead of Ras Abu 'Ammar. There was a checkpoint that stopped us from entering the village. I took photos from a distance, but I found all the land was now a settlement. I felt this was not my village anymore and that they had taken it from me. This is my village, but I could not enter it."

Mohammad is angry as he talks. He displays a passion that may have surprised me in a thirteen-year-old child had I not spent so much time inside Palestine's refugee camps with children who, much as their parents have, have lived their whole life in forced exile.

Ras Abu 'Ammar was not the first village we had visited that morning. The day had begun in Al Malha, a village that has now been eaten up and seemingly swallowed by the sprawling colonization of Al Quds. Blue street signs in Hebrew, a zoo, a train station, the city's largest sports stadium, and thousands of Israeli-inhabited houses covered the site that, until 1948, was home to around three thousand Palestinians. It was as if the Zionists were rewriting history, or rather totally denying that the history had ever existed. But while the signs can mislead, distort, or even mask the horrible truths they hide, they will never completely bury the ethnic cleansing they try to deny. As we headed up a hill in Al Malha, a literal tower of strength stretched out and above the surrounding houses. It had resisted the almost entirely encompassing sprawl of development. If we were lost on a dark night at sea, this tower was our lighthouse. It was the ancient Palestinian mosque that had served the village and its residents for years before they were forced out in 1948.

When Theodor Herzl, the founding father of the Zionist dream, described Palestine as "a land without people for a people without land," he had intended the world to believe such propaganda. While countless governments internationally have attempted to help propagate such lies, this resilient minaret and the more than 750,000 people who were forced from their homeland would never accept this lie in silence. Now these original exiles have become millions of Palestinian refugees, and the lies are horrifically clear to all.

Earlier in the day in Al Malha, as Israeli children skipped playfully into the new school opposite the mosque and bounced basketballs around its playground, I stood outside with Rawan and Samah, two girls who were born into a crowded refugee camp only a few kilometers away as a result of the atrocities that created these facts on the ground. They found a certain pride in seeing the minaret, despite the fact we couldn't reach the mosque itself owing to the maze of Israeli-inhabited houses that now surround it. Rawan wanted to find the houses her grandfather had told her about. She wanted to take back *marimeyah* (sage) and zaatar to him in Aida Camp, but apart from the mosque, there was little she could see. The girls finally found some olive trees, but it was not their age that gave Rawan her connection to these trees.

"Finally I found two trees, two small trees. I knew they were not ancient trees that had been planted in our original country, but it was enough for me, and for my grandfather, that they had been planted in Al Malha's soil."

They photographed the trees and the mall itself that had been built on land their relatives nurtured until security guards began to scream at them and order them to stop taking photos. I approached the fuming guards, who were calling the police, as the girls went back to the bus. More guards and police arrived and began to shout, demanding the camera. They told me it was illegal to take photos at the mall as it posed a "security threat." I asked them to wait while I retrieved the camera from the girls. Their hesitancy gave me just enough time to swap cameras, return with an empty one, and convince them we had not photographed anything at the mall.

In Beit Natif, we found the kibbutz of Netiv. The slight change of name and the ugly housing units that had replaced the traditional Palestinian abodes of rolling archways and local stone once more masked the history, but the huge, gnarled trunks of the olive trees told us other stories. There we tasted the delicious

local rumman fruit (pomegranate) about which we had heard so much from the Nakba survivors of Beit Natif. Young Americans strolled around the kibbutz with shopping bags filled with groceries and beer, while those who could truly call this village their home and who can still remember the place as it was languished in Aida Camp in proud traditional dress and with an inadequate supply of fresh water.

On the land of Ajur village, another kibbutz stood with the name of Agur, and outside its gates we saw the beautiful houses we had heard so much about. They were not complete and were few in number, but they stood proudly as living skeletons of history. In the surrounding fields, the swollen ripe sabar brought joy to the faces of Amjad and Saja, while picking it brought spikes to our fingers. Their grandmother had told them so much about Ajur's sabar. She told me that if she could just taste this delicious fruit, her sweetest memory, once more in her village, she could die a happy woman. She would have loved to come with us, but even had her health permitted it, her ID would not have. The disgusting reality is that the children could only make this journey of discovery back to their home villages because they were too young to have to carry ID and because they had a foreign passport holder with them. Once again I found myself with greater rights in Palestine than Palestinians themselves have.

Amjad's face was alive and his head filled with his grandmother's memories as he knelt on his land and let the rich red earth slide through his fingers. His excitement was uncontainable. He wanted to explore everywhere at once; his walk was two inches taller and his chest two inches wider now that he was back in his village.

Yet when we eventually located Zur Hadassah, built on top of Mohammad's home village of Ras Abu 'Ammar, he found nothing. He, too, had interviewed survivors of Al Nakba in preparation for the trip. His grandfather had recounted in infinite detail his vivid memories of his days growing up among the pine trees, playing in the many freshwater springs, exploring the mountains, and picking herbs and fruit. But none of these memories matched the sight that greeted Mohammad's eyes. Instead, he was greeted by huge, electric fences with warning signs written in Hebrew and by uniform, bland houses with distinctive red roofs that reminded him of the illegal Zionist colonies that litter the West Bank. The sight of the huge yellow gate and control rooms that opened it only for

the entrance of residents' cars, keeping at bay Mohammad and his sister, Ahoud, were painful for the children.

"I felt that my village should have been beautiful like other villages we saw, but when I saw it, I didn't feel like it was my village. My grandfather had told me there were ten water springs and two mountains in Ras Abu 'Ammar, but when I went, I could see nothing. I found that everything had changed as though it was not really my village."

The towering minaret of Al Malha, the steadfast ancient olive trees in Beit Natif, and the ruined houses and immovable cacti of Ajur had all provided other children with a sense of pride. These remnants of days gone by, and of their own identity, were all startling only in their absence in Ras Abu 'Ammar. On the land of the other villages, insignificant as they may seem to the current residents, these physicalities had offered the children something tangible and visible that brought their grandparents' memories, and their own history, to life. We had been told that there were still ruins to be found somewhere in Ras Abu 'Ammar, but we just didn't know where to look. As far as we could see, there was nothing but this settlement that seemed to have swallowed Mohammad's land.

When the bus in which we were traveling had initially pulled up outside the settlement's gates, I asked Mohammad and Ahoud to come with me to take some photographs, but he refused. "This is not my village! I will not take photos here; this is not my village!"

When he eventually came down from the bus, he still could not accept that the sprawling city in front of him now covers the land on which his grandparents had lived. I had never visited the area before, and since there were no signposts or other evidence that we were in fact in the right place, I rang people back in Aida Camp for confirmation. Two people in the camp who knew the land well told me that this was the site of the destroyed village of which Mohammad had dreamed so many times. Mohammad had been to the village himself previously, only three short years ago; Zur Hadassah was there then, but it had grown so much during this time that it was now unrecognizable to him. It had taken in more land, and the fences kept him away from all but a couple of meters of land outside the fence that encircles Zur Hadassah. As we discussed what we could see together, Mohammad's gaze was rooted downward, but it wasn't because he was shying away from eye contact. I realized he was actually looking hard at

the ground around his feet, studying it, looking for something to recognize. He dropped down to his knees and began to touch the soil, playing with it in his fingers. He was feeling the textures and the shapes as though he were a blind man reading Braille. As his fingers caressed the earth, he asked, "Is this my land? Is this my soil? Are these my stones?"

It was not said to anyone in particular; maybe he was asking himself or maybe he was speaking directly to the land. He was looking for something to hold onto emotionally and physically, something about which he could proudly say, "This is from my village," when he returned to Aida Camp. His words may now sound very depressing, but in a way, they were Mohammad's light. They offered him a beacon of hope. The stones and soil were not what he had dreamed about, but they were still from his land. This tiny strip of land on which he stood was all of Ras Abu 'Ammar that he could now reach, but it was at least Ras Abu 'Ammar.

"I saw stones and soil at the entrance to the village. I took some to give to some of my friends in the camp who are also from Ras Abu 'Ammar but who had never visited the village or seen it before. My aunt asked me to bring her zaatar and marimeyah, but I took her stones and soil instead. I could not enter to get her what she had asked for, but I felt that the soil and stones were still ours, and they were better than nothing. Those stones I took will make me always remember that my homeland will return to me and my people one day."

The words and actions of this young boy, who I have known for three years, were both heart wrenching and beautiful at the same time. They devastated me and lifted me simultaneously; it is hard to describe adequately with mere words, yet it is a moment that will live with me forever.

This notion that words simply cannot describe such an experience could be said to sum up this trip. I myself have learned about Al Nakba history through people in the camps; I have talked with Al Nakba survivors and seen the passion with which their grandchildren talk about their villages. I have heard statistic after statistic and seen photograph after photograph, but for three years I had refused, despite repeated requests from friends in the camp, to go to the villages alone to take photographs for them. I had refused because I always believed I could not understand the villages sufficiently from a visual perspective alone and therefore could not have done the land or their memories justice. I am now

convinced that I was right to make such a decision. The villages cannot be understood in such terms because they are not merely physical. As I visited the villages with the children, through their actions and reactions, layer after layer of deep emotion, understanding, and connection unraveled themselves. I saw the children carrying their emotions proudly on their faces and heard them articulate words and feelings that were simultaneously painful and also deeply inspiring.

If Theodor Herzl, Golda Meir, Ariel Sharon, or Ehud Olmert really ever believed the refugees could be forgotten or silenced, they were badly mistaken. If they ever thought memory would die or pass with time, they were wrong. If they hoped that future generations would lie down in submission and dutifully accept all the wrongs that have been perpetuated against them without struggling for their rights, they should have thought again.

Nearly sixty years after Al Nakba, I sat in a chair in a small room in a Palestinian refugee camp and talked with a young boy about our trip back to his land. He said something to me that I have heard uttered by survivors from 1948 many times but have never heard from a thirteen-year-old boy before. He knows that the road ahead may be long but is prepared for the journey irrespective of its duration.

"If I couldn't return, then my sons after me, and the future generations for sure, will go back, because this is my village, my home, and my land on which my grandparents lived. . . . The right to return to my village will come one day, however long it takes."

[Going Home (Part 2): Phone Calls from Beit Jibreen]

As Salah left the bus, realizations set in. They were not realizations that any of us still on the bus were unaware of, but they were painful nevertheless.

Salah is one of Lajee Center's founders; he is also like a brother to me. He is a man who has lived a life about which several books could be written. They would be books filled with stories about time locked up in the occupation prisons; about working as a leader and organizer of people, prisoners, and children; and about his time surrounded by tanks, soldiers, and the world's press while captive inside the Church of the Nativity for forty days during the 2002 siege. They would be stories about visiting every prison in the country as a child to see his elder brothers before he himself was later incarcerated, about seeing friends and family members murdered, and about resistance, life in exile, and what it means to be Palestinian. He was leaving the bus not because he didn't want to come on the rest of the trip with us, but because he has a West Bank ID, and we were approaching a checkpoint to take us out of the West Bank and away from the Apartheid Wall. He would be stopped at the checkpoint and taken from the bus, and he did not want to jeopardize the chances for the rest of us. We were going to places many of the children had previously only dreamed about; they were going home.

I spoke to the young IOF soldier in English, telling him all the children were young and had no ID and that I was taking them to swim in the sea at Yafa. It was not the right time to try to convince an Israeli about the Right of Return. He took my passport to be checked but returned within a few minutes, gave me my passport back, and waved us on. The children waited until Hussan checkpoint

was out of sight, and until they felt a little safer again, to let out a huge cheer. We were out.

Before passing the checkpoint, we had already visited some of the remnants of Al Walaja village. The original village of Al Walaja was ethnically cleansed in 1948, and its residents crossed the Green Line, which runs alongside the village. After the attacks had subsided, they established a new village on the West Bank side of this invisible line. In 1967 some villagers, those who had built houses alongside the Green Line, were forced to flee again, and these residents of Al Walaja moved farther into the West Bank. At this time, the IOF finished the destruction of the evidence of the original village, flattening all houses that still remained in their attempts to erase the memories of Palestine from sight. The village now known as Al Walaja, which is alongside Beit Jala, is the village that was established after the attacks of 1948 but then expanded after the attacks of 1967 as more people fled. So the residents of Al Walaja are themselves refugees, some of them having been displaced twice over. Others from the village came to the camps. Eighty-three-year-old Abu Fahmi is one of those who came to Aida Camp. Before we visited the village, he described some of his memories to his grandson Ahmed.

"In 1948 Zionist gangs attacked Walaja from three sides; they left the eastern side open to people. The people in the village tried to protect it as much as they could, but they couldn't stop the Zionists from occupying their land. Some people fled to the east side of Walaja, where the new Walaja is now, near Beit Jala. Some tried to return; many of them were killed. Days after the 1967 occupation began, Israeli forces came and demolished the old Walaja completely. We were watching that but could not do anything."

Al Walaja's tortured history does not end there, however. The Wall is currently being built around the new village of Al Walaja. This time the village is not being moved; it is being imprisoned. Abu Fahmi remembers life in the original village well. When Ahmed told him about our trip to the village, he made a simple request:

"Oh! If you can just bring me a bottle of water from Walaja springs, I will drink from it and wash to pray. I do not care if I die after that."

So that is what Ahmed did when we returned to walk among the few remaining ruins, the fig trees, and on the rocky ground of Al Walaja. Ahmed

drank from Ein Al Hanieh—the same spring from which his grandfather had drunk nearly sixty years earlier—and he filled a bottle from it to take back to Abu Fahmi in Aida Camp.

Soon after passing Hussan checkpoint, the bus driver pulled over. There was little to see other than evergreen trees and rocks, but we were now on the land of the depopulated and demolished village of Al Kabu. For twelve-year-old Hiba, this was the realization of a dream. There were no houses like those we had found in Al Walaja, but the knowledge that this land was her home stoked a mixture of emotions.

"I enjoyed the natural views and smelled the fresh air. I ran between the trees, photographed everything my eyes fell on, and picked some fruit. I felt sad and happy at the same time—sad because Al Kabu was occupied, my family was not with me, and I could not see everything I wanted and had heard about . . . but happy because I was there, sitting, playing, and dreaming."

In Beit Atab, Yazan explored the land of his ancestors. We sat together to share some of the delicious figs his grandmother had described to him nostalgically a few days earlier.

"Figs nowadays are not like in those days. Beit Atab figs are pure honey!"

Yazan's face was alive and his energy boundless in Beit Atab. The attachment he felt was evident in his every action and word.

"I am not a stranger here in Beit Atab! I feel it belongs to me, and I belong to 'her.' Of course, I am sad because of the demolished houses and because Beit Atab has become a big park for settlers, but I feel safe here between the trees and happy because those trees are still alive and green."

Yazan's words brought a lump to my throat. Children never use sentiments such as "feeling safe" when talking about life back among the airless, gray, narrow streets of Aida Camp. Not even inside their own houses surrounded by their families would these children dream of making such a bold statement, such is the trauma created by the occupation in their daily lives.

As the bus drove up the rocky road away from Beit Atab, eleven-year-old Athal again squeezed my hand and asked me the same question she had been asking since I had first seen her at 6:30 a.m. that morning,

"Now? Are we going now?"

When I smiled and nodded my head, the sparkle in her eyes made my heart race. We were going to a place that was like a mystical dream in her mind, a

village that I have heard more stories about than any other because of my strong bonds with her family, which I have written about many times. Athal Al Azzeh; her brothers, Miras and Rowayed; and her cousins Maysan, Suhaib, Sa'ed, Abud, and Samah were all on their way home. We were heading for Beit Jibreen.

When I had taken Miras to visit his grandfather in the hospital in Al Quds, Abu Waleed, Miras's grandfather, had again begun to tell us stories about Beit Jibreen. I love to listen to his memories, and the pleasure he gets from them is clear in the way his face lights up during these discussions. Having heard so much about the village, I was also excited, but not in the way the children were. They felt more than just excitement; it was something indescribable, something beautiful yet saddening in the same moment, knowing that their level of attachment has been built up while living in forced exile. When we saw the first sign for Beit Guvrin, the noise levels exuding from the Al Azzeh children went up several decibels. Beit Guvrin is the name of the Israeli kibbutz built on top of the Palestinian village. All the children knew about the kibbutz and the name change, so seeing their village described in this foreign tongue didn't dampen their spirits. As we drove up to the village, cameras snapped wildly at every cactus, tree, and rock in sight, despite my repeated remarks that they didn't need to take photographs yet because we would get out and walk around the village. But they were taking no chances of missing anything, just in case something went wrong and we were not allowed our visit. When the children first saw Antica, the ancient Roman ruins in the village, squeals of excitement filled the bus.

It had been a long morning, so when the bus finally pulled up alongside the entrance to the kibbutz and ruins, we decided to first eat a late breakfast. I was also at pains to explain to the children that we may not be able to visit the ruins or kibbutz, knowing they were all fenced off and not wanting the children to build up their hopes only to be let down. The kibbutz was not of real interest to the group anyway. We all knew there were still a few Palestinian houses here and the remains of the mosque, and it was these relics of their history and identity that excited the children. Our first port of call was not the ruined houses but the ancient cacti that had stood steadfastly since well before the days when Abu Waleed had himself been no more than a child in Beit Jibreen. The children had heard much about sabar from Beit Jibreen, and it was to prove the most delicious desert with which to finish off our food. Before we could taste the succulent fruit,

we had to find a way past its razor sharp thorns. Suhaib has never been a fan of sabar, but that did not stop him taking up the challenge immediately.

He explained to me the day after the trip, "Although I do not like cactus, I picked cactus . . . I loved to do that because it was in Beit Jibreen, and they were tended by my great grandparents. Some of its needles got into my hands, one needle is still now in my foot. . . . I wish I could keep it forever as a memory."

The cactus is a sturdy plant, one that, once established, can live through most conditions. Beit Jibreen's cacti had stood firm through so much. They had resisted war and occupation and were resilient through drought and flood. Their huge, flat, green shapes twisted in all directions, but their roots never let go of their earth. To the children, these historic plants represented all things Palestinian, and these incredible natural structures were every bit as Palestinian as the children themselves. They held onto the village physically, much as the children did emotionally.

As we walked toward the entrance to Antica, the lucky children laughed at their unfortunate friends who cursed and squealed while plucking thorns from their young hands. I had been warned that an entrance fee was required to enter the Roman ruins, which is why I had explained to the children that we may not be able to enter. The issue was not about finances; it was about principles. We would not pay Israeli guards to walk in a Palestinian village, whatever its current name may be. The guards approached me with questions, but with some quick talking, the children were soon inside the ruins. At the entrance stood rows of black plastic buckets labeled in Hebrew. They contained artifacts excavated from the site and were being stored before being sent off to an Israeli museum. The ancient, broken pottery within looked uncared for and bore modern blue stamps of Hebrew writing. The suspicious eyes of the guards were on us, but Miras's eyes were on his sister.

"Israeli guards prevented my sister Athal from touching any piece of broken pottery, but Athal took one for memory. . . . She did not feel that she was stealing; she was happy and said to me, 'It is not theft; this piece is ours. It is from Beit Jibreen, and when we return to Beit Jibreen, I will bring this piece with me to its home.'"

Athal felt she was safeguarding the village's history. She did not want to see all the artifacts forced to leave against their will and felt she could protect

this little piece of history until she could return it to its home when she returned to hers.

The ruins provided a maze of adventure and history for the children. The towering archways, dark tunnels, and defiant walls could have kept them amused for hours, but there was more we wanted to explore in the village. Rowayed used my phone to ring his father, Nidal, back in Aida Camp. He spoke at a hundred miles an hour, trying to describe everything at once—the trees he could see, the ruins, and the cactus thorns now stuck in his fingers; the guards, his sister, the blue sky, the songs he had sung; and the dance he had performed for us all to accompany his sister's beautiful singing in the ancient Roman hallways of Antica. He had so much to tell. He wanted his dad to know every minute detail and to see it through his eyes, as Nidal himself could only dream about such a visit. There was something very uncomfortable and surreal about this phone call. Nidal had spent so long passing on the history of their family's roots to his children, and now he was blind to physically see what his children could. This was not to be the last phone call of the day.

We visited the old mosque that now stands barren and unloved alongside the road. Next to it, a large, white sign had been placed on the ground. The sign was written in Hebrew, but two words in English read "Gift Shop." Maybe there are future plans to "develop" the mosque.

I had seen a beautiful old house up a hill a few hundred meters away on the road out of the village and asked the children if they wanted to explore it before we left. I didn't really need to wait for the answer, so I directed the bus driver in the right direction. Pulling off the main road so as to reach the hill on which the house stood defiantly, Hebrew signs informed us that we were entering an "Israeli National Park." We pushed trees apart and clambered up the slope eagerly.

Four magnificent and perfectly intact archways decorated the face of this now neglected, yet visually stunning abode. The small, neat steps leading to the entrance had also remained firm. A tree was growing in one room. It had worked its way determinedly through cracked walls, and its branches cast a refreshing shadow where the room's roof had been in the days when this home had housed a family who had loved it. In another room, we found ancient bullets littering the floor. The casings had long ago lost their color, and their green hue made them

look as if they had been dredged up from the sea floor. The children wondered if these were bullets that had been fired in 1948.

Nidal called again while we were there. He had been unable to talk for long earlier as he had been in a meeting. "Rich, are you still in Beit Jibreen?"

I explained we were exploring an old house up on the hill.

He seemed excited, "Let me speak to Rowayed again."

I found Rowayed sitting on a large windowsill in the third room in the house and handed him the phone. He started again to tell his dad about their village, describing everything he could see. Then he began to describe the house we were in, again at breakneck speed. Athal was also in the room. Rowayed stopped suddenly. His jaw dropped as he turned to look first at me and then over into the shadows were his sister stood. His eyes were now as wide as saucers. My heart missed a beat. Was something wrong?

"Hay dar sidy?" (This is my grandfather's house?) Rowayed's mouth was open as he waited for confirmation. "Sidy Abd Al Rahman?" (Grandfather Abd Al Rahman?)

It was clear from his expression that it was true. He jumped down from the window excitedly and began to walk around the room with the phone still pressed to his ear. "Zeinab, wein Zeinab?" (Zeinab, where is Zeinab?) Rowayed began to look around the walls of the room. Then he stopped. "Zeinab! Zeinab! Zeinab!"

Zeinab is Rowayed's aunt, and he found the confirmation he was looking for. On the wall in the far corner of the room from where he had been sitting, he found her name etched into the historic walls. His aunt had written this many years ago. As he continued to look, following telephone instructions from his father, he found names of more members of his family. We were not just in a Palestinian house; we were actually in an Al Azzeh house, the house of one of Rowayed's grandparents. Those few seconds when this young boy first realized where he was were something deeply precious. Rowayed, Athal, Miras, Suhaib, Sa'ed, Abud, and Samah were truly back home.

Once Miras heard the news, he was equally proud. Just before we left the house, I heard a loud scratching coming from one of the rooms. I went to have a look. In the corner of the room, with sunlight through an arched window highlighting the determined but proud look on his face, was Miras, stone in

hand. He was writing on the ancient stone walls. As he finished, he turned and looked at me; he looked strong. Etched into the wall behind him were the marks of the new generation. Here in his grandfather's house, alongside the names of many previous generations of Al Azzehs, were five new letters: "M-I-R-A-S."

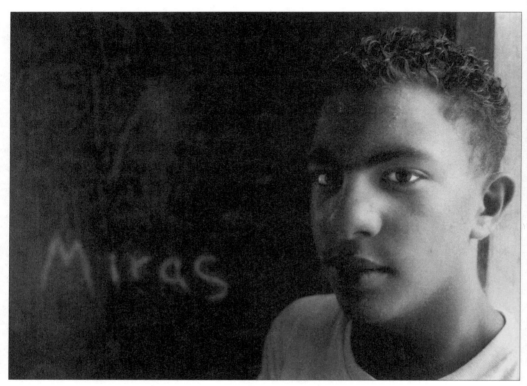

"Home Again"—Beit Jibreen

"The Water of Al Walaja"—Al Walaja

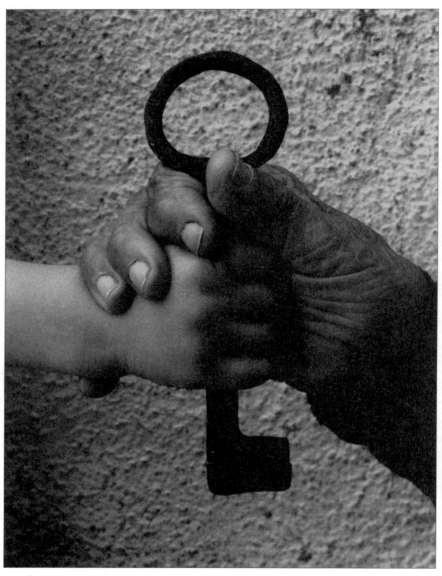

"Muftah al-Awda" (Key to Return)—Aida Refugee Camp

[ABOUT THE AUTHOR]

Rich Wiles is a British photographic artist and human rights activist. He is the coordinator of international relations at Lajee Center (www.lajee.org) in Aida Refugee Camp, where he directs collaborative youth arts projects. He has also run similar projects in schools in the United Kingdom. Exhibitions of his photographs and youth arts projects have been shown extensively across Europe, in Australia, in the United States, and in Palestine itself. His photographs have been widely published, including by the *British Journal of Photography*, the *Times Educational Supplement*, and the *Yorkshire Post*, and in Palestine by *Haq-Al-Awda* and *Al Majdal*. For more information, please visit www.richwiles.com.